NECROMEDIA

Cary Wolfe, Series Editor

(continued on page 232)

NECROMEDIA

MARCEL O'GORMAN

posthumanities **33**

University of Minnesota Press

Minneapolis

London

The University of Minnesota Press gratefully acknowledges financial assistance for the publication of this book from the University of Waterloo.

An early version of chapter 3 was published as "American Beauty Busted: Necromedia and Domestic Discipline," *SubStance* 33 (2004): 34–51; copyright 2004 by the Board of Regents of the University of Wisconsin System; reprinted courtesy of the University of Wisconsin Press. An early version of chapter 5 was published as "Angels in Digital Armor: Technoculture and Terror Management," *Postmodern Culture* 20, no. 3 (May 2010). An early version of chapter 7 was published as "Speculative Realism in Chains: A Love Story," *Angelaki* 18, no. 1 (2013). An early version of chapter 9 was published as "Broken Tools and Misfit Toys: Adventures in Applied Media Theory," *Canadian Journal of Communication* 37, no. 1 (2012).

Published by the University of Minnesota Press
111 Third Avenue South, Suite 290
Minneapolis, MN 55401–2520
http://www.upress.umn.edu

Library of Congress Cataloging-in-Publication Data

O'Gorman, Marcel.
Necromedia / Marcel O'Gorman.
(Posthumanities ; 33) Includes bibliographical references and index.
ISBN 978-0-8166-9570-6 (hc : alk. paper)
ISBN 978-0-8166-9571-3 (pb : alk. paper)
1. Mass media—Philosophy. I. Title. P90.O425 2015
302.23—dc23

 2014025342

Printed in the United States of America on acid-free paper

The University of Minnesota is an equal-opportunity educator and employer.

22 21 20 19 18 17 16 15 10 9 8 7 6 5 4 3 2 1

FOR THE ONE WHO TALKS TO ROCKS

CONTENTS

INTRODUCTION

Yet, at the same time, as the Eastern sages also knew, man is a worm and food for worms. This is the paradox: he is out of nature and hopelessly in it; he is dual, up in the stars and yet housed in a heart-pumping, breath-gasping body that once belonged to a fish and still carries the gill-marks to prove it.

ERNEST BECKER, *THE DENIAL OF DEATH*

You loved him when he was alive and you loved him after. If you love him, it is not a sin to kill him. Or is it more?

ERNEST HEMINGWAY, *THE OLD MAN AND THE SEA*

THE FIRST ONE CAME LIKE A LIGHTNING FLASH, only seconds after he dipped the worm into the cold lake at the end of the dock. He nearly dropped the five-foot fiberglass rod, which spasmed and jerked in his hands when the fish first struck. We could see it down there in the shallow water, struggling against the tension of the invisible line. It took only four or five turns of the reel to bring it up. A good-sized perch with six full stripes. It was the largest fish he had caught that week, and he reminded me immediately of our bargain: this one was big enough to eat. The perch went into a bucket, a new worm went onto the hook, and before we could finish our conversation about how to clean a fish, he had caught another. It would be three in all that August morning, in less than twenty minutes, each one suitable for pan frying.

It was in the midst of this questionable paternal exercise that I experienced the horror, which also came on like lightning. I carried the bucket onto the porch and set it down next to the morning paper and a thin filleting knife. With meticulous care, I pulled a fish from the bucket, careful not to be stung

by the prickly dorsal fin, held it firmly on the newspaper, and briskly severed its head with the filleting knife. I did the same twice more, but with each decapitation, my hands trembled more fiercely and my head spun more wildly. In spite of my strange dizziness, I stood the fish heads up side by side on the newspaper as always, a habit that I must admit was inspired by a strange music video, "Fish Heads," I had seen on MTV when I was my son's age:

> Ask a fish head,
> Anything you want to,
> They won't answer,
> They can't talk. (Barnes and Barnes, 2002)

I tried to think of the silly video, but it brought no relief. The fish heads stared back at me, opening and closing their mouths and gills. Speechless, waterless, but vital, even vulnerable. I hastily flung the heads into the lake, where they would be eagerly devoured by greedy gulls and bottom-dwellers. With great difficulty, my own spasmodic hands scaled the still-wriggling sheaths of muscle, coaxed out the spines, and dropped the fillets back into the bucket, where, as meat, they no longer stared back at me.

Snatched from the lake, relieved of their heads, fins, and spines, rolled in cornmeal and fried in butter, the perch were the highlight of the day. But I could not eat what would otherwise have been a much-anticipated treat. After several decades of my being a carnivore, even to the point of taking pride in teaching my son how to hook and cook a perch, what had provoked this sense of horror at the sight of a few small fish heads? One explanation might be the increasingly crowded shelves of books on animal studies next to my desk. Perhaps I had developed a new suspicion, to both paraphrase and contradict Martin Heidegger, that other species might bring a world into being. Or perhaps the horror was a result of domestic circumstances, namely, living with an ardent vegan. It has taken me, as a raging omnivore, a labor of empathy to identify with this vegan, even to the point of adopting some eating habits that would make Ernest Hemingway cringe. Perhaps the exercise in empathy toward this vegan, this labor of love, has trained me to be empathetic more generally, even to cows, pigs, and fish. I understand very well that I can no more talk with fish than I can reckon whether they might actually need a bicycle. I cannot put myself in their place, share their being, or even, and especially, speak for them. But this does not stop my effort to bridge the gap between human and fish. In the very exercise of imagining what it might be like to be a fish, or a bat,[1] or even a bicycle, one must take a leap that is at once discursive, philosophical,

creative, and speculative. It is a leap worthy of a technical creature whose nature is to constantly put itself outside of itself. It is a lover's leap into an infinite abyss.

In *Eating Animals*, Jonathan Safran Foer (2009) suggests that "war is precisely the right word to describe our relationship to fish—it captures the technologies and techniques brought to bear against them, and the spirit of domination" (33). Fish heads aside, this is not a book about animal rights, nor even about *animal rites*, to borrow a term from Cary Wolfe (2003) that brings to mind ethics, culture, and the discourse on species. There will be no breast-beating comparison here between factory farming and the Holocaust, although this questionable notion will be raised. This is, however, a book about animals, and more specifically a book about technical animals, creatures with the necessary foresight and wherewithal to fashion an arrowhead, a nuclear warhead, or a filleting knife sharp enough to excise the head of a ten-ounce perch with a single stroke. But a machine-fashioned knife, or any other tool for that matter, only captures in part the technicity of *Homo sapiens*, a technicity that is a question not just of biological evolution but also of symbolic evolution. As cultural anthropologist Ernest Becker suggests, *Homo sapiens* is characterized not only by its technical striving but also by its *symbolic* striving (1973). The technics and spirit of domination brought to bear in the war against fish is as much a matter of symbolic action as it is a matter of technicity. I didn't have to kill the perch for the sake of survival; I did it for the sake of fulfilling the symbolic roles and actions set in place by a specific culture. The story of horror that I just recounted documents how one cultural symbol system (perhaps wrongheadedly inspired by Ernest Hemingway) might be exchanged for another (perhaps inspired by Jane Goodall), all for the sake of what Becker might call the human need for a heroic sense of recognition. Above all, this book is an examination of how, in contemporary culture, the technical aspect of the human has collided with the symbolic aspect, resulting in a situation where technicity itself has become the basis for heroic recognition.

This is a book, then, about technoculture and its origins, the hero systems that allow it to thrive, and the behaviors these systems provoke, including a range of strategic maneuvers designed to help humans deny their own finitude. To flesh out these topics, I draw on a very broad range of disciplines, including critical theory, media theory, philosophy, cultural anthropology, and social psychology. By putting Ernest Becker into an assemblage with Martin Heidegger, Jacques Derrida, Friedrich Kittler, Bernard Stiegler, and Julia Kristeva,

among others, my goal is to add an existential dimension to contemporary philosophies of technology. Following Becker's own conspicuous transdisciplinarity, I have attempted to sketch a "general science of man" by paying close attention to two universal and inevitable elements of human being: death and technicity. The ridiculously ambitious nature of this project has not eluded me. Rather than attempting to generate lengthy tomes on the topic of death and technology, my goal has been to approach the problem tactically, taking on very specific topics such as how and why media technologies betray humans, why humans can find a heroic sense of self-worth by owning a gadget, and whether or not a piece of computer equipment can, in Heidegger's terms once again, *bring a world into being*. Besides the range of disciplines and topics in this study, the reader will also encounter in my work a range of methodological approaches to the problem of death and technology, which includes but is not limited to academic essays, poetry, autobiographical writings, digital art, and artistic performance. This explains the unusual format of the book.

Like the goal of my previous book, *E-Crit: Digital Media, Critical Theory and the Humanities* (2006), the goal of *Necromedia* is not just to lay out a theory, but to demonstrate it in action. Or, to draw on a cliché used by teachers of writing, my objective is not just to tell but also to *show*. With this in mind, I have structured the book as a rhythmic passage that vacillates between media theory essays and digital media projects in which these theories are applied. The result is what might be called a compendium of *objects-to-think-with*, a term borrowed from Sherry Turkle.[2] The object-oriented chapters in the book are experimental, and written in a variety of voices and genres, including autobiographical entries such as the one I have already tested on the reader in this introduction.

The reader may have to do some of the work in deciphering how these eclectic entries relate to the chapters on media theory and philosophy that bookend them. There are, however, some explicit links between chapters that can be noted here for the sake of giving a broad overview of the project. For example, the issues of surveillance, prosthetics, and cross-disciplinary border crossing explored in chapter 1 are applied quite explicitly to the *Border Disorder* project of chapter 2. The *Dreadmill* performance documented in chapter 4 replays chapter 3's themes of disembodiment, the collusion of war and technology, and the spectre of betrayal that haunts the pursuit of technological mastery. While chapter 5 looks at technocultural antiheroes, the discussion of *Cycle of Dread* in chapter 6 provides an autobiographical account of video gaming and heroic self-fashioning, followed by a discussion of William Blake's printing methods. This prepares the reader for chapter 7's focus on romanticism

and object-oriented ontology. Chapter 8's *Myth of the Steersman*, a project that required careful carpentry practices, was positioned immediately before chapter 9 to foreshadow an argument that humanities research must engage directly with the crafting of digital products, even at the risk of creating "broken tools and misfit toys." Finally, chapter 10's *Roach Lab*, a project by Jessica Antonio-Lomanowska, puts into question the terror management theory experiments that conclude chapter 9, just as it introduces the distinctions between terror and horror that are central to chapter 11. There is a danger here of explaining away the structure of the book, which was not hardened into place according to an exacting methodology but which emerged organically out of several years of academic and artistic practice. This list of connections between chapters is not exhaustive, and I do not expect the readers to recognize all of them. What I do expect from readers is that they remain open to the possibility that media theory and philosophy can take on various discursive modes beyond the research essay, an expectation that explains the book's experimental format.

In his bull-fighting treatise *Death in the Afternoon*, Ernest Hemingway (2002) makes the following observation on writing technique, which has come to be known as "iceberg theory" or "the theory of omission":

> If a writer of prose knows enough of what he is writing about he may omit things that he knows and the reader, if the writer is writing truly enough, will have a feeling of those things as strongly as though the writer had stated them. The dignity of movement of an ice-berg is due to only one-eighth of it being above water. (154)

It may be risky, given the fish tale at the opening of this introduction, to refer once again to an author nicknamed "Papa" who has been labeled as homophobic and misogynistic and who is ardently in favor of cruelty to animals. But perhaps Hemingway's observation is all the more poignant here for these very reasons. For the reader to experience "a feeling of those things," a leap of imagination and even empathy must be undertaken—whether this means attempting to empathize with a despicable character such as "Papa" or a strange, nonhuman thing. My hope is that readers will plunge far enough below the surface to see the iceberg that looms deep beneath the chapters and interstices of this book.

Finally, I could recommend that the reader skip alternating chapters in order to transform this volume, like many other books written in an intermittent chapter format, into either (a) a digital art book or (b) a media theory book. But this binary approach disregards the struggle that is at the heart of this project, which is an earnest attempt to marry media theory and digital practice

in a hybrid narrative about death and technology. What I recommend instead of this binary approach is that readers engage fully in the struggle that is required to bridge these chapters, approaching the most difficult parts of the task not with a philosophy of "catch and release," but rather in a spirit of "eat what you catch." Happy fishing.

1 NECROMEDIA THEORY AND POSTHUMANISM

Unless we are forgetting the invention of the shipwreck in the invention of the ship, or the rail accident in the invention of the train, we need to examine the hidden face of new technologies, before that face reveals itself in spite of us.

PAUL VIRILIO, *OPEN SKY*

And this is the simple truth: that to live is to feel oneself lost. He who accepts it has already begun to find himself, to be on firm ground. Instinctively, as do the shipwrecked, he will look around for something to which to cling, and that tragic, ruthless glance, absolutely sincere, because it is a question of his salvation, will cause him to bring order into the chaos of his life. These are the only genuine ideas; the ideas of the shipwrecked. All the rest is rhetoric, posturing, farce.

JOSÉ ORTEGA, *THE REVOLT OF THE MASSES*

Necromedia Theory

In May 2004, I was stopped at the border en route from Windsor, Ontario, to Detroit, Michigan. Alarms sounded and gates at the customs booths went down. Three armed officers rushed to my car and asked me to get out. One of them eyeballed me at close range and asked forebodingly: "Do you have anything you want to tell me before I get into this vehicle?" I had no idea what was taking place. Only later, after encountering the rapid-fire clicks of a handheld isotope detector in the customs office, did I realize that I was radioactive. Not radioactive in the superhero sense (unfortunately), but radioactive because of the bone scan my doctor had ordered two days before the incident. It seems that the radionuclide in my bloodstream had set off the post-9/11 surveillance

equipment designed to root out the throngs of terrorists entering the United States from Canada.

When I returned to my car hours later, which a guard had taken on a joyride through a "radioactivity portal," I once again experienced a mortifying sense of how life had changed since the day passenger jets were turned into weapons of mass destruction in American skies. This border experience is in every sense what I would call a "necromedia scene," a brief event that reminds us of the interrelatedness of death and technology. By unraveling this particular media scene, I hope to give a fairly lucid account of what this book is all about.

First, there is the question of the radioactivity detector itself. After 9/11, Homeland Security began equipping customs officers with "radiation pagers" such as the nukeAlert developed by Berkeley Nucleonics Corporation, a detection device small enough to clip to a belt. Pager technology, which was first used by the Detroit Police Department in 1921 and destined to be recognized as the communication device of choice for drug dealers, has come a long way in its design for ensuring public security. This brief history of the device underscores, at a very basic level, the idea that media technologies are indifferent toward the intentions of their users. Any technology designed for the purpose of law and order can just as easily be turned into a criminal device, and vice versa. It is clear, then, that this book is not about judging the moral or ethical nature of technological innovations, a task that, for the reason stated earlier, would be absolutely futile. I will argue, however, that technology is indeed *deadly*, not because gadgets lead to the demise of humans but because there is an incontrovertible link between death and technology. As far as technological devices go, they are examined here as objects designed to distract us from the single most imminent possibility of everyday life—the possibility that we might, on any given day, stop living.

Returning now to the necromedia scene at the border, there is also the question of the bone scan. There is something uncanny about willfully accepting the injection of radioactive materials into your bloodstream. Cancer patients experience this radical irony most palpably in their recognition that an agent responsible for the specter of global annihilation can be applied toward the prolongation of life. It is here that we encounter the pharmacological nature of technology. Socrates, in the last moments of his life, recognized the hemlock he was about to ingest as a *pharmakon;* the poison would put an end to his physical being, but at the same time, as he so brazenly informed his private audience, it would also secure his immortality, his heroism or *kleos.*[1] For Plato, writing technology also serves as a *pharmakon*—a tool that in one stroke

enhances the human capacity for knowledge and endangers the capacity to remember. These issues, as pursued by Jacques Derrida and more recently by Bernard Stiegler in the form of the *techno-pharmakon,* are central to this study. The *pharmakos* (scapegoat) is here as well, in the form of a ritual, cathartic social rite. Indeed, it is at the border, in the hands of Homeland Security, that we encounter the first *pharmakos* of this book, banished from his vehicle and sent to a purgatorial holding tank, all in a ritual of expiation against the specter of terror.

Finally, the media scene at the border might prompt a curious reader to ask, what was the purpose of the bone scan in the first place? In this case, my doctor had ordered the test to further examine the cause of chronic pain in my hip and lower back. The bone scan eventually revealed that I had suffered a stress fracture in my left acetabulum, a result of the two dominant activities that defined my lifestyle at the time: (1) sitting for up to twelve hours a day in front of a computer screen and (2) training for and running in ultramarathons, primarily 50K races on hilly off-road trails. The sitting part is merely a professional liability—I'm an academic and a digital media designer. The running part is something I view as a form of stress release, a way of *unsnarling* "structural problems," as Joyce Carol Oates so elegantly put it in an essay about running in Detroit (1999). In any case, this extremist lifestyle is not conducive to human skeletal health—particularly the sitting part. Like the majority of North Americans today, I'm more than willing to neglect my body, submit myself to relative immobility, all for the sake of having increased access to information and more efficient means of communication. I live my life—or at least the majority of it—on the screen.

Also like a growing number of North Americans, I am attempting to make up for what I sometimes view as an unheroic, sedentary lifestyle by following in the marathon-running footsteps of the Greek hero Pheidippides. The original marathoner ran to rescue his fellow troops from mortality, but today's marathoners have very little opportunity for such heroic acts. Running a marathon, like riding a monstrous roller coaster, whitewater rafting, or guiding computer avatars through apocalyptic landscapes, is a direct defiance of our own fleshly mortality and an attempt to achieve recognition, which I posit here as the common existential objective of all human beings. Here is the formula: we make up for our unheroic lifestyles by immersing ourselves in controlled environments that allow us to purchase the experience of physical risk for the sake of achieving recognition.

This book focuses on our attempts to outstrip our human limitations as a way of fulfilling our need to be recognized and our desire to be immortalized.

We do so not only by running marathons, however, but also by relying on technology's false promise of immortality. This promise comes in many shapes and forms, from medical technologies designed to extend life, to artificial intelligence research that seeks to transfer human consciousness into machines, to highly immersive video games and the identity-morphing spaces of the Internet. This false promise of immortality, as I have called it, is facilitated largely by our technologically mediated ability to vanquish space and time, to reproduce and extend ourselves electronically through transmission and storage. The extent of this ability ranges from the simple (handing a photograph of yourself to a loved one) to the complex (performing telepresent surgery on a patient five thousand miles away).

When I crossed the border each day to teach at the University of Detroit, I had to show my passport image to a guard. When I accessed the university gym and library, I scanned my faculty ID card. When I rented a video at the local store, I showed my driver's license. Put simply, I relied then, just as I rely now, on a visual and databased reproduction of myself to achieve legitimacy, to affirm my existence, and to gain access to the world around me. What's more, in each of these instances of self-identification, as my digital identity was being entered into a database, my *live* image was also being recorded by a video surveillance device. My son, who was with me in the car on that ill-fated day of borderline radioactivity and was less than two years old at the time, had already been photographed and videotaped in utero by means of an ultrasound device. Even before he was born, we were developing a relationship with him through his recorded image. Nearly every day of his life, he will be videotaped, databased, and recorded for a variety of purposes. All of this is to suggest that my children live in a culture where their recorded images circulated in the world before they did, will be disseminated in multiple locations and contexts while they are alive, and will remain in databases and media archives long after they die. They might store their *digital assets* on a commercially run server to be opened by their survivors after their death, and as morbid as the thought may be, their own children may create eternal video monuments to play at their funerals and store them for replay on whatever social media outlet is most popular at that time.

These observations have been made by several media philosophers and critics of surveillance technology over the past couple of decades, most of whom cringe at the mounting banks of data containing our personal information. What I would like to target is not our careless surrendering of personal information, but the psychological and even metaphysical transactions that take place in this constant self-imaging and self-databasing. As I have already

mentioned, my primary focus here is not on media technologies per se, but on *technological being.* I should no more focus on my son's ultrasound than I should on the bottle of infant formula that I fed him while waiting in Homeland Security's holding tank. The bottle, the prosthetic nipple, and the nutrient-rich simulation of human breast milk are just as technological as any electronic gadget or recorded medium. All of these items must be considered together as part of an assemblage that includes my own body, my car, my passport, and so on, in order to begin questioning what it means to be a technological animal.

As Martin Heidegger (1982) suggests in his discussion of the term *enframing,* there is nothing technological about the essence of technology;[2] that is, we cannot understand technology by looking solely at devices and their function. Technological being does not even start with modern industrial man, as Heidegger seemed to suggest. Rather, as I argue throughout this book, following the work of André Leroi-Gourhan, Gilbert Simondon, and Bernard Stiegler, there is no human being without technological being. To be anything other than technological is to be nonhuman. And to make this proclamation more challenging, I will add that being technological comes of necessity with knowledge of one's own finitude. No humanity without technology. No humanity without death reckoning.

In her book *Tactical Media,* Rita Raley (2009) suggests that "if border crossings are understood to be 'individually experienced,' then, absent a direct testimony, a witnessing of one's own experience, one can only have recourse to the categorical" (49). What I have attempted to do with this border scene is provide a *media testimony* that creates an existential context for technological being. Still, as an autobiographical anecdote, the "necromedia scene" at the Canada–U.S. border can be stretched only so far into a philosophy of media. My method in this book, however, is to make use of such scenes in each chapter as a way of locating necromedia theory in the everyday contexts of contemporary Western culture. For the remainder of the book, I will rely less on scenes from my own life than on scenes from the lives of other *modest witnesses,* including Hollywood actors. Movie stars, and the movies they star in, provide us with excellent case studies in necromedia theory. Bernard Stiegler's (2001) examination of the film *Intervista* is a case in point. In a crucial scene from the film, Anita Ekberg watches herself onscreen in *La Dolce Vita,* forty years after its production. As Stiegler suggests, at this moment, the actress recognizes her own "passing," her own mortality (2001, 49). What Stiegler doesn't suggest is that Hollywood actors are merely extreme examples of what it's like to *live on the screen* in our contemporary technoculture. While we may

consciously emulate the idealized images of Hollywood stars by means of fashion, dieting, exercise, and even plastic surgery, we are unconsciously emulating their lifestyles by living out most of our lives on video screens. Today, we are all immortalized on the screen, though that screen may not be in a movie theatre.

Technocultures, Dorsality, and Applied Media Theory

The investigation of technology and human finitude inevitably runs into questions posed by posthumanist philosophers. In many ways, this study picks up where Cary Wolfe (2010) leaves off in *What Is Posthumanism?* In the final chapter, Wolfe examines Brian Eno and David Byrne's (1981) album *My Life in the Bush of Ghosts* in the context of Derridian spectrality, equally informed by Roland Barthes, Bernard Stiegler, and David Wills. What is ghostly about Eno and Byrne's uncanny soundscape, notes Wolfe, is that it underscores the way in which recordings of ourselves live on in our absence. Wolfe further suggests that Derrida's logic of the specter, "a trace that marks the present with its absence in advance" (Derrida 2002, 117), need not be considered as a "kind of fatalism or necrophilia," but a simple "fact" about where "futurity itself resides" (294). The simple fact is "that the words we record now, the images we make now, will be iterable in our absence, and indeed in the absence of any 'empirical being' currently alive in 'the living present'" (294). Derrida's morbid notion of the "messianic" comes into play here, since, as Wolfe puts it, "we die so that they, the future ones [the recordings of ourselves], may live" (294). While this self-spectralization via media comes across in Wolfe's work as a simple "fact," it is a fact that, in Derrida's words, "has a curious taste, a taste of death" (quoted in Wolfe 2010, 294).

This taste lingers in the work of David Wills (2008), whose *dorsal* conception of the human always looks back, back to the first human hand that reached out and beyond itself to "enter into a prosthetic relation with a tool" (295). Relying heavily on the work of Derrida but most evidently on Bernard Stiegler and André Leroi-Gourhan, Wills suggests that this exteriorization, which includes the exteriorization of memory, is what marks the turn from nonhuman animal to human being. In Stiegler's words, "the human invents himself in the technical by inventing the tool—by becoming exteriorized technologically" (1998, 141). And this scene of invention, of prostheticization, of technologization, Wills suggests, is also a "matter of archivation: what is created outside the human remains as a matter of record and increasingly becomes the very record or archive, the artificial or exterior memory itself" (10). It is not

the first use of a flint to crack a skull that defines the protohuman (and hence prototechnological) moment, but memory of the task, the *repeated* use of the flint to perform the same task (O'Gorman and Stiegler 2010). The flint, once put down, retrieved, and reused, exemplifies the "matter of archivation" to which Wills insists we always *look back* upon as a species.

The moment of archivation is at once a moment of transcendence and a grounding in materiality, an entry into time itself. It is a moment of death reckoning. As Stiegler notes, "this time he then is, this outside is also his death, his own death or the death of what is proper to him, his falling off *[déperissement]*, his denaturalization" (1998, 122). It is for this reason that Stiegler suggests "to ask the question of the birth of the human is to pose the question of the 'birth of death' or of the relation to death" (1998, 135). Here, then, we see the essence of the collusion of death and technology, which is also the collusion of the human species and technics. This situation is described by both Stiegler and Wills in terms of a fall, a Promethean melancholy: "*Homo oeconomicus, faber, laborans, sapiens:* the logical, reasonable, or speaking animal, the politico-social animal, the desiring animal, all that traditional philosophy has always used to qualify the human race, from Plato to Aristotle to Marx and Freud—this all comes only after this accident by which man enters into the disastrous feeling of death, into melancholy" (Stiegler 1998, 131). As I suggested earlier, there can be no humanity without technology, no humanity without death reckoning. To be human is to be prosthetic, archival, outside and beyond one's fleshly shell.

In an attempt to resist this melancholic turning back or *dorsality,* this so-called deadening effect of technology, Wolfe focuses on the recursivity and folding inherent in technological being, also identified in Brian Massumi's understanding of *sampling.* By looking not only back but also forward and beyond death, archivization becomes a "source of creation" (Wolfe 2010, 295). Wolfe's point is driven home through an examination of Brian Eno and David Byrne's *My Life in the Bush of Ghosts.* Paying particular attention to the resampled and distorted vocals on the album, Wolfe notes that Eno and Byrne extract "the vocal material from its original anthropological, religious, or political context, but only to underscore its strangeness, . . . a musicality and exteriority that exceeds intention, denotation, and sense, confronting the listener with his or her own nonknowledge" (Wolfe 2010, 297). This sampled material embodies the theory of what Barthes calls the "*phantom being* of the voice" (quoted in Wolfe 2010, 297), the fleeting nature of the spoken word, which, even when not recorded, is subject to a resampling by the receiver of the message, whose subjective interpretation ensures the impossibility of any stable

meaning or subject. Eno and Byrne remind us that beyond our Promethian melancholy, our messianism without a messiah, we are generative, creative beings. But to embrace this generativity in full, one must achieve a certain relationship with archiving, and with the archive itself, a subject I have approached already in *E-Crit* (2006) and that I take up again in this book. Whereas in *E-Crit* I lamented the archiving that characterized much of the work in the digital humanities, here I employ a more expansive understanding of archivation as the essence of our technological animality. This new configuration alters the meaning of the digital archive fever I identified in *E-Crit*, which might now be understood as a symptom of the desire for immortality, the results of a human compulsion for self-externalization.

In his discussion of *My Life in the Bush of Ghosts,* Wolfe notes that when Byrne and Eno first undertook the project, their intention was to create "a series of recordings based on an imaginary culture" (2010, 297). Wolfe grabs hold of this statement to launch into a discussion of the "we" of culture, which like the "I" is subjected to the "alterity and radical otherness of time," already noted briefly (298). It is in this gesture toward the interrelatedness of time, culture, otherness, and memory storage that Wolfe concludes his book. And it is here that I wish to begin. Rather than viewing Eno and Byrne's fantasizing about an imaginary culture as a means of reifying poststructural theory (e.g., their work embodies Derridian *spectrality* just as George Landow [1992], for example, argued that hypertext embodies Barthesian *intertextuality*), I would like to resist this folding of Eno and Byrne's work back into theory and to consider their fantasy as the desire of two contemporary artists to produce an artifact that breaks free of their own culture's overbearing mode of production.[3] For musicians attuned to the technics of the studio production machine, this break would require inventing an equally sophisticated technics, a technical fold achieved not only by resampling vocal content but also by repurposing the very recording and communications technologies that were the tools of their trade, such as the boom box and the radio. The culture that Eno and Byrne hoped to resist is what I will identify throughout this study as a "technoculture," a culture of *technology for technology's sake,* in which the technological nature of human being has been transformed into a system of heroic cultural action. Most importantly, Eno and Byrne's fantasy culture of resistance did not take the shape of a primitive or romantic, antitechnological culture, but as yet another technoculture, an alternative vision of how technoculture might look if liberated from the binds of technocapitalist manufacturing. By producing *My Life in the Bush of Ghosts,* Eno and Byrne did indeed create an artifact from an imaginary culture, a technoculture that, unlike ours, acknowledges human

finitude and finds within it a generative force that is not ultimately geared toward repetition, mass production, and marketing.

As I have argued thus far, to fully acknowledge human finitude is also to acknowledge our own technological being. It is from this coincidence, this collusion as I have called it, that the term *necromedia* emerges. All media, I would suggest, by pointing at once to both our technicity and finitude, are necromedia. But this acknowledgment need not "taste like death," as Derrida suggests. In *Dorsality*, David Wills (2008) proposes a "dissidence" to the relentless fetishization of technological progress that characterizes Western culture. Acknowledgment of our always-already-technological state can be accompanied by what Wills calls a "right to *hold back*, not to presume that every technology is an advance" (6). Wills roots this dissidence, which is by no means a Luddite stance, in the idea that technology "comes at the human from behind" (7), and thus encounters us in a relationship of *chance*, rather than in a straightforward, progressive manner. This point of view contradicts any understanding of technology as a form of control, as a "fabrication produced by hands manipulating matter within a visible field" (7). To view the relationship between human being and technology as a game of chance requires a more critical and careful understanding of technological production, since this view also acknowledges that we cannot fully predict the impact of technology on the human, an impact that always occurs "upstream" from the point of production. The notion of *dorsal chance* relies on a "conceptual account of a technology whose effects exceed the strict conditions of its production, a technology that proliferates or mutates as the viral life that—for example, in information technologies—is the form and name it actually borrows" (7).

What shape would technological production take if it were engaged in this spirit of dorsality, in this spirit of chance and critical perspective, performed by humans with a full sense of their always-already-technological state of being? I would like to propose that Byrne and Eno, spurred by their desire to create an artifact from an imaginary (techno)culture, have already given us a sense of how such a mode of production might look. But to place Eno and Byrne in this position would require transforming these media artists into media theorists. Conversely, what I try to outline in this book is a dorsal mode of technological production that requires transforming media theorists into media artists. Put otherwise, what I prescribe in this book is a technics of *applied media theory*, a mode of humanities scholarship designed to produce an alternative technoculture. This book is punctuated with chapters that illustrate projects inspired by *applied media theory*, which attempt to imagine or possibly even generate an alternative technoculture rooted in the media theories outlined here.

As I have already suggested, the philosophical bent of this discussion might be described as posthumanist, but I would apply this label with caution, for this is a word fraught with many challenges. First, we must accept the idea that, just as we acknowledge the existence of a *prehuman* world, we might also imagine, in a less sanguine way, the possibility of a future time without humans, a *posthuman* world. But this notion has little to do with the sense of posthumanism explored in this book. As Quentin Meillassoux (2009) suggests in his discussion of the *ancestral,* to conceive of a prehuman time is in itself a humanist gesture, a conjuring act that cleverly introduces a human invention into a universe that existed well before the concept of time. In his challenge to the "truth" of science, specifically the science of origins, Meillassoux asks, "How are we to grasp the *meaning* of scientific statements bearing explicitly upon a manifestation of the world that is posited as anterior to the emergence of thought and even of life—*posited, that is, as anterior to every form of human relation to the world?*" (9–10). This is a posthumanist question, one that challenges the privileged seat that humans have pretended to occupy at least since the Enlightenment. What is at stake here is not exclusively a question of temporality regarding the position of the human on an evolutionary scale. Rather, it is a question of humanism and its prejudices, its blindness, its vulnerability.

The version of posthumanism as a philosophy that challenges humanism has developed great momentum over the past two decades, culminating perhaps in Cary Wolfe's *What Is Posthumanism?,* an attempt to set the record straight and perhaps take some ownership of the term. What is evident in Wolfe's book is that there is more than one version of the posthuman. As Katherine Hayles (1999) points out in *How We Became Posthuman,* the term has the potential to elicit a certain degree of terror: "'Post,' with its dual connotation of superseding the human and coming after it, hints that the days of 'the human' may be numbered" (19). Of course, as Hayles suggests throughout her book, the understanding of the posthuman as a being in the future that supersedes humanity is an object of science fiction, provoked by the progressivist rhetorics of artificial life scientists such as Rodney Brooks and transhumanists such as Ray Kurzweil. In spite of Wolfe's reservations about Hayles's temporal understanding of the word *posthuman,* he nevertheless agrees with her conception of the posthuman as a figure that rejects the prejudices of humanism.[4] Wolfe does not imagine anything like a posthuman being, proposing instead a posthumanism that is more a philosophy than an evolutionary state. Quite simply, posthumanism is a philosophy that denies humanism's conception of the autonomous, self-possessed subject. The conception of the human as always-already-technological, always-already-prosthetic is in itself a posthumanist

concept in that it challenges the anthropocentric autonomy that is character-istic of a humanist conception of being. Through a process of coevolution or what Stiegler calls *epiphylogenesis*, we *are* our prostheses, and technology is not something we use to control so-called *nature*. In fact, we are not in control at all, and we never have been. This is a radical challenge to humanism's con-ception of the rational, self-possessed subject.

In spite of her use of the term *posthuman* to designate some sort of futuris-tic being, Hayles's work resonates very well with the argument I am attempting to develop here. This is primarily because of her rejection of fantasies of disembodiment—fantasies that reflect humanism's neat division of body and mind—that are prevalent in our current technoculture. Thus, I have adopted the following statement by Hayles as an accurate reflection of my own "dream" as captured in this book and in the projects undertaken by the Critical Media Lab:

> If my nightmare is a culture inhabited by posthumans who regard their bodies as fashion accessories rather than the ground of being, my dream is a version of the posthuman that embraces the possibilities of information technologies with-out being seduced by fantasies of unlimited power and disembodied immortal-ity, that recognizes and celebrates finitude as a condition of human being, and that understands human life is embedded in a material world of great complex-ity, one on which we depend for our continued survival. (1999, 4)

Stiegler's concept of *epiphylogenesis*, which encompasses an understanding of the human as simultaneously technical and death-aware, provides a vehi-cle for elaborating upon Hayles's dream, which I understand as a desire to create an alternative technoculture.

While Hayles does not overtly flesh out a strategy for achieving her "post-human dream," she provides the reader with a multidisciplinary form of schol-arly practice firmly rooted in the humanities, but with an eye toward the materiality of technocultural life. If critical theory is going to respond appro-priately to the problem of creating an alternative technoculture, then it will have to reach—like Hayles—toward a more holistic, multidisciplinary approach to research, one that creates discourse networks between the production of knowledge in the humanities and the production of new technologies in both the high-tech sector and the cultural industry.

Becker the Posthumanist

Hayles is working in a hybrid scholarly mode that is shared by Ernest Becker, author of the Pulitzer Prize–winning book *The Denial of Death* (1973). Becker's

work, which I discuss at length throughout this book as a sort of existential curative, has been widely recognized for its attempt to achieve a synthesis of several fields of study in the process of examining the "vital lie" of human existence. Becker's ambitious work attends to nearly all of the failures of cultural theory as outlined by Terry Eagleton (2003) in his slanderous book *After Theory*. As Eagleton puts it, ever so bluntly, "Cultural theory as we have it promises to grapple with some fundamental problems, but on the whole fails to deliver. It has been shamefaced about morality and metaphysics, embarrassed about love, biology, religion and revolution, largely silent about evil, reticent about death and suffering, dogmatic about essences, universals and foundations, and superficial about truth, objectivity and disinterestedness. This, on my estimate, is rather a large slice of human existence to fall down on" (101–2). Posthumanism has done a great deal to challenge Eagleton's defamatory accusations, primarily by turning to questions of biology, death, and suffering, particularly in the animal studies field of posthumanist philosophy. What's more, posthumanist animal studies have also demonstrated an effective model of multidisciplinary research that is self-questioning just as it asks difficult questions about the nature and origin of being. As Wolfe suggests, animal studies, or at least the nonanthropocentric strain of it, has been able to carve out a multidisciplinary or even transdisciplinary mode of scholarship that, at its best, forms a "distributed network of first- and second-order observers (disciplines) that, precisely by 'doing what they do,' call into question—and are called into question by—other disciplinary formations" (2010, 116).

It is for the sake of synthesis, self-questioning, and conceptual clarity that this study is inspired more by cultural anthropologist Ernest Becker than it is by Derrida, Heidegger, or even Wolfe, to whom I owe a great debt. Becker deals explicitly and straightforwardly not only with death but with evil, morality, religion, and love. His earnest work provides a way out of the pervasive irony, relativism, and potential nihilism that characterize much of contemporary critical theory. Becker's work, I would suggest, is a much-needed antidote to what cultural theory has become, and he gives us a lucid cross-disciplinary vocabulary with which we can ask the question of the human—and the nonhuman. As Eagleton suggests, cultural theory was built on direct political dissidence; it had more in common with art or public protest than it did with scholarship. When cultural theory was founded, "writers like Barthes, Foucault, Kristeva and Derrida were really late modernist artists who had taken to philosophy rather than sculpture or the novel. . . . The boundaries between the conceptual and the creative began to blur" (Eagleton 2003, 65). Critical theory, which began as a well-informed dilettante's mode of provocation, has become yet

another specialization, a field for endless play and inconclusive irony, a subject for graduate field examinations rather than a mode of dissidence that fosters creative political thought and action. I draw on Becker's work here for an escape route out of this self-serving spiral, one that points the way toward a mode of cross-disciplinary scholarship that allows for a direct confrontation of technoculture.

As exemplars for his scholarly method, Becker chose Otto Rank and Søren Kierkegaard, whose philosophical work defies a strict disciplinary labeling. As Becker notes, "Rank's thought always spanned several fields of knowledge; when he talked about, say, anthropological insight, you got something else, something more. Living as we do in an era of hyperspecialization we have lost the expectation of this kind of delight; the experts give us manageable thrills— if they thrill us at all" (1973, xx). Similarly, Becker refers to the theologian-philosopher Kierkegaard as somewhat of an unwitting psychoanalyst. This book is an attempt to carry on the legacy of Ernest Becker in both form and content. Formally, I am attempting to achieve a synthesis of several fields of knowledge, including anthropology, philosophy, media theory, and digital art. As far as content is concerned, the title of this book says it all. *Necromedia* is an attempt to form a merger between Becker's philosophical-psychological-anthropological theories of death-denial with media theory and contemporary posthumanist philosophy. My goal is to apply Becker's theories, to materialize them, so to speak, in contemporary culture, as a framework for investigating the relationship between technology and death. In this sense, I am attempting to renew and extend Becker's project in order to demonstrate both its relevance and limitations in a culture that can be defined only by its self-imposed technological imperative.

Echoing Kierkegaard as much as Herbert Marcuse, Becker readily applies the label of "philistinism" to describe the contemporary human condition. According to Becker, this is "man as confined by culture, a slave to it, who imagines that he has an identity if he pays his insurance premium, that he has control of his life if he guns his sports car or works his electric toothbrush" (1973, 74).[5] Becker posits that this condition is a result of existential "sickness," a suggestion that has also been taken up by Bernard Stiegler in his diagnosis of contemporary *malaise*.[6] "Immediate men," as Becker called them, are existentially ill, a condition that Kierkegaard diagnoses as "inauthenticity," a term that fell out of fashion in postmodern theory:

> They follow out the styles of automatic and uncritical living in which they were
> conditioned as children. . . . They are one-dimensional men totally immersed in

the fictional games being played in their society, unable to transcend their social conditioning: the corporation men in the West, the bureaucrats in the East. (1973, 73)

Following Kierkegaard, Becker explains this sickness in terms of a concept that is all too familiar and troublesome to contemporary philosophers, namely, the interrelation of body and mind:

> Kierkegaard is painting for us a broad and incredibly rich portrait of types of human failure, ways in which man succumbs to and is beaten by life and the world; beaten because he fails to face up to the existential truth of his situation— the truth that he is an inner symbolic self, which signifies a certain freedom, and that he is bound by a finite body, which limits that freedom. The attempt to ignore either aspect of man's situation, to repress possibility or to deny necessity, means that man will live a lie, fail to realize his true nature, be "the most pitiful of all things." (1973, 75)

Admittedly, Becker's reference to a discrete mind/body split echoes a humanist, Cartesian conception of human experience. What's more, his use of the words *true, self,* and *nature* are fingernails on the chalkboard of contemporary critical theorists for whom objective "truth" is impossible, "self" can be understood only as "selves," and "nature" is an anthropocentric construction. But Becker's naïveté toward the impossible complexity of such concepts as truth, self, and nature is what makes his work a useful antidote to postmodernist theories that provide nothing more than increasing complexity and problematization rather than potential avenues for political, ethical, or social action.

Becker's axiomatic thinking is what ultimately permits him to prescribe a therapy for the sickness of a late industrial culture. He explains the sickness of "automatic cultural man" in terms that are common to psychologists, but informed by a more open acceptance of cultural theory. This sickness ranges from schizophrenia to depression. Whereas postmodern theorists, from Gilles Deleuze and Félix Guattari to Sherry Turkle, have drawn on the idea of schizophrenia to explain the postmodern condition, Becker positions postmodern being within a much more complex continuum of neuroses and psychoses, a continuum that is simply framed by necessity at one end and possibility at the other. If the immediate man finds his identity uniquely in the material necessity of everyday life, schizophrenic man loses himself in the infinite possibilities of selfhood in a world of rampant consumption. Becker identifies the schizophrenic as experiencing a radical "split between self and body, a split in which the self is unanchored, unlimited, not bound enough to everyday things, not

contained enough in dependable physical behavior" (1973, 76). Such defini-
tions of schizophrenia have allowed for pat comparisons in contemporary cri-
tical theory between a specific medical illness and a more generalized,
technocultural way of being. But unlike postmodern theorists, Becker does not
abandon the definition of schizophrenia as a neurosis, nor does he glorify it.

Since Becker's understanding of contemporary cultural neuroses rests on
a sliding scale, it includes a condition that is not often explored in contempo-
rary theory: depression. Although depression is the most commonly treated
mental illness today, this mood disorder is more readily associated in the
humanities with modernism.[7] Given our contemporary obsession with pre-
scription antidepressants, it's time to work depression, or more specifically,
anxiety, more effectively into our understanding of the postmodern condi-
tion. Schizophrenia may be useful as a metaphor for describing how our cog-
nitive functioning is mediated and fractured by communications technologies
in contemporary culture, but anxiety gets to the root of the desire to escape
into multiplicity and reveals a great deal about our blind embrace of technol-
ogy. According to Becker,

> depressive psychosis is the extreme on the continuum of *too much necessity,* that
> is, too much finitude, too much limitation by the body and the behaviours of the
> person in the real world, and not enough freedom of the inner self, or inner sym-
> bolic possibility. This is how we understand depressive psychosis today: as a bog-
> ging down in the demands of others—family, job, the narrow horizon of daily
> duties. . . . The depressed person is so afraid of being himself, so fearful of exert-
> ing his own individuality, of insisting on what might be his own meanings, his
> own conditions for living, that he seems literally *stupid.* He cannot seem to under-
> stand the situation he is in, cannot see beyond his own fears, cannot grasp why
> he has bogged down. (1973, 78–79)

Digital media, in their various instantiations, serve a crucial role in our lives
as means of escaping what Becker calls *necessity;* they can distract us from
necessity altogether through an ever-renewed product line, or they can immerse
us in an alternate, illusory necessity that is rule governed and free of physical
risk.

Kierkegaard, in what would typically be conceived as a modernist under-
standing of being, posited that the most existentially balanced being is one
that has been "educated by dread" (Ortega 1957, 57) or anxiety, but without
being crippled by it. While an education in dread might not sound like an
enticing way to pass the time, what Kierkegaard and Becker mean by this is
that one must learn to accept human finitude as an essential component of

our animal condition. This is where the humanist bent of Becker and Kierke-gaard's existentialism meets the posthumanist bent of contemporary philoso-phies. Today, the faintest sign of anxiety is deemed as unhealthy, associated with mental illness, and can send the most rational person rushing off to his doctor for Paxil or Zoloft. Postmodern theorists of the past few decades who glamorized technoschizophrenia or painted a picture of the liberated, frag-mented, distributed self enmeshed in computer networks have only exacer-bated this problem by projecting a liberating world without anxiety. By focusing on depression, and more specifically on anxiety, rather than glamorizing schizo-phrenia, we might conceive of a diagnosis for our technocultural malaise, but also a therapeutics. This does not mean, however, that such a therapeutics would revel in existential terror. Nor should it tip the precarious scales of ter-ror into horror, which, as I argue in chapter 11 of this book, is one possible outcome of posthumanist philosophies that seek to escape the finite essence of human being. Rather, the therapeutics I prescribe here attempts to strike a balance by using posthumanist conceptions of being to better understand what is admittedly a humanist technocultural malaise.

By further expanding his theory of neuroses into psychological character types, Becker goes beyond the extremes of schizophrenia and depression to describe alternative ways of being that exist along the continuum of possibil-ity that defines mental health. One of these alternatives, which Kierkegaard identified as the "introvert," "has great contempt for immediacy." This type of person "tries to cultivate his interiority, base his pride on something deeper and inner, create a distance between himself and the average man. He enjoys solitude and withdraws periodically to reflect, perhaps to nurse ideas about his secret self, what it might be. This, after all is said and done, is the only real problem of life, the only worthwhile preoccupation of man: What is one's true talent, his secret gift, his authentic vocation?" (Becker 1973, 82). We see in Beck-er's archetypes the roots of later personality assessment tools such as the Myers-Briggs Test, and even more pertinently, the Kiersey Temperament Sorter, which sorts individuals into Promethean and Epimethean personality types, among others. But Becker's research agenda has little to do with this empirical cate-gorization of ways of being, nor does Becker romanticize Kierkegaard's *introvert*. Instead, he paints a bleak picture of this reflective type of being as having little place in a busy hyperindustrial world. This leads Becker to a more universal, existential account of what it means to be human, trapped between the pres-sures of necessity and possibility. "Introversion is impotence," suggests Becker, "but an impotence already self-conscious to a degree, and it can become trou-blesome. It may lead to a chafing at one's dependency on his family and his

job, an ulcerous gnawing as a reaction to one's embeddedness, a feeling of slavery in one's safety" (1973, 84). In spite of this warning, and in spite of the stigma associated with the term *introvert,* this character type might be viewed as an alternative to the pathologies (depression and schizophrenia) that characterize our current technocultural way of being. In short, what this character type represents is an individual who is capable of reflection, an activity that is being jettisoned from the prevailing cognitive modes fostered in our technoculture. To salvage this reflection from impotence, the introvert would benefit from a good dose of Prometheanism.

The "final type of man" described by Becker in *The Denial of Death* is the Promethean self-creator, a person who "asserts himself out of defiance of his own weakness, who tries to be a god unto himself, the master of his fate, a self-created man. He will not be the pawn of others, nursing his own inner flame in oblivion. . . . At its extreme, defiant self-creation can become demonic, a passion which Kierkegaard calls 'demoniac rage,' an attack on all of life for what it has dared to do to one, a revolt against existence itself" (1973, 84). The Promethean self-creator embodies "the all-encompassing demand by ordinary people to be recognized not for who they are but for who they *think* they should be" (1973, 27). But he or she takes this project more seriously than most, driving the desire for recognition toward a desire for fame, or *kleos.* Becker notes that this type of Prometheanism can be relatively innocuous in small doses. We see it today in the growing popularity of extreme sports, violent video games, and the endless pursuit of recognition by any means possible, as long as it can be tweeted or uploaded to YouTube. However, defiant self-creation, or Prometheanism, can also be incredibly destructive when it answers, in extreme ways, to the challenge posed by technology, which demands for ever new and more sophisticated methods of self-extension and self-archivation. It is the difference between fishing off the dock at the cottage and factory farming. "The ugly side of this Promethianism," suggests Becker, is that, much like philistinism, "it, too, is thoughtless, an empty-headed immersion in the delights of technics with no thought to goals or meaning; so man performs on the moon by hitting golf balls that do not swerve in the lack of atmosphere. The technical triumph of a versatile ape, as the makers of the film *2001* so chillingly conveyed to us" (1973, 85). Becker's focus on technology here is essential for an understanding of the unreflective mode of technocultural being that *Necromedia* sets out to resist.

There is another understanding of Prometheanism, to which I have already alluded, that does not involve a blind pursuit of technics, but rather is constantly immersed in reflection on both the technical and mortal nature of

human being. For this version of Prometheanism, which is admittedly melancholic, I turn to Bernard Stiegler. In *Technics and Time 1,* Stiegler (1998) draws on the Promethean myth, and especially on the less addressed role of Epimetheus in the myth, as an allegory for the invention of the human. The story is well known, and has already been recounted to great effect by David Wills in *Dorsality.* Prometheus, chained to a rock and forced to suffer the daily torment of having his liver feasted on by an eagle, commemorates mortality, the entry of the human into time and therefore into death. As Stiegler notes, "Just as the future is as inevitable as it is implacably undetermined, so Prometheus's liver, consumed by day and restored by night, is the Titan's *clock—* become feast of the sacrifice, as much as his torment. It is the ceaseless process of *différance* in which time is constituted with that one coup of technicity that is the mark of mortality" (1998, 203). This image of Prometheus as a champion of technics but also as an icon of human mortality serves as a model for the alternative mode of technocultural being that I am attempting to imagine in this book: a therapeutic mode of being that embraces technical triumphs, but only as a result of a reflection on and recognition of human finitude.

This book is an attempt to devise a therapeutic approach to our current technocultural way of being, which is characterized by an unreflective production of technology for technology's sake. Reflection, an endangered commodity in our culture, is a key ingredient of this therapy. How do we carve out spaces for reflection in an environment where, as Stiegler has suggested, our attention has become a commodity for sale, as evidenced, for example, in the astronomical price paid for commercial advertising during Superbowl games?[8] One possible answer, developed throughout this book, is to embrace our technological essence without sacrificing our human capacity for careful reflection. For example, this book prescribes a curriculum of reading, making, and writing as a space for resisting the commodification of attention demanded by a capitalist technocultural system. The ultimate outcome of this approach would be a therapy, one that in this case takes the shape of a scholarly method, blueprint for social intervention, and mode of digital production, all of which take into account the pharmacological nature of technology. As Stiegler (2010) suggests, "symbolic media are a network of *pharmaka* that have become extremely toxic and whose toxicity is systematically exploited by the merchants of the time of brain-time divested of consciousness. But it is also the only first-aid kit that can possibly confront this care-less-ness, and it is full of remedies whose texts were, since the very origin of the city (and first for Plato), the prime example" (85). Rather than turning against media technologies and striking

a stubborn Luddite pose, *Necromedia* is about fighting technology with technology, developing "first-aid kits" against the carelessness that characterizes our current technocultural way of being.

Finally, I must stress that engaging in critical reflection, paying attention, or *taking care,* as Stiegler famously puts it, requires an acknowledgment of our vulnerability and finitude, and a rejection of the promise of immortality put before us by cultural industries and their psychotechnological apparatuses. As discussed in the following chapters, I am proposing a form of humanism informed by posthumanist philosophy. Returning to the concept of *pharmakon,* what this book ultimately sets out to do is prescribe a technical therapeutics that treats the toxicity inherent in our current technocultural hero system. The therapeutics prescribed here, which requires a contemplation of both the finitude and possibility of humans and nonhumans, as well as a simultaneous embrace and denial of technoculture, is ultimately a precarious therapeutics, balancing carefully on the border between poison and cure.

2 *BORDER DISORDER*

> If border crossings are understood to be "individually experienced," then, absent a direct testimony, a witnessing of one's own experience, one can only have recourse to the categorical.
>
> **RITA RALEY,** *TACTICAL MEDIA*

By Car

In the first few days after 9/11, getting across the border between Windsor, Ontario, and Detroit, Michigan, was an excruciating exercise in anxiety. The commute of one mile could take anywhere from two to three hours, much of that time spent inside the tunnel itself, sitting in an idling vehicle, buried in a concrete cave far beneath the Coast Guard patrols on the Detroit River. Commuters at the Ambassador Bridge were spared this claustrophobia, only to be subjected to an agoraphobic traffic jam above the river, which left plenty of time to watch for oncoming jetliners. Getting to the front of these lineups hardly left room to exhale. The guards at the customs booths, newly minted Homeland Security officers, ordered commuters to open trunks and doors so they could rifle through duffle bags and briefcases with rubber-gloved hands, sweep beneath the seats, and check the spare tire compartment. The usual questions "Do you have any citrus fruit?" and "Do you have any beef products?" became redundant as guards fumbled roughly through lunch bags and coolers, not to root out invasive species and Mad Cow Disease, but to sniff out weapons of mass destruction.

After a week of submitting terror-stricken post-9/11 commuters to a choice between claustrophobia and agoraphobia, the customs agencies decided that a tunnel full of nervous border-crossers in idling vehicles might not be a good idea, nor would a mile-long, cross-border bridge jammed with innocent

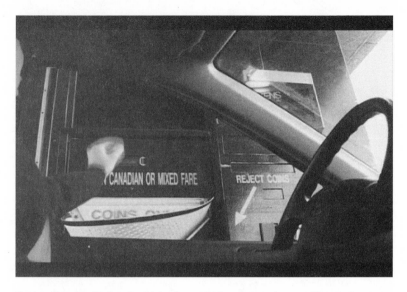

Figure 1. Crossing the Canada–U.S. border at Windsor, Ontario, by car. Still image from hidden handycam footage, 2005.

civilians and transport trucks. And so the lineups were moved to the streets of Downtown Windsor. Eventually, the two-hour cross-border limbo shrunk to an unpredictable wait of anything from twenty minutes to an hour. But the assault on privacy by Homeland Security didn't let up. Every day, robot-like sidearmed officers in blue caps and rubber gloves fingered the contents of briefcases and slid their hands under trunk linings. After several months, this fondling of private space finally subsided and was used only as a random security tactic or during "Code Orange" times, which were rarely if ever explained to civilians. As one of my neighbors put it, this was a "small price to pay for freedom." But what was at stake here was not freedom—certainly not freedom from terror. In spite of security checks easing up, the border experience had taught a valuable lesson: the 9/11 terrorists had won.

What is terror, after all? Flying passenger jets into buildings is clearly an act of terrorism. Sneaking a vial of plutonium across the border in your lunch bag might also be an act of terrorism. But this is not the terror that characterized the post-9/11 border-crossing experience. This terror was existential, not political. Even after the nail-biting idling on the bridge and in the tunnel subsided, the terror remained; it was embedded into the customs booth experience. The daily ritual of being interrogated, prodded, searched, and perhaps most of all willfully ignored by a sunglasses-wearing uniform behind a computer amounted

to a complex tactic of dehumanization. This is the terror: to be in the presence of other human beings who do not acknowledge you as human at all. The Canada–U.S. border has become a site of terrorization and deculturation, in which you are stripped of individuation, denied recognition, robbed of the ability to say "we." One possible countertactic against this daily loss of power, of culture, of humanity is to transform it into a spectacle, feed it back into culture, back to the "we," as a sort of testimony, a bearing witness.

I began this countertactic by recording my daily passage through the Detroit-Windsor Tunnel on a first-generation iPod rigged with a microphone, tucked under my sun visor. Each day, when I emerged unscathed from the customs area, I felt a sense of accomplishment, a creative rush. I would review the recording on the drive down the Lodge Freeway to 9 Mile Road, where I taught at the University of Detroit. I played the best of them back to colleagues and friends, who would laugh at the guards' questions about citrus fruit and meat, and even one threatening inquisition about the content of a DVD tucked into my briefcase, which the guard suggested might be pornographic. The result of my admittedly weak tactic of *sousveillance* was ultimately the transformation of a terrifying experience into one of adventure and humor, thanks to a simple digital recording device. My plan was to assemble these recordings into a sound installation about border zones for a gallery. But I decided that sound was not enough to get my point across. I needed to capture the full experience of descent beneath the river, which involves claustrophobia, interrogation, and terror.

On a sunny morning in the spring of 2004, I propped a Sony miniDV camera on a pile of books in the passenger seat of my car and covered it with a jacket. None of the camera was visible, not even the lens, which was peering out from the back of a tunnel constructed by the positioning of the jacket. I first tested the apparatus at the window of a Tim Horton's drive-thru on Wyandotte Street. The results were encouraging. The footage showed a smiling woman in a brown uniform taking my change and passing a "large with milk" through her window to my outstretched hand. Perfect angle and lighting. Acceptable volume. I returned the camera to its original place and headed for the tunnel.

I timed my border crossing for 9:30 a.m. on a Friday, after the morning rush, which minimized the time in line. After throwing my token into the hopper at the Canadian tollbooth, I descended into the darkness under the river. My goal was to document the drive through the tunnel as authentically as possible. For this reason, I left the radio on, glued in at 101.9 WDET, which at the time played a stimulating morning blend of indie music and NPR news bursts on the hour. The song on the radio was "The One You Love" by Canadian crooner

and gay icon Rufus Wainwright: "We've traded in our snap shots. / We're going through the motions." Midway through the tunnel, the radio transmission turned to static for a few minutes, as it always did, until the car emerged on the U.S. side of the border with Rufus still wailing plaintively. The lineup for each booth was about seven or eight cars long, and a group of border guards on foot wandered through the rows of vehicles, following a leashed German shepherd that eagerly sniffed tires, door handles, and trunk lids. I wasn't counting on this level of scrutiny; not that the camera could be sniffed out, but a guard looking through the passenger-side window might become suspicious of the pileup on the front seat. Fortunately, they were distracted by what looked like a driver with insufficient identification, and I was able to position my car on deck at the booth, happily not preinspected. When the minivan ahead pulled away, I slowly eased forward, rolling down my window with the hand crank. I barely had a chance to hand my passport to the guard before he stuck his head right out of the window of his booth, looked at me with a tough, sardonic grin, and asked: "What do you think I am, stupid?" I didn't dare answer the question the way I wanted to answer, which would likely have led to the loss of my H1-B visa. Instead, I said nothing at all. "I know you have a camera in there," he informed me calmly, shaking his head in the navy blue Homeland Security ball cap. I was busted.

But how? How could the guard know I had a camera even before I had arrived at his booth? Weeks later I approached a representative from U.S. Customs at a university job fair, and posed my question in a third-person sort of way so as to stay out of trouble. I'm sure he saw through that, and he asked ironically what kind of camera the "perpetrator" had. He said it could have been detected in one of many ways, none of which he was at liberty to disclose. Was it the moving parts in the camera motor? Radioactivity leaking from the battery? Infrared rays controlling the auto focus function? I will never know the answer.

My busting at the border actually took less time than many other incidents I have experienced at U.S. Customs, where border-crossing detainees are casually left to wait for unreasonable periods of time, sitting on plastic chairs and staring at a framed picture of George W. Bush on the wall. In these processing areas, border guards at a safe distance behind a counter or glass barrier joke with each other about their weekend adventures, shuffle papers with disinterest, and occasionally launch a menacing glance out at their helpless quarantine. The border guard who busted me took care of the entire situation outside, right at my car, so there was no need for a holding tank. First, he lumbered out of his booth and gestured toward two guards, a uniformed man and woman,

both in sunglasses, who were standing outside an immigration building. They sauntered over, hands on their heavy belts, and asked what was going on. By then, I had already taken out the camera, and explained that I was doing an "art project" to show my students at the University of Detroit. I must have looked professorial enough to convince them. But this was only after a rough grilling in which I was informed that recording the tunnel property, and especially taking images of guards, could be considered a felony in the United States and could place someone under suspicion of terrorism. What I didn't tell them is that I was aware of this, but I viewed it as a ridiculous limitation of my human rights. I kept my mouth shut and obeyed their orders to erase all of the footage from my tape. Or so they thought.

By Foot

It seemed like a strange oversight for the border guards not to confiscate the video equipment or even the tape itself. One of the guards took charge of ensuring that the tape had been erased, but she didn't do a thorough job. In fact, once I finished the "erasing," she gave me a satisfied nod, and I left the border

Figure 2. Crossing the Canada–U.S. border at Windsor, Ontario, by foot during the Detroit Marathon. Still image from headcam footage, 2005.

that day with a full recording of the tunnel commute, from the plunking of the token at the Canadian entry right up to the edge of the U.S. guard's booth, where the footage ends abruptly. The video ultimately documents a game of chance "written under the sign of risk," which is how Rita Raley (2009) describes Schleiner and Hernandez's border video game *Corridos*. And like the best of games, it left me wanting more. The project was by no means complete.

In the dark of morning on October 24, 2004, I emerged through the tunnel once again, but this time as a participant in the twenty-seventh annual Detroit Free Press International Marathon, which I had already completed twice before. I was determined to get the full borderline footage I was seeking one way or another, and the Detroit Marathon is the only day of the year in which pedestrians can cross both the Ambassador Bridge and Detroit-Windsor Tunnel. I ran in polyester trousers, a dress shirt and tie, and a runner's cap equipped with a headcam. The race of three thousand participants started with a gun shot at 7:00 a.m. outside the Free Press operations on Fort Street. I hit the Ambassador Bridge before 7:30 a.m., crossed over into Canada without a hitch, ran the few miles through Windsor to the tunnel crossing, and engaged the subterranean quest once again, this time fueled not only by the adrenaline of concealing a recording device but also by the sheer dopamine explosion of participating in a large-scale footrace. When I emerged from the tunnel there were several border guards lined up, inspecting the runners. The timing chip on my shoe went off as I stepped across an RFID (radio frequency identification)-sensing carpet near the customs booths, a German shepherd started barking, and one of the border guards seemed to point at me and call out, but he was drowned out by the throngs of spectators at the exit of the customs area. I was told later by another runner that the guard was calling out not at me, but at a marathoner who had set off a radioactivity detection device—a result of nuclear residue remaining in his bloodstream from a premarathon stress test ordered by his doctor.

The bouncy, low-res footage from the headcam is nausea inducing, but it also follows a rhythmic pattern that accurately captures the motion of running. My preceding description of the event comes not from recalling the direct experience of the event, but from watching the video hundreds, maybe thousands, of times. The emergence from the tunnel and left turn down Jefferson Avenue lasted about twenty seconds, and I was in a near state of panic at the time. Trying to recall that moment without reference to the video is impossible, and without the video, I would no doubt be unable to describe the details outlined here. What I do recall quite palpably is the sound of the event, which is perhaps the most striking detail about the video: the erratic beeping of the

RFID sensors, the barking dogs, the border guard yelling, the cheering crowd, the sound of the camera beating against the side of my head.

This ill-advised border adventure, which I now view as a relatively immature bit of risk-taking behavior, eventually became a video installation called *Border Disorder*. The video is a mash-up of the two border crossings, one by car and one by foot. The effect is that of a race between a car passenger, whom we watch fiddling with the camera nervously, and a marathon runner, whom we never see. The climax of the video occurs after the music in the car has ceased and the image cuts to a runner in the tunnel who turns around with a terrified look on his face, as if he were fleeing a menacing pursuant. The sound of a booming voice, echoing through the tunnel, adds an eerie resonance to this scene, as do the cuts back to the interior of the car, where Rufus Wainwright's angelic choir backs his plaintive whine. "In the early morning, In the early morning, The one I love . . ." Eventually, the two scenes seem to collide as the once-distant howl in the tunnel, now recognizably yelling "Get out of the way!" is accompanied by the clear, authoritative voice of a course guide sitting on the tunnel's half-wall, who yells, "Wheelchair on the left!" The sequence ends with a wheelchair rider passing the camera on the left and heading up into the light along the slow, upward grade out of the tunnel, where the beeping of the RFID sensor can already be heard.

Sousveillance

Border Disorder required acts of self-documentation designed not for the sake of satisfying the dominant heroic action system propelled by Twitter and Facebook but rather, following Steve Mann's tactics of *sousveillance*, to recommend alternative technocultural actions. In a web essay simply titled "Sousveillance," Steve Mann (2002), the self-proclaimed Cyborg-Luddite suggests the following: "Rather than tolerating terrorism as a feedback means to restore the balance, an alternative framework would be to build a stable system to begin with, e.g. a system that is self-balancing. Such a society may be built with sousveillance (inverse surveillance) as a way to balance the increasing (and increasingly one-sided) surveillance." Mann is calling for a wide-scale tactic, emerging from his research in wearable computing, to counter the power imbalance imposed by authorities after 9/11. In his book *Cyborg*, working with cowriter Hal Niedzviecki, Mann (2001) describes what it might be like to live each day with a similar spirit as that of the tunnel-crossing escapade described in the preceding section. For over a decade, Mann has worn a headmounted computer display designed to target the paranoiac cycle of watching and being

watched that emerged at the outset of the twenty-first century. His self-sacrifice, as he describes it, for the sake of countering the oppressive panoptics of post-9/11 surveillance, seems like an odd form of messianism given today's mania for social networking, which has turned surveillance into a gratifying ritual of self-disclosure. But mainstream social networking sites are precisely the sort of technological development that Mann is targeting in his dissidence toward "technology's tendency to homogenize and reduce difference for the sake of conformity and universality" (Mann and Niedzviecki 2001, 23).

Although he calls himself a "reluctant cyborg" (Mann and Niedzviecki 2001, 7), Mann is anything but a Luddite. The irony of this self-imposed moniker is equaled by Mann's use of both progressivist technological rhetoric and a rhetoric of dissent. "I accept and seek to implement the awesome power of technology to alter human life," writes Mann (2002). "However, I also believe that the individual—whether human, post-human, or cyborg—must be able to make his or her own decision. The road forward demands that we aggressively encounter and counter technology" (Mann and Niedzviecki 2001, 4). Evidently, Mann is voicing a posthuman (cyborgist) perspective here, but it is by no means a posthuman*ist* philosophy. Mann is guided by an Enlightenment-inspired conception of human individuality and freedom, which he believes contemporary technoculture has endangered. Ultimately, *Cyborg* is a book "about finding a way to position the human being at the crux of technological 'improvements' that can reassert freedom and individuality" (Mann and Niedzviecki 2001, 4). Mann's tactical goal is admirable, and in many ways it reflects the agenda of my own research, but the problem of this anthropocentric ideal is that the human being is already, *always-already* positioned at the crux of technology. The problem Mann wants to target is essentially the uncareful production of technologies for the sake of production alone, or more accurately, the production of technology guided cynically for the sake of profit above all else. To take on this problem, we must begin by better understanding how the blind production of technology for technology's sake effectively satisfies the existential needs of a technical animal. *Border Disorder*, and this entire tale of border crossing, might be viewed allegorically as the battle of a human to come to terms with his technical being, his always-already status as a cyborg.

The scene of emergence from the tunnel is an easy mark for students of Otto Rank (1993), who might recognize this claustrophobic video as a post-traumatic birth reckoning. In Rank's words, "the anxiety mechanism, which is repeated almost unaltered in cases of phobia (claustrophobia, fear of railways, tunnels, traveling, etc.), [is] the unconscious reproduction of the anxiety at birth"

(1993, 12). I have no intention of further developing Rank's thesis of the birth trauma as the "ultimate biological basis of the psychical" (xxii). What I will suggest instead is that *Border Disorder* provides an alternative origin story of the psychical, a birth trauma for a technical animal, accompanied by noise, static, and wild howling. In this scene of precarious human emergence, a split second before the moment of birth, an unanticipated twin comes up from behind, and in a terrifying act of betrayal, he exits first, rolling by deftly on prosthetic legs.

3 TELEPHONE, PAGER, TWO-WAY SPEAKER,
AND OTHER TECHNOLOGIES OF BETRAYAL

The older, traditional ideas of private, isolated thoughts and actions . . .
are very seriously threatened by new methods of instantaneous elec-
tronic information retrieval, by the electrically computerized dossier
bank—that one big gossip column that is unforgiving, unforgetful and
from which there is no redemption, no erasure of early "mistakes."
MARSHALL MCLUHAN, *THE MEDIUM IS THE MASSAGE*

Since 1880, there has been a storage medium for each kind of betrayal.
FRIEDRICH KITTLER, *GRAMOPHONE, FILM, TYPEWRITER*

VIVECA ST. JOHN, an 80s porn star, is mildly stoned and having an intimate
conversation with her cat Tito as she slips gently into the bathtub. "Ooh, that
feels so good. . . . Who's my lover? Yes, yes. Aren't you glad I rescued you?" Tito,
seemingly oblivious to the sweet nothings of Viveca, makes his way onto the
side of the tub and nudges the curling iron that Viveca had plugged in just
moments before. As the cat walks away, still oblivious, Viveca St. John dies of
electrocution. The scene fades to white, and episode 5 of *Six Feet Under,* a tele-
vision series that ran on HBO from 2001 to 2005, is underway. While it might
be tempting to say that the cat is at fault for this wrongful death, Viveca (Jean-
Louis McArthur) is really the victim of her own carelessness. In any case, we
would be more likely to blame the cat than to blame, for example, the curling
iron. After all, the curling iron is just an inanimate object. It has no intentions,
no consciousness, and certainly no ill will toward the aging porn star. Then
again, people can become attached to technological objects, or they can at
least treat them as though they are vital and vulnerable entities deserving of
recognition, much like pets. People whisper sweet nothings to their high-
performance sports cars or plead for mercy from their stalling clunkers. We

yell at our computers for not cooperating, and coax them gently into performing tasks for us. Sherry Turkle (2007, 2011) explores these animistic tendencies in her books *Evocative Objects* and *Alone Together*, the latter of which takes a close look at the human tendency to grant "aliveness" to mechanical objects. The goal of this chapter, however, is not to chastise the anthropomorphizing fetishes of technocultural beings, nor is it to argue the case for treating machines as companion species. Instead, this chapter takes a hiatus from posthumanist speculations about the vitality of cats and curling irons to investigate how our willingness to invest trust in technological devices can simply be reckless, and may even lead to death in many shapes and forms. This situation is ironic given the fact that, more often than not, our investment in machines is rooted in a deep-seated need to deny our own finitude. The devices that distract us from the fact that we are mortal beings may just as easily kill us.

Six Feet Under is merely one example of the early twenty-first-century rise in TV programs about death. At the time I began writing this book, on any given night I could watch a death program on cable television. I'm not referring to typical television violence such as that seen on *The Sopranos* during the period. I'm talking about programs that focus specifically on the dead or death itself, from what I would cautiously call a philosophical perspective. The list includes *Dead Like Me* (Showtime 2003), about a lovable grim reaper coming of age; *Six Feet Under* (HBO 2001), about a terminally dysfunctional family of undertakers; and *Family Plots* (A&E 2004), about a quirky and lovable family of funeral directors. I should also mention *Angels in America* (HBO), an Emmy-showered miniseries dealing with the AIDS crisis in New York during the 1980s. These cable shows would be followed by network programs such as *Ghost Whisperer* (CBS 2005) and *Medium* (NBC 2005), both of which involved leading women who "see dead people." What is one to make of this morbid trend? These programs didn't just make light of death, but dealt with its inevitability in trenchant scenes that border on existential philosophy. They prove that there is a sincere interest, somewhere in American popular culture, in death. Then again, one might take the cynical side of the argument and suggest that these series are merely fantastic soap operas or detective stories that capitalize on the shock factor of death. From this perspective, these shows help viewers repress the reality of death by demystifying or even glamorizing it on terms that are strictly Hollywood fantasy. The more recent trend in zombie movies and television programs provides some of the best examples of this fantasy.

An even more specific necrophilic trend in popular entertainment at the fin de millennium is a genre that I would dare call *necromedia cinema*. In a

very general sense, I use the term *necromedia* as a philosophical neologism to describe the relationship between death and technology. But the term can also be used to describe films, literature, and other cultural artifacts in which technological objects are personified, sometimes even anthropomorphized as a deadly antagonist. Consider the following summaries of films that I would place in the category of necromedia cinema:[1]

> *Ringu,* 1998, Japan, Dir. Hideo Nakata (adapted as *The Ring,* 2002, Dir. Gore Verbinski). A mysterious video kills whoever views it, unless that viewer can solve its mystery.
>
> *Kairo,* 2001, Japan, Dir. Kiyoshi Kurosawa. Japanese teens investigate a series of suicides linked to an Internet webcam that promises visitors the chance to interact with the dead.
>
> *Pon,* 2002, South Korea, Dir. Ahn Byeong-ki. A young woman buys a new cell phone, only to discover that those who had the same phone number before her died suddenly under unusual circumstances.

It should come as no surprise that these technoparanoiac films, seemingly inspired by apocalyptic manga, come out of Eastern Asia at the turn of the millennium. As I discuss in chapter 5, not only did Japan and South Korea see a huge growth in Internet usage during the years these films were released, but the countries also experienced an epidemic of tech-related social problems, including Internet and computer game addiction, mass suicide via webcam, and even computer-enabled *karoshi* (death by overwork).

Of course, we have our own tradition of necromedia cinema right here in North America. Films such as *Poltergeist* (1982), *Videodrome* (1983), *Maximum Overdrive* (1986), *Fear dot com* (2002), and *The Ring* (2002) register our tech-related anxieties about everything from TV, VCR, and radio to the Web, robots, virtual reality, and even toasters and soda vending machines. *Poltergeist,* for example, as Jeffrey Sconce (2000) argues in *Haunted Media,* "emblematizes the long history of cultural anxiety over the seeming vulnerability of the family before the unwavering eye of television" (164). As Sconce argues, these techno-haunted films embody some of the prevalent strains of postmodern theory, especially those of Guy Debord (life as spectacle), Michel Foucault (life as surveillance apparatus), and Jean Baudrillard (life as a "hyperreality" or simulation). In reference to such films as *A Face in the Crowd* (1957), *Network* (1976), and *The Truman Show* (1999), Sconce suggests that "the Baudrillardian strain of postmodernity shares with these other more popular tales of omniscient electronic media the basic premise that 'reality' is now inescapably mediated by spectacle, a form of covert attack in which an electronic mirage is gradually

replacing the real world" (2000, 169). While I may be swayed by Sconce's critique of the paranoia and science-fictionality inherent in the "Baudrillardian strain," I would not be so quick to dismiss its potential as a radical critique of technoculture. Nor would I so quickly dismiss the potentially devastating impacts that electronic media can have on so-called reality. What's more, it doesn't take a Baudrillardian polemic or a science-fictional film to teach us about the "vulnerability of the family" to media technologies. Even a film such as *American Beauty* (1999), also released at the fin de millennium, demonstrates how the technologies we invite into our homes can perpetrate a seemingly "covert attack" on our ways of being. *American Beauty* demonstrates that it doesn't take a technohorror movie to teach us about technological betrayal, which rears its head in even the most uptight suburban homes.

Alan Ball, the creator of *Six Feet Under,* is also responsible for *American Beauty,* both of which are cogent attempts to explore human finitude, though from very different perspectives. Whereas the deceased in *Six Feet Under* rarely provide more than a pretext to each episode, the deceased in *American Beauty* plays the leading role and narrates the entire film—from an omniscient, postmortem perspective. This chapter draws on a variety of domestic media scenes from *American Beauty* to investigate the many ways in which technology, when positioned at the center of a cultural hero system, can betray us, and can even lead to our literal deaths. What's more, the characters in this film might serve as case studies in the cultural characterology that Ernest Becker derives from the work of Søren Kierkegaard. From the depressive (Lester Burnham) to the schizophrenic (Carolyn Burnham), *American Beauty* also provides an opportunity to examine how the cultural neuroses identified by Becker may be facilitated by a variety of media technologies. The goal of this chapter, then, is to "test" some of Becker's theories regarding the relationship between death denial and existential authenticity, all in a cultural context that includes contemporary media technologies. This particular film, a fin de millennium revision of Arthur Miller's play *Death of a Salesman,* was chosen because it demonstrates that even without the Internet, media technologies—what Bernard Stiegler would call *psychotechnologies*—assert themselves in the contemporary psychological and cultural landscape.

Miscommunication Technologies

The following scenario has occurred to almost anyone who has ever used e-mail, a form of communication that is itself ripe for extinction: you compose a message, hit the "send" button, and then shudder in terror as you realize, in the

split second the mouse button unclicks, that your message, which is now out of your hands and hurtling through cyberspace, is on the way to the wrong recipient. You watch helplessly as the proverbial curling iron plunges toward the bath water. There's no way to stop the inevitable and instantaneous course of miscommunication once the message hits the wire. As noted in the epigraph at the beginning of this chapter, electronic communications media, as McLuhan proclaimed, are "unforgiving" and "unforgetful." More recently, Viktor Mayer-Schonberger (2009) has railed against the pitfalls of an unforgiving and unforgetful Internet, and he calls for new strategies to ensure forgetfulness.

There are innumerable instances in which technological devices fail us— or if we look at it differently, instances in which we fail at using these devices. After all, the technologies themselves seem cruelly indifferent to how we use or abuse them. This is a situation that we can only greet with terror and anguish, yet we continue to rely on digital communications systems, welcoming them into the bosom of our very households, perhaps unaware of their potentially disruptive effects. Media and cultural studies often stop at the identification of communication networks and their effects, but I want to focus on miscommunication networks, or even "dyscommunication" networks, discourse networks created by a dysfunctional use of communications technologies.

Of course, the issue of miscommunication and dyscommunication is not strictly "digital," and is certainly not a recent phenomenon: a letter sent by post can sometimes arrive in the wrong hands, conversations can be overheard and misunderstood, embarrassing gestures can be observed from afar and misinterpreted, and so on. It is quite likely that miscommunications both preceded and outnumbered effective communications during the early stages of human evolution. New technologies, however, have radically increased not only the potential for miscommunication but also the sheer velocity of miscommunication. We can now miscommunicate faster and on a larger scale than ever before. This hypothesis seems to support the technoapocalyptic claims of Paul Virilio, Jean Baudrillard, and Friedrich Kittler. Virilio has argued consistently that the sheer velocity of telecommunications networks radically enhances the potential for "accidents" of all kinds. For Kittler, the basic McLuhanesque premise that "media determine our situation" leads to the implication that we are merely an "accessory in a scenario of technological apocalypse" (Winthrop-Young and Wutz 1999, xxxiii). This is backed by Kittler's enduring devotion to the holy trinity of media, war, and death—as we shall see, both literal death and the Foucaultian death of the *concept of man* on which posthumanism is founded. There is an unquestionable affinity—both

metaphorical and literal—between media technologies and death. As Kittler (1999) points out in *Gramophone, Film, Typewriter,* "once memories and dreams, the dead and ghosts, become technically reproducible, readers and writers no longer need the powers of hallucination. Our realm of the dead has withdrawn from the books in which it resided for so long" (10). Not only did the first recordings on gramophone and film strike their listeners as ghostly apparitions, but most of the early footage recorded on those devices was an attempt to capture death, ghosts, and doppelgangers. Jeffrey Sconce (2000) investigates this uncanny history of media technologies in his book *Haunted Media,* where he suggests that the "myth of electronic presence," propagated from the early days of the telegraph, is still alive and well. Furthermore, Virilio, Kittler, and other so-called necromedia theorists who take a materialist approach appropriately link this death/media affinity to the fact that most communications technologies are actually the by-products of military research and war. New media, from the two-way radio to the Internet, often originate in research programs guided by a logic of seek and destroy, and hence they are always-already about human death. When Kittler notes that media are always "flight apparatuses to the great beyond" (echoing Paul Virilio's [1989] maxim, "Cinema Isn't I See, It's I Fly"), he is alluding simultaneously to "the great beyond" of death, as well as "the great beyond" of military flight apparatuses, including fighter jets, surveillance planes, and satellites.

The evolution of the video camera from the chronophotographic gun is for Kittler a typical result of the "perfect collusion of world wars, reconnaissance squadrons, and cinematography" (1999, 124). Given this deadly history, the opening credit sequence of *American Beauty,* which vacillates from a video-recorded murder plot to Lester Burnham's ghost soaring over the suburban landscape, could not possibly be more appropriate.[2] Fulfilling the prophetic theorizations of Kittler and Virilio, *American Beauty* features a protagonist who not only is dead before the film begins; he is dead before his actual murder, shot by a consumer video camera before he is shot by a handgun. This is truly a film about death by video. But video is not the only villain here; the telephone, the numeric pager, and even the two-way speaker are all accomplices in Lester's murder; moreover, they lead to the undoing of the entire cast. Unwittingly or not, *American Beauty,* a pre-Internet film, reveals that media technologies are double-edged swords, or *psychotechnical pharmaka,* to borrow a term coined by Bernard Stiegler (2010). What's more, these devices may cruelly facilitate not only literal death but also a self-deluding denial of death. After all, in order to take the film seriously, viewers must accept the fact that the main character is dead from the very beginning, but through the magic of

video recording they can place their trust in the narrative voice of a ghost: "My name is Lester Burnham. This is my neighborhood. This is my street. This . . . is my life. I'm forty-two years old. In less than a year, I'll be dead. Of course, I don't know that yet. And in a way I'm dead already." Video recording permits Lester's ghost to engage in a brutally honest self-evaluation, drawing on the 20/20 hindsight only a dead man can enjoy.[3]

With an existential ghost at the helm, *American Beauty* provides an excellent backdrop for investigating the role that technology plays in the cultural pathologies laid out by Kierkegaard and Becker. If one follows Kierkegaard's characterology, *American Beauty* might be seen as one man's refusal of a philistine way of being, and his attempt to transform himself from a philistinic, *depressive introvert* into a *defiant self-creator*. When we first encounter Lester, he rises from bed in the early morning exuding utter hopelessness, and encloses himself in the shower—the first of a series of physical enclosures in the film— where he proceeds to masturbate: "Look at me. Jerking off in the shower. . . . This will be the high point of my day." As a disembodied narrator, Lester is perfectly self-actualized and authentic, able to assess the pitifully hopeless nature of his own life. Unfortunately, he does not have access to such a perspective while he is still embodied; the non-narrator Lester, at the beginning of the film, is a stupefied drone mired in depression. He epitomizes Becker's characterization of depressive psychosis,

> a bogging down in the demands of others—family, job, the narrow horizon of daily duties. In such a bogging down the individual does not feel or see that he has alternatives, cannot imagine any choices or alternate ways of life, cannot release himself from the network of obligations even though these obligations no longer give him a sense of self-esteem, of primary value, of being a heroic contributor to world life even by doing his daily family and job duties. (1973, 78)

The opening scenes of the film establish Lester as the suburban antihero, a fin de siècle Willy Loman, closed in from others by the structures society has built for him.[4] This is underscored visually, as director Sam Mendes reveals in the DVD voiceover, when Lester moves from the shower enclosure to the picture-frame window of his suburban house, to the front passenger seat of the family SUV, and finally to his work cubicle, where his face is reflected in the computer screen, giving the impression that columns of numbers are the bars of his private cell. When we confront Lester in that cubicle, we see his frustration at being shackled to a telephone headset, yet another enclosure that demonstrates Lester's imprisonment. The telephone facilitates Lester's first step out of existential depression when he takes charge of a conversation with a surly

client and is ultimately fired for his conduct. Yet another telephone, this time at home, also serves Lester as a way out of his "bogged down" situation. In the following scenarios, we see how media technologies might collide with Kierkegaard's characterology, as filtered through Ernest Becker.

Telephone

When the woman in Jean Cocteau's one-act play *The Human Voice* wraps the phone cord around her neck in despair, this fate by phone seems morbidly appropriate. After all, it is the phone—in this case, a phone that stubbornly refuses to ring, rings for wrong numbers, and then fails miserably to function effectively while delivering a lethal message—that has led to her attempted suicide. This scene of "death by phone" and others like it—the one in Hitchcock's *Dial M for Murder* being the penultimate example—register some of the fears with which the telephone was first greeted at the time of its invention. John Brooks, author of *Telephone: The First Hundred Years,* goes so far as to suggest that technophobia actually "delayed the invention of the telephone" (1977, 209).[5] As Brooks (1976) argues, "people were made very uneasy by the notion. Hearing voices when there was no one there was looked upon as a manifestation of either mystical communion or insanity" (37). It is no coincidence that Henry Watson, Bell's right-hand man, had an early interest in "spirit sessions" and had once "imagined a halo around his own head" (Brooks 1976, 43). Nor is it a coincidence, perhaps, that the first electric speaking telephone sketched by Bell and assembled by Watson in 1875 was the gallows telephone, a wooden frame equipped with a harmonic receiver, a steel-reed armature, and a parchment membrane. Such deadly coincidences are part of the material history of necromedia.

From the beginning, then, the telephone was construed as an execution device. More accurately, perhaps, the telephone was viewed as a conduit to the spiritual realm, as is evident in these Faustian lines written by Benjamin Franklin Taylor in 1886:

> Your little song the telephone can float
> As free of fetters as a bluebird's note,
> Quick as a prayer ascending into Heaven,
> Quick as the answer, "all thy sins forgiven" (265)

Taylor's words are not far from the mark; after all, the telephone was "the first device to allow the spirit of a person expressed in his own voice to carry its message directly without transporting his body" (Boettinger 1977, 204). Or in

the words of Friedrich Kittler, "wherever telephones are ringing, a ghost resides in the receiver" (1999, 75). Although we may not take this assertion as literally as the superstitious newspaper reporters in 1877, the ramifications of this claim must not be ignored.[6] The telephone, long before the Internet, served to obliterate space, momentarily rendering the body redundant and facilitating shifts in identity.[7]

In *American Beauty*, Lester uses the telephone as a means of following up on the out-of-body experience he has in bed, while fantasizing about Angela (Mena Suvari), the cheerleader friend of his daughter Jane (Thora Birch). In a moment of weakness, a delusional Lester peeks into his daughter's address book and dials Angela's number. Angela picks up the receiver, and Lester waits silently, thrilled by the telepresent link to the object of his desire. The pleasure is abruptly terminated as Jane emerges from the bathroom and catches him in the act. When Angela "star 69s" Lester's call and the line is reconnected, she is greeted by Jane, who, realizing her father's "gross" indiscretion, spirals further into a severe disrespect and hatred of him, a hatred that eventually leads to her half-joking suggestion into Ricky Fitts's camera that "somebody really should put him out of his misery." To put it in the haunting and insistent words of R.E.M. lead singer Michael Stipe,

> I know you called—I know you called—I know you called—I know you called—I know you called—I know you hung up my line star 69. (1994)

Lester never had a chance against his own self-imposed surveillance apparatus. Communications technology provided him with a direct conduit from his own domestic scene into the bedroom of a sixteen-year-old girl, and the eventual result is fatal.

What exactly is it that Lester was trying to accomplish with this phone call? It isn't reasonable to think that he intended to say anything to Angela. This is a purely voyeuristic, or rather an *auditeuristic*, act on Lester's part—an act that implicates the film viewer as well, who is exposed not only to Angela's voice but to her scantily clad body. Lester, who had just experienced a "spec-tac-ular" dream of Angela, was attempting to relive his masturbatory fantasy by grounding it in the materiality of her "live" voice. The scene underscores the real-time and immediate nature of telephony, which, as Sherry Turkle (2011) suggests, is increasingly viewed as an inconvenience, a sort of physical captivity to both a device and an interlocutor (15). E-mail and text messaging (to a lesser degree) alleviate us from this captivity by making possible a communications lag. More to the point, from an existential perspective, this scene marks Lester's first authentic action toward escaping his depression, as perverse as

that action may seem. As Lester notes only briefly before this scene, "I feel like I've been in a coma for about twenty years, and I'm just now waking up." Lester's impossible relationship with Angela disturbingly illustrates the dilemma of what Kierkegaard characterized as "the introvert":

> Kierkegaard's introvert feels that he is something different from the world, has something in himself that the world cannot reflect, cannot in its immediacy and shallowness appreciate; and so he holds himself somewhat apart from that world. But not too much, not completely. It would be so nice to be the self he wants to be, to realize his vocation, his authentic talent, but it is dangerous, it might upset his world completely. He is after all, basically weak, in a position of compromise: not an immediate man, but not a real man either, even though he gives the appearance of it. (Becker 1973, 83)

As Becker suggests, the introvert may fall into despair if he comes to a full acknowledgment of his weakness and senses fully the discrepancy between his self-expectations and the real world. "For a strong person, it may become intolerable, and he may try to break out of it, sometimes by suicide, sometimes by drowning himself desperately in the world and in the rush of experience" (Becker 1973, 84). For Lester, it is the latter of these two options, beginning with the phone call. But by throwing himself "in the rush of experience," Lester still ultimately meets his demise—thanks to media technologies.

Lester is not the first to draw on the telephone as a means of escaping his embeddedness and immersing himself "in the rush of experience." Phone sex hotlines have provided this service for several years, although online video versions have led to their imminent demise. More recently, alternate reality games (ARGs) involve players in fictional narratives that can take place online and via texting and cell phone calls that players can receive anywhere and at any time. Lester's indiscrete use of the corded home phone to access a live "rush of experience" seems like a quaint anachronism in our world of ARGs, nonsynchronous sexting, and on-demand video pornography. But this scene reminds us that the use of telecommunications networks to immerse oneself in an alternate reality is not just a modern convenience or practical efficiency— it is also a social and existential act driven by psychological motivations.

In an article entitled "The Agenbite of Outwit," Marshall McLuhan (1996) notes that Kierkegaard's *The Concept of Dread* (1844) was published in the same year as the establishment of the commercial telegraph in the United States. In a passage that seems to echo Kierkegaard's concerns quoted earlier in this chapter regarding "the immediate man," McLuhan notes that new technologies provoke a certain "psychic numbness" in our culture:

As Narcissus fell in love with an outering (projection, extension) of himself, man seems invariably to fall in love with the newest gadget or gimmick that is merely an extension of his own body. Driving a car or watching television, we tend to forget that what we have to do with is simply a part of ourselves stuck *out there*. Thus disposed, we become servo-mechanisms of our contrivances, responding to them in the immediate, mechanical way that they demand of us. The point of the Narcissus myth is not that people are prone to fall in love with their own images but that people fall in love with extensions of themselves which they are convinced are not extensions of themselves. This provides, I think, a fairly good image of all of our technologies, and it directs us towards a basic issue, the idolatry of technology as involving a psychic numbness. (1996)

McLuhan's odd choice of a title for this article is a revision of James Joyce's repeated references in *Ulysses* to "agenbite of inwit," or a remorse of conscience. For McLuhan, the remorse is related to the outering of wit, the "social extensions of the body" by means of technological devices. However, these technologies seem less likely to facilitate remorse than they are to assist in its repression. We have created the ideal environment to foster the production of remorseless "immediate men." Technological gadgets of all sorts—driven by an economy that capitalizes on human attention and abides by the law of progress for the sake of progress—are designed to distract us from any sort of existential contemplation, let alone death reckoning. The opportunity for engaging in private thought has become a rare commodity in our attention economy. As McLuhan suggests, "the kind of private consciousness appropriate to literate man can be viewed as an unbearable kink in the collective consciousness demanded by electronic information movement" (1996).

The "collective consciousness" facilitated by new media, however, is not a form of global awareness, a sharing of the burden of anxiety placed on human being. Instead, this collective consciousness is an all-encompassing electronic static produced by millions of individuals fleeing contemplation by filling the electronic airwaves with noise. Even in public, as Sherry Turkle suggests, individuals seek to be alone and distracted: "What people mostly want from public space is to be alone with their personal networks. It is good to come together physically, but it is more important to stay tethered to our devices" (2011, 14). Furthermore, as Nicholas Carr (2010) suggests in *The Shallows,* a study of technoculture and cognition, our digitally networked culture is diminishing our "ability to know, in depth, a subject for ourselves, to construct within our own minds the rich and idiosyncratic set of connections that give rise to a singular intelligence" (143). In chapter 9, I explore this theory more carefully, drawing

on Bernard Stiegler's concept of transindividuation as it relates to synchronized and ubiquitous global networking. But for the moment, I will continue to focus on less contemporary technologies, which help demonstrate that technoculture's emergent *shallowness* (Carr 2010) and *alone-togetherness* (Turkle 2011) did not emerge out of the blue at the outset of the twenty-first century.

Pager

As Lester demonstrates, communications technologies can be useful for the introvert seeking to escape the hero system in which he has no choice but to participate. We see this as well in the case of Ricky Fitts, Jane's boyfriend. As an adolescent, Ricky is programmed to be a Kierkegaardian introvert, and so he shares Lester's dilemma, chafing between his inner world and the path that his culture has set out for him. Becker pays particular attention to the adolescent's constrained sense of possibility:

> In what way is one truly unique, and how can he express this uniqueness, give it form, dedicate it to something beyond himself? How can the person take his private inner being, the great mystery that he feels at the heart of himself, his emotions, his yearnings and use them to live more distinctively, to enrich both himself and mankind with the peculiar quality of his talent? In adolescence most of us throb with this dilemma, expressing it either with words and thoughts or with simple numb pain and longing. But usually life sucks us up into standardized activities. (1973, 83)

Lester admires Ricky for his unwillingness to adhere to what Becker calls "the standardized hero-game into which we happen to fall by accident, by family connection, by reflex patriotism, or by the simple need to eat and the urge to procreate" (1973, 83). What Lester recognizes in Ricky is the aura of "possibility" that characterizes an individual who is not "bogged down" in the "narrow horizon of daily duties" (Becker 1973, 78). Ricky is indeed constrained within the militaristic horizon of his father, Colonel Fitts, but he escapes this particular manifestation of the "social hero system" by means of media technologies, most notably the movie camera but also the pager.

The uncanny combination of public space and private conversation makes cell phone use unacceptable in certain environments such as movie theaters and many restaurants. But most people show no remorse while having a full-blown cell phone conversation on the street, at the mall, or even on public transit systems. Pager technology, on the other hand, required a certain degree of discretion. A page was merely an intermediary notification, indicating that

someone was trying to contact the recipient. It was up to the recipient to leave his or her current physical location, locate a telephone, and return the call. Perhaps because of this discretion and the sparse use of pagers, the device, now an almost entirely dead medium by consumer standards, was prone to suspicion. Pagers were viewed as the preferred communication tool of call girls and drug dealers. This is an ironic development, considering that the first pager technology was invented for the Detroit Police Department in 1921.

In *American Beauty*, Ricky Fitts demonstrates that he can fit the profile of both call girl and drug dealer when, positioned in the sacred seat of family communication, Lester pages him for a drug delivery. Ricky immediately lies his way out of a dreary family dinner to respond to the call, and this interruption spurs the curiosity of Colonel Fitts, whose suspicions lead him into Ricky's room. There, the Colonel's homophobic fears about his son are twice confirmed: first on screen by Ricky's clandestine video of the half-naked Lester doing bicep curls and then live and in person through an obstructed window view of what the Colonel thinks is Ricky engaged in an act of fellatio with Lester. But Ricky is indeed a drug dealer and not a "call girl," as I discuss at greater length in this chapter.

For the moment, suffice it to say that Ricky's pager, the device that facilitates his flight from an overbearing social hero system, is also the device that gets him busted. This is possible because within the family's moral economy, all media technologies are subject to surveillance; they are de facto submitted to a disciplinary system built on surveillance effects. In other words, the family unit is built with its own "star 69" function, which is more commonly known as parental discipline. When it is working in full force, parental discipline shields the privacy of the home (and thus of the children) from external influences by controlling the layout of domestic space as well as the distribution of objects within that space, including, of course, technological objects. This disciplining function is in full force in the Fitts household, as witnessed in the scene where the Colonel thrashes Ricky for sneaking into his locked gun case:

COLONEL: You little bastard—

> Ricky scrambles to dodge his father, but the Colonel is too fast; he punches
> Ricky in the face, knocking him to the floor.

COLONEL (cont'd): How did you get in there?

> EXT. BURNHAM HOUSE—CONTINUOUS
> From her window, Jane watches, pulling the drapes in front of her.
> EXT. FITTS HOUSE—CONTINUOUS

Jane's POV: In the WINDOW across from us, the Colonel proceeds to give
 Ricky a serious beating, punching his face.

INT. FITTS HOUSE—RICKY'S BEDROOM—CONTINUOUS

Ricky's lip is bleeding, but he maintains a steady gaze at his father during
 this violence.

COLONEL (unnerved): How!? How?! C'mon, get up! Fight back, you little pussy!

RICKY: No, sir. I won't fight you.

 The Colonel grabs him by the collar.

COLONEL: How did you get in there?

RICKY: I picked the lock, sir.

COLONEL: What were you looking for? Money? Are you on dope again?

RICKY: No, sir. I wanted to show my girlfriend your Nazi plate.

 A beat.

COLONEL: Girlfriend?

RICKY: Yes, sir. She lives next door.

 The Colonel glances toward the window.

 His POV: In the WINDOW across from us, Jane peeks out from behind the
 drape. She quickly pulls it shut.

RICKY (cont'd): Her name's Jane.

 A beat. The Colonel is suddenly, deeply shamed.

COLONEL: This is for your own good, boy. You have no respect for other people's
things, for authority, for . . .

RICKY: Sir, I'm sorry.

COLONEL: You can't just go around doing whatever you feel like, you can't—there
are rules in life—

RICKY: Yes, sir.

COLONEL: You need structure, you need discipline—

RICKY (simultaneous): Discipline. Yes, sir, thank you for trying to teach me. Don't
give up on me, Dad.

What the Colonel doesn't realize at this point is that firearms in his cabinet are
not nearly as lethal as Ricky's pager and video camera. The fine-tuned disci-
plinary system mobilized by the Colonel relies on a strict maintenance of
domestic privacy, which is thwarted by *public* communications apparatuses
such as the telephone, the pager, and as we shall see, the television and the

video camera. This threat becomes clear to the Colonel when he sneaks into Ricky's private space, and interprets the video of Lester as corroborating evidence of the suspicions aroused by his son's pager. Eventually, this misunderstanding on the Colonel's part will lead him to "come out" of his private domestic environment and make a homosexual advance on the unsuspecting Lester. The result of this domestic transgression, mediated by various media technologies, proves to be fatal.

Indeed, there are examples of media technologies providing a *safe* escape from the private, domestic economy. The family room television serves such a purpose, as I discuss later in this chapter. But it is safe only as long as it facilitates a shared, family experience. Once the television appears not only in the center of the home but in the children's bedroom as well (which is the typical situation in America today), the domestic surveillance system is weakened, and the disciplinary apparatus will, of necessity, fail. This was also the case with the record player. When portable turntables began competing with the bulky living room hi-fi in the 1950s—that is, once teenagers were able to play their own records in their bedrooms—the public surveillance space of the family home was irremediably disrupted. It was only a matter of time before rock and roll could liberate a generation of teens from the moral economy of the household. This phenomenon is ingeniously modified in another film released in 1999, *The Virgin Suicides.* This Sofia Coppola film demonstrates how a teenager, equipped with a phone and record player in her bedroom, can escape the crushing privacy of her domestic scene by becoming a telephonic DJ for boys at the other end of the line.[8] The film is set in the 1970s, yet the teens' disconnected media system, designed to thwart parental discipline, provides insight onto the possible antidomestic effects of the more recent, fully connected system of peer-to-peer music sharing made famous by Napster.

Although the ill-fated Napster and a plethora of other antidomestic computer technologies were in their heyday when *American Beauty* was first released, computer-mediated, domestic transgressions play no part in *American Beauty.* That is because this is not a film about computers, but a film about video. Parental policing as depicted in *American Beauty* is not a matter of confiscating iPhones at bed time, but of asking, "Do you know what your children are watching on TV?"

Two-Way Speaker

The Colonel's impulsive homosexual pass at Lester is not nearly as transgressive as Lester's full-scale attack on the suburban mediocrity of the "immediate man." Fed up with his mediocre life, Lester quits his job, trades his Camry

for a classic Firebird, spends most of his time in the garage smoking pot and lifting weights, goes jogging with homosexuals, and, pushed over the edge by his wife's choice of music, violently disrupts the sacredness of the family dinner table by flinging a plate of asparagus at the wall. Naturally, most of these transgressions are provoked or mediated by technologies inside and outside the home, including a remote-controlled car, a stereo system, and most importantly, a two-way speaker at the fast-food restaurant Smiley's.

Before I go into greater detail about the infamous Smiley's scene, I should note that Lester's Firebird, pot-smoking, weightlifting, and remote-controlled car are by no means evidence that he has successfully shed his depressingly philistine lifestyle. On the contrary, Lester's midlife crisis is a rejection of one form of philistinism for another. He has become Ernest Becker's "automatic cultural man," the one who senses that "he has control of his life if he guns his sports car or works his electric toothbrush" (1973, 74). The sense of control that Lester is trying to harness is reflected most palpably, perhaps, in the remote-controlled car and in his newfound hobby of bodybuilding. Still, these adolescent activities, a "drowning in the rush of experience," are a step for Lester out of the abstract world of rules and ideas that has constrained him. For Lester, the return to a visceral mode of adolescence might be interpreted as a form of resistance against a cultural hero system that was imposed on him. But we never find out for sure if this is Lester's intention; even if he were attempting to achieve some authentic confrontation of mortality by accepting his materiality and finitude, the attempt is thwarted by a variety of technological apparatuses including, of all things, the two-way radio at a drive-thru restaurant.

Not even the drive-thru restaurant speaker system can claim immunity from the history of military seek-and-destroy research. Once the Detroit Police Department mastered the use of a 2MHz radio communications system in 1921, it was only a matter of time before the wireless technology pioneer Al Gross would make the system increasingly mobile. He did so at frequencies above 100MHz on two-way handheld radios, for which he coined the term *walkie-talkie* in 1938. It is not surprising that Gross was recruited immediately by the U.S. Office of Strategic Services, which capitalized on the invention during World War II to deliver Hertzian radio waves that evaded the surveillance of the enemy. A more creative use of the device came in 1951, when Robert O. Peterson, founder of Jack in the Box Restaurants, put a two-way radio in the head of a smiley, plastic clown, thereby inventing the first drive-thru restaurant. This nightmarish creation, an uncanny miscommunication device, makes two cameo appearances in *American Beauty* at a garish drive-thru restaurant appropriately called Smiley's.

Early in the film, when Lester pulls up to the drive-thru speaker and places his order, he is irritated by the noisiness of the shoddy device. But substandardness is precisely what Lester is looking for in his attempt to forgo the standards prescribed by his heretofore conservative lifestyle. And thus he is inspired to apply for a substandard career at a fast-food restaurant. Lester's clearest expression of a desire to abandon his prescribed social hero system is mediated by the Smiley's two-way radio, which he uses to inquire about a new career path:

COUNTER GIRL: There's not jobs for manager, it's just for counter.

LESTER: Good. I'm looking for the least possible amount of responsibility.

Lester does indeed go on to flip burgers at Smiley's, a career move that puts him in an ideal location not only for ironically subverting his former lifestyle of drab responsibility but also for discovering his wife's own transgressions. In one of the most memorable scenes in the film, Lester overhears a flirtatious conversation between his wife, Carolyn, and her clownish, plastic lover, Buddy.

CAROLYN (O.S.) (over speakers): What's good here?

BUDDY (O.C.) (over speakers): Nothing.

CAROLYN (O.C.) (over speakers): Then I guess we'll just have to be bad, won't we? (then) I think I'll have a double Smiley Sandwich and curly fries, and a vanilla shake.

BUDDY (O.C.) (over speakers): Make that two.

COUNTER GIRL (O.C.) (over speakers): Please drive around thank you.

Lester's face darkens, then . . . he smiles. He puts his spatula down.

EXT. MR. SMILEY'S—CONTINUOUS

The Mercedes pulls around to the DRIVE-THRU WINDOW. Carolyn drives; Buddy sits beside her.

CAROLYN: I think we deserve a little junk food, after the workout we had this morning.

BUDDY (nuzzles her neck): I'm flattered.

They are too involved with each other to notice Lester watching them from the drive-thru window.

LESTER (overly cheerful): Smile! You're at Mr. Smiley's!

Carolyn almost jumps out of her skin.

Lester's words manically echo Allen Funt's famous words, "Smile, you're on Candid Camera!," the trademark line of one of the most successful reality TV

series in America. This surveillance scene at Smiley's makes it clear that in a culture saturated with electronic communications devices, secretly transgressing prescribed social roles is no easy task. No one could have assessed this situation any better than the real drive-thru clown in this scene, the Smiley's counter girl, who summarizes the scene to Carolyn thusly: "Whoa. You are *so* busted." Foucault himself could not have produced a more vivid image of man trapped within the panoptic disciplinary structures that he has created for his own self-policing. As the characters in *American Beauty* struggle to resist their entanglement in these structures, they are driven closer to their imminent demise.[9]

Handycam

By the conclusion of the film all roads lead to Lester's death, and they are all mediated by or recorded on communications technologies. Jane, disgusted by her father's telephonic come-on to Angela, assigns Ricky to shoot a fantasy video about her father's assassination. Carolyn, frenzied by the intercom mishap and fueled by an inspirational, self-help tape in her SUV, shares in the fantasy by loading her gun. But in the end, the only person armed with hard, videotaped evidence of Lester's transgressions is the Colonel, and he gets to Lester first. From the privacy of his bedroom window, Ricky shoots Lester with a camcorder; the Colonel mistakenly interprets this footage as evidence of a homosexual tryst between his son and his neighbor, and he responds by shooting Lester with a handgun. Which of the two shootings is responsible for Lester's death? This seeming conundrum makes perfect sense to anyone who understands that "the history of the movie camera . . . coincides with the history of automatic weapons.[10] The transport of pictures only repeats the transport of bullets" (Kittler 1999, 124).

As we have already seen, it is video technology that plays the greatest role in busting the various members of the cast. When the Colonel views the video of Lester in Ricky's room, coupled with the view out the window of what he thinks is his son engaged in oral sex with Lester, the privacy of the domestic scene is breached altogether. Of course, Ricky is not a call girl (which is what the Colonel concludes here); he's a drug dealer. And what the Colonel sees through the bedroom window is not an act of fellatio, but the rolling of a joint. In this crucial scene, Colonel Fitts is caught in a dizzying, asynchronous feedback loop between the window view and the video projection, both of which facilitate a transgression of the public/private border that makes domestic discipline a possibility. The loop concludes in a domestic short-circuit when the

Colonel ultimately projects onto it his own closeted homosexuality, and he attempts to kiss Lester on the mouth.

For Colonel Fitts, a man deeply entrenched in a conservative, militarist, homophobic hero system, the only choice is to destroy the recording mechanism that can provide evidence of his homosexuality: Lester. Once Lester is out of the way, the Colonel can return safely to his life of introversion and philistinism. Only one character in the film witnesses what the Colonel has done to silence Lester: his catatonic wife, Barbara Fitts. The scene in which Barbara sits shock-still in front of the television while the Colonel, at the other end of the couch, laughs automatically, is iconic of the way in which technologies facilitate a denial of human finitude. While Barbara's empty stare depicts the hopeless futility of the repressive nuclear family, the Colonel's manic laughter demonstrates the utility of television, in the heart of the family home, as a vehicle for escaping the dread that lies beyond the private safety of the domestic household. It is appropriate that the Fittses are watching a military film starring none other than Ronald Reagan, who is leading his troops in a calisthenics session. In a culture that is willing to ignore its embeddedness in a finite, physical world to immerse itself in the infinitude of technological recordings, the greatest heroes are those who have been mediated to the greatest extent. In such a situation, only Hollywood stars, expertly trained in the calisthenics of electronic mediation, are suitably equipped as political leaders. It is equally appropriate when, in the Burnham family room, Jane and Angela watch a carefully orchestrated, black-and-white slapstick scene that, although clipped from an indie music video, is equally calisthenic in nature.[11] The mechanized, physical antics in both of these media scenes are appropriate in the cold-war atmosphere that lingers in the households of *American Beauty;* combined, they capture a trenchant image not only of domestic discipline but also of war as a ridiculous slapstick exercise. And they point the way toward a technoculture in which bodies are disciplined by and for mass media, not for the battlefield. As Paul Virilio (1997) suggests in *Open Sky,* "Social organization and a kind of conditioning once limited to the space of the city and to the space of the family home [are] finally closing in on the animal body" (11).

As argued by Virilio, Kittler, and others, the primary strategy in war today, as in the past, is surveillance, and surveillance technologies are the most effective form of artillery.[12] This strategy has crept stealthily into civilian culture, where voyeurism drives popular culture. This "surveillance effect" is reflected in the technique and content of *American Beauty.* In the opening scenes alone, we are subjected to a helicopter fly-by of a suburban household, a zoom shot of a man masturbating in the shower, and a murder confession amateurishly

captured on consumer-quality digital video. The alternation between recording formats in the film is key here, since it registers a revolutionary shift in American media from the tight, professional images of celluloid and television to amateur, handheld digital video.

The realer-than-real digital images that Jane and Ricky watch on the screen in Ricky's room are several generations away from the well-synchronized TV calisthenics mentioned earlier in this section. Ricky and Jane have no need for television, for they are able to record and project their own self-starred, soft-porn video spectacle in the privacy of Ricky's bedroom.

> JANE: Well, now, I too need structure. A little fucking discipline.
>
> They LAUGH. She lays back on the bed.
>
> JANE (cont'd): I'm serious, though. How could he not be damaging me? I need a father who's a role model, not some horny geek-boy who's gonna spray his shorts whenever I bring a girlfriend home from school. (snorts) What a lame-o. Somebody really should put him out of his misery.
>
> Her mind wanders for a beat.
>
> RICKY: Want me to kill him for you?
>
> Jane looks at him and sits up.
>
> JANE: Yeah, would you?

If Colonel Fitts had seen this video instead of the footage of Lester doing biceps curls, he never would have misinterpreted the boy's pager as a sign of unmanliness. But such is the tragically random nature of miscommunications technologies. These video scenes make it clear that today we are all immortalized on the unforgiving and unforgetful "big screen" of surveillance systems, home movies, and incidental amateur footage, whether we like it or not.

The adolescent escape fantasies of Jane and the desire of Ricky to turn that fantasizing into art may suggest that these two teenagers are perhaps the most existentially well-adjusted characters in the film. They, more than any other characters, are fully immersed in the anxiety that possibility presents to all of us—an anxiety that we repress by choosing this or that path laid out by our cultural hero systems. Ricky in particular, though his character is not developed to the extent of Lester's, seems to fit Becker's description of the character who is able to "use anxiety as an eternal spring for growth into new dimensions of thought and trust" (Becker 1973, 92). Ricky's black-clad goth presence in the film and his videotaping of a "beautiful" dead bird provide a stark contrast

to Carolyn Burnham's perfectly pruned American Beauty rose bushes and white picket fence. As viewed in the softness of celluloid, the domestic scenes in the film are comedy. But viewed in the handheld ultrarealism of Ricky's miniDV footage, these scenes reveal terror, dread, anxiety. Ricky, who has suffered through the self-annihilating experience of an abusive home life, is what Kierkegaard might call a "pupil of dread": "He who is educated by dread [anxiety] is educated by possibility. . . . When such a person, therefore, goes out from the school of possibility, and knows more thoroughly than a child knows the alphabet that he demands of life absolutely nothing, and that terror, perdition, annihilation, dwell next door to every man, and has learned the profitable lesson that every dread which alarms may the next instant become a fact, he will then interpret reality differently" (Becker 1973, 88). In the final minutes of the film, Ricky's video of the plastic bag whirling playfully in the wind demonstrates his ability to express his unique vision of the world, give it a material instantiation, and share it with others.[13] Moreover, the bag video may be seen as an image of the infinite possibilities of being, the possibilities that account for our freedom but also lead to the dread associated with a recognition of our finitude. Ricky captures this by embracing the discursive potential of media technology:

> On VIDEO: We're in an empty parking lot on a cold, gray day. Something is floating across from us . . . it's an empty, wrinkled, white PLASTIC BAG. We follow it as the wind carries it in a circle around us, sometimes whipping it about violently, or, without warning, sending it soaring skyward, then letting it float gracefully down to the ground . . .
> Jane and Ricky sit on the bed, watching his WIDE-SCREEN TV.

> RICKY: It was one of those days when it's a minute away from snowing. And there's this electricity in the air, you can almost hear it, right? And this bag was just . . . dancing with me. Like a little kid begging me to play with it. For fifteen minutes. That's the day I realized that there was this entire life behind things, and this incredibly benevolent force that wanted me to know there was no reason to be afraid. Ever.

> A beat.

> RICKY (cont'd): Video's a poor excuse, I know. But it helps me remember . . . I need to remember . . .

> Now Jane is watching him.

> RICKY (cont'd) (distant): Sometimes there's so much beauty in the world I feel like I can't take it . . . and my heart is going to cave in.

This is a far cry from Lester's description of Angela as "the most beautiful thing I have ever seen," which is no more than a pitiful denial of his own finitude, a pedophilic desire to immerse himself in her youth. Ricky's video, as he notes, is not a form of escapism, but a vehicle to "help him remember." His embodiment of alienation and despair and his commitment to contemplation qualify him perhaps as a Kierkegaardian "pupil of possibility," one who embraces his own finitude and survives the dread of infinitude by means of faith in a higher creative power:

> Now the dread of possibility holds him as its prey, until it can deliver him saved into the hands of faith. In no other place does he find repose. . . . He who went through the curriculum of misfortune offered by possibility lost everything, absolutely everything, in a way that no one has lost it in reality. If in this situation he did not behave falsely towards possibility, if he did not attempt to talk around the dread which would save him, then he received everything back again, as in reality no one ever did even if he received everything tenfold, for the pupil of possibility received infinity. (Becker 1973, 91)

My goal here is not to suggest that Sam Mendes wrote Ricky's part as a way of portraying this Kierkegaardian ideal. I am simply trying to draw on the characters in the film to flesh out this characterology while opening up new possibilities for technocultural being.

Ricky demonstrates an awareness of technology as something other than a status symbol, a means of forgetting, a distraction from contemplation and self-examination.[14] His videos of Jane, which figure him as a producer rather than a consumer of media, capture both the essential human desire for recognition and the squeamishness about being recognized that forces most of us into prescribed social roles. This is the very paradox that resonates in a culture where we detest the notion of hidden surveillance cameras, but wave our arms vigorously and yell "Hi Mom!" into cameras that offer the promise of short-lived TV fame. It is a paradox that can only, perhaps, be captured in art. As McLuhan suggests,

> when new technologies impose themselves on societies long habituated to older technologies, anxieties of all kinds result. . . . I believe that artists, in all media, respond soonest to the challenges of new pressures. I would like to suggest that they also show us ways of living with new technology without destroying earlier forms and achievements. The new media, too, are not toys; they should not be in the hands of Mother Goose and Peter Pan executives. They can be entrusted only to new artists. (1996)

I should note that Ricky Fitts, while potentially fulfilling the role of artist-visionary hailed by McLuhan, may also be seen as a technocultural antihero, which I will discuss in chapter 5, one who uses media technologies to rehearse tragically heroic actions that might possibly earn him fame *(kleos)*, if not infamy. But there is no Internet or YouTube in *American Beauty*, and Ricky's videos are more like personal journals than weblogs. What Ricky begins to develop through his videos of the dead bird and the plastic bag is an alternative technoculture, one that is rooted less in a desire for recognition mediated by communications technologies than it is in a desire to document the strange beauty of nonhuman things. But that is the subject of another chapter.

4 DREADMILL

THE FOLLOWING IS A SCRIPT used for *Dreadmill* (2004–2006), a kinetic performance piece delivered on a treadmill hardwired to a notebook computer. In lectures of five to seven kilometers, I walked and ran while discussing the relationship between death, technology, and human embodiment. The speed of the treadmill controlled the speed of the video display, allowing me to enact a form of embodied rhetoric designed to supplement the arguments in my discussion. *Dreadmill* has been performed at several galleries and universities across North America, including the Georgia Institute of Technology, the School of the Art Institute of Chicago, and Washington University.

The left column represents the script itself, accompanied by text in brackets that describes the video image accompanying the spoken words. The right column indicates the speed at which I typically walk or run while delivering the lecture. *Dreadmill,* which I would call an iconic example of "applied media theory," explores several themes outlined in chapter 3—in fact, the essay on which chapter 3 is based was written during the same period in which I devised *Dreadmill.* This project demonstrates what happens when a humanities scholar turns to digital art rather than the academic essay as a means of testing and disseminating media theory. *Dreadmill* also provides a counterpoint for the antiheroes of chapter 5, whose dissatisfaction with a sedentary screen life leads them to engage in precarious physical activities. Fortunately, unlike the lives of these antiheroes, *Dreadmill* does not end in tragedy.

<table>
<tr><td></td><td>4 mph</td></tr>
</table>

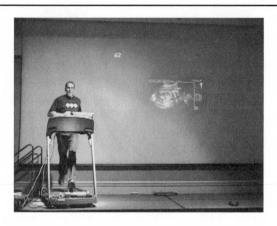

You are born in technology.
Even before you're born, you are electronically probed,
measured, recorded, and digitized. In a word, you are
rendered redundant even before your birth.

5 mph

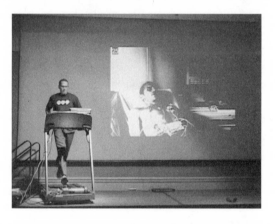

6 mph

And you will die in technology, entangled in electronic
appendages designed to help you outstrip your physical
limitations.

7 mph

In between these two moments, you are endlessly
recorded, catalogued, databased, and placed on call in
a culture driven by technology.

7 mph

Your image comes into the world before you do, and remains in the world long after you are gone.

Your identity is determined by an endless number of recording devices, from surveillance cameras to ID cards.

7 mph

Your identity is also determined by your desire to mould yourself after the recorded images that you see. You work out to achieve a Hollywood physique. You decorate your home like the pictures in magazines and on TV. You dress your kids like pop stars.

This is the way of being in a technological culture. And you can't outrun it. It's a struggle between your body and your multiple digital shadows.

8 mph
9 mph

But let's just rewind for a moment. What exactly is technology?

10 mph

Technology is not about material things like ultrasound
devices, EKG machines, or home computers.

8 mph

Technology is a way of being.
Living technologically means viewing all earthly things
as potential resources. A river is not a river, in Martin
Heidegger's famous example, but an energy resource.
You put a dam in it to power a hydroelectric plant.

6 mph

4.5 mph

The river is challenged by technology to be something
more than a river.

And human beings are not immune to this challenging
forth. You are standing reserve, placed on call in a world
challenged by technology. Heidegger entitled this activity
of challenging forth as "enframing," or *Ge-stell.*

It's important to remember that "gestell" can also be
translated as "skeleton."

What's ironic about Heidegger's definition of technology
as "standing reserve," is that technology today is not about
standing at all. It's about sitting. In a screen-obsessed
culture, we are all sitting reserve.

Now consider Detroit, the motor city, the city that moves the world. It is also America's fattest city. America's most anti-pedestrian city. Technological mobility comes at the cost of physical activity.

But the immobility of our culture has less to do with wind screens than it does with video screens.

You're more than willing to give up the limited physical abilities of your body for the sake of enjoying the unlimited expanse of virtual space.

Your body is rotting, decaying, dying. But you don't care, because on the screen you have multiple lives. You reinvent yourself in chat rooms and e-mail. And you die and resurrect infinitely in video games.

10 mph

7 mph

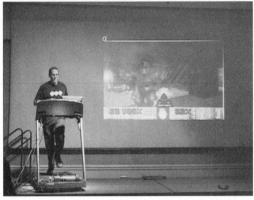

These infinite deaths are merely a rehearsal for the slow and deliberate media death that you experience each time you are recorded and entered into a database. Death by duplication. Death by redundancy.

5 mph

7 mph

It should come as no surprise that the first video camera was nothing more than a modified rifle. The camera and the gun are both instruments of death.

8 mph
9 mph
10 mph

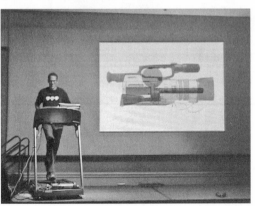

The instant gun-shot death on an urban street is rivaled by the slow, home-movie death of suburbanites capturing memories.

10 mph

Your mania for media immortality is exacerbated by the acceleration of culture. As information accumulates and flows more quickly, you panic about the impossibility of capturing it.

7 mph

And so you try to make up for this by capturing yourself and others digitally.

You are a recording device, archiving your life for future generations that won't have the time to watch it, let alone watch their own lives.

5 mph

If only you could slow it down.

7 mph

But you can't.

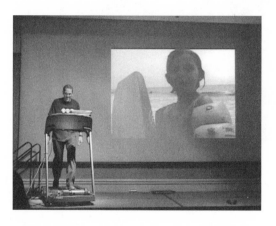

Aristotle walked as he philosophized, relying on the physical activity to help him recall information and generate new ideas.

5 mph

Today, memories are externalized more than ever. The activity of remembering involves sitting in front of a screen. | 4 mph

But humans aren't designed to sit. In fact, chronic back pain caused by sitting is the most common medical complaint in our sedentary culture. | 3 mph 2 mph

Such pain leads to a discernible disintegration of the brain's gray matter. | 1 mph

It's time to reframe our understanding of technology around the human body itself, which can only go so fast, and can only last so long. | 0 mph 0 mph

It's time to embrace your finitude. | 3 mph 5 mph

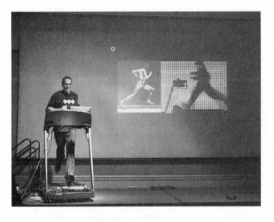

Your body isn't going anywhere.
Your body isn't going anywhere.
Do you get it? It's not really a joke.
Your body isn't going anywhere. | 7 mph

7 mph

5 mph

	8 mph
	9 mph
	10 mph
	10 mph
	Continue to exhaustion.

5 ANGELS IN DIGITAL ARMOR

Technoculture, Terror Management, and the Antihero

Reality is death. If only we could, we would wander the earth and never leave home; we would enjoy triumphs without risks and eat of the Tree and not be punished, consort daily with angels, enter heaven now and not die.

MICHAEL BENEDIKT, CYBERSPACE: FIRST STEPS

Tree Glitch

There's a "glitch" in the video game *Call of Duty 4: Modern Warfare* that allows players to climb into a tree, thereby achieving a superior vantage point for sniping. The glitch appears on a level called "Downpour." All a player has to do is find the craggy tree next to the shattered greenhouse, jump at its trunk, and run up into the branches.[1] The sense of power and security in this lofty nest is extremely gratifying, whether or not it leads to any productive sniping. I didn't learn about the glitch (which is most likely a deliberate design feature) by logging hundreds of hours a week playing the game. I found it by lurking on a few of the hundreds of COD4 game forums, such as Game-Spot, where I observed the following conversation in the thread "Climbing Trees":

ASSASSIN144 (Oct 21, 2008 6:55 pm PT): A while ago i heard that you will be able to go into trees in multiplayer and snipe, is this true? I heard a perk will let you do it but after reading the perk list nothing sounded like it, so is the ability not going to be available?

PSN_BOOMFIELD (Oct 21, 2008 8:27 pm PT): The perk is called "Monkey."

NX01AX (Oct 21, 2008 8:31 pm PT): Actually, that proved to be false.

The perk part, not the climbing trees part.

THEHAK114 (Oct 21, 2008 8:32 pm PT): As far as I know, they climb the same way as you would climb any ladder. Not sure if all trees are climbable or just certain types, but it just adds another place to look before running around wildly.

(Oct 21, 2008 8:36 pm PT): I want to set fire to a tree that someone is in

THEHAK114 (Oct 21, 2008 8:36 pm PT): And I am pretty sure you will have that ability with the Flamethrower perk.

. . . .

MACARBEONE (Oct 24, 2008 11:11 am PT): yes setting fire to some one in a tree would be amazing and then as they fall to the ground on fire i shoot them up wildly and yell OWNED!!!!!!!!

SYCO(Oct 26, 2008 5:47 pm PT): Yeahh ^^ while i knife you in the back >_>

ASSASSINWALKER (Oct 26, 2008 6:38 pm PT): i will light all the trees on fire. :)

These and other forum contributors are players who practically live in the game (or perhaps wish they could), making themselves at home in its environment and documenting their most impressive tricks and cheats on video, which they subsequently upload to YouTube in the hope of gaining bragging rights. As puerile and casually apocalyptic as the preceding conversation may seem, COD4 has provided millions of players with an empowering existential vantage point that features a clear set of goals, opportunities to make heroic choices, a sense of belonging to a responsive and committed community, and the chance to achieve instant recognition for their actions. As Jane McGonigal (2011) suggests in *Reality Is Broken,* "The real world just doesn't offer up as easily the carefully designed pleasures, the thrilling challenges, and the powerful social bonding afforded by virtual environments" (ii). For only $59.95, COD4 offers more to the average player than his or her family, school, church, or neighborhood community center can provide. Indeed, COD4 is part of a complex system of rituals (all of them short-lived and subject to programmed obsolescence) within what Ernest Becker might call the dominant *heroic action system* of today; a system that we know as "technoculture."

I would like to position contemporary technocultural being in the context of Becker's broad conception of culture in order to develop a well-rounded, cross-disciplinary conception of what motivates behaviors in an age of networked video games and online self-documentation. Central to this chapter is the work of Bernard Stiegler, who suggests that the culture of technoprostheticization, rooted in the "unlimited organization of consumption," leads "inevitably to suicidal behavior, both individual and collective" (2009a, 42). With this in mind, I will examine a variety of suicides and mass murders linked to the use of video games and the Internet, supplementing Stiegler's grim

prognosis, which he bases in part on the suicide of Richard Durn, with that of Ernest Becker.[2] In *Technics and Time,* Stiegler develops a technopsychoanalytic theory of human prostheticization, which leads to a critique of the cultural industry as a force that dominates contemporary consciousness, resulting in a "liquidation of the 'libidinal economy'" (2001, 120). Like Stiegler, Becker brings together philosophy, cultural theory, and psychology to suggest that the cultural industry succeeds by meeting two persistent desires: the desire for recognition and the desire for immortality, which are manifested ultimately in the denial of death. Considered in conjunction, the work of Becker and Stiegler provides a broad existential theory of how specific technocultural behaviors can be motivated. Combined with material and economic theories about technoculture, this existential analysis helps explain how the hyperindustrial programming of consciousness can persist, even as it leaves a visible wake of destruction at the individual, cultural, and ecological levels. That being said, this chapter is not designed to endorse wide-ranging apocalyptic media theories or truth claims levied in the name of religion or myth, but to demonstrate how religion, myth, and other cultural hero systems that are rooted in a technological imperative respond to some of the human animal's existential needs.

Ernest Becker understands culture as a force of social cohesion, generated and maintained by heroic action systems through which an individual can achieve both recognition and a sense of immortality. In chapter 3, we saw how each of the characters in *American Beauty* engaged in specific actions for the sake of resisting their cultural hero systems. We also saw how media technologies facilitated antiheroic actions, ultimately leading to each character being "busted" in one way or another by those who upheld the predominant cultural hero systems. In this chapter, I explore how, after the widespread use of the Internet, we can identify a more distinct "technoculture," a heroic action system in which technological production is viewed as an end in itself and individual recognition and death-denial are hypermediated by digital technologies. In this technoculture, antiheroes are not merely chafing against antiquated cultural hero systems (family, school, nation); instead, they are deeply engaged in what Stiegler has called a "war of the spirit" in which digital technologies are the primary artillery.[3]

This clash can be put into focus by considering a number of tech-related suicides made famous in recent years by the popular media, which sometimes attempt to explain these events by pointing a finger at consumer technologies. Consider the case of Brandon Crisp from Barrie, Ontario. In the fall of 2008, his parents exiled the fifteen-year-old from the COD4 community and

took away his Xbox out of fear that he had become addicted to the game. Crisp responded by threatening to run away. His father even helped him pack clothes, a toothbrush, and deodorant into his backpack, figuring that Brandon, like most other teens who make such threats, would return in a couple of hours. But Brandon did not return. After an exhaustive search, funded in part by Microsoft, he was found dead three weeks later in a wooded area ten kilometers south of his home. The autopsy suggested that he died from injuries related to falling out of a tree. This detail was especially troubling to Brandon's family. What was he doing up in that tree? Hiding? Seeking shelter? The mystery will likely remain unsolved. This story of exile in the wilderness has a mythical air about it. To the COD4 community, Brandon is a hero of mythic proportions; or better yet, he is the Patron Saint of Xbox, a martyr who was robbed of his most sacred artifact, was expelled from his holy land, and like other holy men sought refuge in the wilderness.

Myth, Religion, and Cybernetic Apocalypse

Such religious and mythical rhetoric, as overblown as it may seem here, is by no means unique in critical studies of media technologies. In *The Digital Sublime,* Vincent Mosco (2005) examines myth in cyberspace narratives with the hope of "destabilizing the dominant representations of what we are supposed to be and where we are going" (16). According to Mosco, mythical rhetoric about the infinity of cyberspace and the disembodying potential of online worlds is a central component of many culturally important narratives. Like the tales of Homer and Plutarch, many cyberspace myths provide us with a buffer against some of the anxiety related to human finitude. As Mosco suggests, "the thorny questions arising from all the limitations that make us human were once addressed by myths that featured gods, goddesses, and the variety of beings and rituals that for many provide satisfactory answers. Today, it is the spiritual machines and their world of cyberspace that hold out the hope of overcoming life's limitations" (2005, 78). Arguably the greatest limitation we have to face is our mortality. Mosco's reference to "spiritual machines" deliberately echoes the title of a book by Ray Kurzweil (2000), an uncompromising immortalist whom Mosco identifies as one of the most ardent and influential myth-makers of our time. Kurzweil is one of a number of transhumanists, many of them lining up to attend Kurzweil's Singularity University, who long for the disappearance of the human body into a network of celestial circuits. As Mosco argues, the trope of digital disembodiment, from the essays of robot scientist Hans Moravec to the mutant performances of the artist Stelarc, is consistent

with mythological discourse, which promises immortality to those who are willing to believe in and propagate the narrative. We might consider whether players of online video games, for example, who enjoy a sense of superhuman power and experience infinite resurrections, have this mythic promise fulfilled—as long as they stay online.

Mosco turns to myth as an extended analogy for understanding the powerful rhetorics of progress that characterize technoculture. But he may very well have come to similar conclusions by drawing on a religious analogy. As David F. Noble (1999) argues in *The Religion of Technology,* "the technological enterprise has been and remains suffused with religious belief" (5). Noble illustrates how the concept of *imago dei* (being created in the likeness of god) has been used to justify technological innovations, including nuclear arms and the Human Genome Project. Echoing a common utopian strain in scientific discourse, Noble writes, "Totally freed from the human body, the human person, and the human species, the immortal mind could evolve independently into ever higher forms of artificial life, reunited at last with its origin, the mind of God" (1999, 149).

This Cartesian rhetoric is far removed from the adolescent chatter of gamers in online forums such as those quoted in the preceding text. But as both Mosco and Noble suggest, rhetorics of technological progress, like many video game narratives, are informed by a millenarian yearning for apocalypse ("i will light all the trees on fire"), a dramatic break with the past that signals both the newness and specialness of a given generation. As Noble writes, "Millenarianism is, in essence, the expectation that the end of the world is near and that, accordingly, a new earthly paradise is at hand" (23). This strain is evident, for example, in Michael Benedikt's (2006) anthology, *Cyberspace: First Steps.* Benedikt proclaims that cyberspace evokes "the image of a Heavenly City, the New Jerusalem of the Book of Revelation. Like a bejeweled, weightless palace it comes out of heaven itself" (15). Mosco suggests that this sort of discourse reflects a form of "historical amnesia," a desire to transcend history and all of the complexities that accompany life as a physical being in a material world (2005, 8). A whiff of this apocalyptic strain is discernible whenever a keynote speaker stands up and suggests that "we are living through a time of unprecedented change." These words hold great political and existential weight, filling listeners with a sense of cosmic importance, as if their daily lives are somehow enriched by a vague promise of specialness, all in the name of technological progress.

Benedikt's apocalyptic "cyberbole" (Mosco 2005, 25) coincides with a number of late-90s academic projects that announce or predict the death of space,

time, and politics.[4] These proclamations, by the accounts of both Mosco and Noble, emerge from a seemingly atavistic need to deny human finitude. Mosco pays particular attention to Francis Fukuyama (1992), whose Pulitzer Prize-winning book announces "the end of history and the last man." Fukuyama draws on Kojève's interpretation of Hegel, which suggests, "History can end, only in and by the formation of a Society, of a State, in which the strictly particular, personal, individual value of each is recognized as such, in its very particularity, by *all*" (Kojève 1980, 58). From the conservative, apocalyptic perspective of Fukuyama, liberal democracy and advanced capitalism have brought about this "end." Like many other critics, Mosco rejects Fukuyama's somewhat easy, perhaps uncritical resignation to this supposed end of history. Indeed, Fukuyama later retracted his own argument in light of the events of 9/11. But Fukuyama's work should not be rejected altogether, for to do so would be to ignore his important conception of the notion of *thymos,* which provides a very useful tool for understanding the relationship between human desire, existential needs, and technology. I return to this subject later. For the moment, I wish to point out the limitations of mythic (e.g., Mosco's) and religious (e.g., Noble's) analogies as a means of explaining technocultural behavior.

People create myths and religions not just out of a need for social order, but to convince themselves that they are not finite beings. The greatest contribution of Mosco's work is that it demonstrates how rhetorics of technological progress are driven forward by a desire to overcome the constraints of human finitude. Taking a cue from Heidegger, perhaps, Mosco suggests that the "danger" of mythological narrative is that it provides us with an "unfulfillable promise" (2005, 22), which masks the reality of our situation and blinds us to the problems and complexities of human history.[5] Noble's analysis of technology and religion leads him to similar conclusions. Consider, for example, the words of AI visionary Danny Hillis, a self-proclaimed agnostic, quoted in Noble's book: "I want to make a machine that will be proud of me. . . . I'm sad about death, I'm sad about the short time that we have on earth and I wish there was some way around it. So, it's an emotional thing that drives me. It's not a detached scientific experiment or something like that" (quoted in Noble 1999, 163).

According to Noble, these words reflect a religious rhetoric, falling neatly in line with the *imago dei* theme. But there is nothing particularly "religious" about these terms, and in fact, to categorize them as religious is to limit the scope of the analysis. To clarify, Hillis's words do not reflect a religious calling but an existential call to action that he is able to satisfy through the pursuit of technological innovation. The primary motivations for his actions are clearly (1) a desire for recognition ("I want to make a machine that will be proud of

me") and (2) the denial of death ("I'm sad about death . . . and I wish there was some way around it"). Hillis's words are inspired not by myth or religion, but by a cultural hero system that views technological production as an end in itself and possibly as a way out of the certainty of death. Like myth and religion, technological innovation and the sublime rhetorics of "progress" that accompany it serve primarily to mitigate the terror of human finitude. Rather than attempting to fit such rhetorics within a religious or mythical paradigm, it may be more productive to consider them in the broader context of "culture," as understood by Becker. In so doing, we may develop a better understanding of how contemporary cultural industries, which play a role heretofore dominated by religious and mythical narrative, are able to program the consciousness of a vulnerable public. And they may achieve this end by preying on our capacity for existential terror.

Terror Management Theory

The contemporary political inflection of the word *terror* has no doubt led to an increase in book sales for psychologists Tom Pyszczynski, Sheldon Solomon, and Jeff Greenberg (2003). Their groundbreaking study, *In the Wake of 9/11: The Psychology of Terror,* is not about the 9/11 terrorists at all, but about psychological and existential implications of having a finite body matched with an infinite symbolic system for representing reality. The authors touch on this distinction when they introduce their theory of *terror management,* which emerges directly from the texts of cultural anthropologist Ernest Becker: "Terrorism, as the word implies, capitalizes on the human capacity to experience terror. Terror is, in turn, a uniquely human response to the threat of annihilation. Terror management theory is about how humans cope, not with the imminent threat of extermination but with the awareness that such threats are ubiquitous and will all eventually succeed. Death will be our ultimate fate. How then do we manage this potential for terror?"[6] (Pyszczynski, Solomon, and Greenberg 2003, 8). Terror management theory has led to the publication of over three hundred peer-reviewed journal articles, documenting a range of experiments that test the hypotheses of Ernest Becker and have been inspired by his interdisciplinary work. Typically, these experiments involve placing participants in a state of "mortality salience," and then studying their behaviors in controlled situations. What these experiments have proven, above all, is that individuals who are reminded of their own mortality either consciously or subliminally, cling to their cultural beliefs more readily than do control groups, and are more apt to reject cultures that are potentially at odds with

their own. Such experiments have been adapted recently by the Critical Media Lab at the University of Waterloo, where we are attempting to identify whether technoculture, defined by a constantly renewed desire for gadgetry and a strong belief in technological progress, can itself be viewed as an immortality ideology, a terror management system for a generation raised on computer games, texting, and iPods.

The concept of terror management brings us back to the discussion of myth and religion, both of which serve as "management systems" against the awareness of death and ever-present existential terror. One way in which myth and religion conquer terror is by bringing us closer to death, but only within the safe confines of a controlled narrative, or more specifically through ritual. As Mosco suggests in *The Digital Sublime,* what makes the sublime pleasurable is that it gives us a brief "near-death experience," conveniently packaged to create the illusion that we can skirt death (2005).[7] This concept is explored by Fukuyama, but it is examined in greater detail and depth by Becker.

Becker's (1973) Pulitzer Prize–winning *The Denial of Death* outlines an ambitious explanation of the human condition that is based on a very simple concept: all human cultures (including those rooted in religious and mythical metanarratives) might be viewed as "hero systems" that are devised to counter the anxiety caused by knowledge of our inevitable deaths. While this may not come as a surprise to social psychologists, the application of this idea to cultural criticism and media theory remains to be explored. Today, as Mosco would no doubt agree, technoculture itself is a hero system, and it mediates the denial of death in a number of ways, from the sense of belonging one achieves through mere ownership of an iPod (an ironic sense, given the alienating effect of this device) to the hope of achieving immortality through gene therapy and other medical technologies. Our awareness of our own *being-toward-death* has led humans to concoct ingenious antidotes, from elaborate myths and religions to *Call of Duty 4*.[8] As Sherry Turkle (1984) suggests, "as a computational object," the video game is imbued with "a touch of infinity—the promise of a game that never stops" (87). In late capitalist culture, mythic morality tales and religious rites have given way to the formula for immortality embodied in Moore's Law.

The infinitude that is at the heart of technological production might be described in terms of the sublime. Technoscientific research and development offer us an immense, complex, and terrifyingly sublime array of possibilities; terrifying if only because these possibilities open up before us without warning, leading to what Stiegler calls a state of "ill-being" or *malaise.* In Stiegler's terms, our technocultural situation asks us to "identify what it is we want, given

the immense possibilities that are irresistibly open to us . . . , and *we must admit that we do not know what we want,* while at the same time, as Nietzsche understood so well, *we cannot not want.* This is the meaning of ill-being and ontological indifference" (2001, 296). This critique of technological being, like much of Stiegler's work, comes not only from Nietzsche but also from Heidegger. More precisely, Stiegler's work, particularly *Technics and Time 1* (1998), is a corrective of Heidegger. For Heidegger, living technologically means that we are constantly called on to outstrip nature, including the inevitability of our death. Technology and death are linked, then, in that the ultimate goal of technological being is to overcome the inevitability of our "natural" horizon, our finitude. Heidegger describes this technological imperative as an "impossibility" that we impose on nature:[9] "The unnoticeable law of the earth preserves the earth in the sufficiency of the emerging and perishing of all things in the allotted sphere of the possible which everything follows, and yet nothing knows. The birch tree never oversteps its possibility. The colony of bees dwells in its possibility. . . . Technology drives the earth beyond the developed sphere of its possibility into such things which are no longer a possibility and are thus impossible" (1967, 108). The language of "overstepping" or outstripping nature requires one to have a ground zero conception of nature as something distinct from humanity, technology, or culture. Not surprisingly, critiques of Heidegger challenge his romantic conception of the premodern world as something pure and untouched, and even less surprisingly, decry Heidegger's affiliation with the Nazi Party, which seems to follow logically from his purist vision.

Stiegler, while refusing to do away with Heidegger's theories altogether, challenges the conception of technological being as something manifestly "modern." According to Stiegler, "technics is the history of being itself" (1998, 10). The very definition of the term *human,* or more precisely, the "invention of the human," is in itself something technical. In Stiegler's terms, "the human invents himself in the technical by inventing the tool—by becoming exteriorized techno-logically" (1998, 141). The tool, and more specifically the flint-cutting tool, represents for Stiegler a uniquely human capacity for "anticipation." Anticipation of the tool's utility for a given task leads to the making of the tool, just as anticipation of the repetition of this task leads the human to keep and reuse the tool. But perhaps most importantly for Stiegler, the capacity to anticipate is also a curse, for it gives man the foreknowledge of his own death. That is why, for Stiegler, "to ask the question of the birth of the human is to pose the question of the 'birth of death' or of the relation to death" (1998, 135). In this sense, Stiegler agrees with Heidegger's conception of *Dasein* as

being-towards-death, tying it to a "primordial situation" that is at once technological and thanatological: "*Between* god and beast, neither beast nor god, neither immortal nor prone to perish, sacrificial beings, mortals are also and for the same reasons nascent, bestowing meaning, and "active." . . . [A] technical *activity* that characterizes all humanity as such, that is, all mortality, can plunge out of control. To be active can mean nothing but to be mortal" (1998, 198). It is this capacity for humanity to "plunge out of control" that propels Stiegler's apocalyptic critique of contemporary technoculture. Unlike Heidegger, then, Stiegler does not consider the question of human finitude in terms of "impossibility," but in terms of "immense possibility," which opens up before us today by means of genetic engineering, for example. This "immense possibility," a virtual infinitude of being that Becker might align with the schizophrenic in his characterology, is also opened up by the adoption of avatars and multiple identities made possible by digital technologies.

Becker approaches the question of human finitude in terms that are strikingly similar to Stiegler's. He alludes to the human capacity for anticipation as the curse of a creature, to echo Kierkegaard, that is suspended between angel and beast—a creature endowed with the ability to make tools and invent an infinite symbolic system, but also with a palpable sense of its own finitude. "What does it mean to be a *self-conscious animal?*" asks Becker, in his typically unabashed speciesist fashion. "It means to know that one is food for worms. This is the terror: to have emerged from nothing, to have a name, consciousness of self, deep inner feelings, an excruciating inner yearning for life and self-expression—and with all of this yet to die" (1973, 87). Unlike Stiegler, Becker does not suggest that humans are primordially technological beings. But Becker shares with Stiegler an understanding of the human as a being defined by its motivation, a primal *motivation,* to extend beyond itself, or in Heidegger's terms, to "overstep" itself. Following Kierkegaard, Becker suggests that people deal with the terrifying knowledge of death by erecting individual systems of organization that give value and meaning to their lives. Becker refers to this organizational activity as the fashioning of *character armor,* which is a prosthetic image in itself, "the arming of the personality so that it can maneuver in a threatening world" (1975a, 83). In our current technoculture, the denial of death is mediated primarily by an unbridled faith in technological progress and by a donning of what might be called digital character armor. Taken to its logical conclusion, which can be glimpsed in the ideology of transhumanism, technoculture results in a situation of all armor, no angel. In Stiegler's terms, "today the issue is absolutely that of humanity's demise—which is also a way of talking about the death of God and of 'the last man,' since the real possibility

challenging us today, appreciably practicable, is the last evolutionary stage of technics: the possibility of an artificial human being who is neither 'last man' nor 'overman'" (2008, 149). But how did we reach the point where we are willing to program our own demise for the sake of a calculated, "artificial" immortality? An understanding of technoculture must entail a study of human attitudes toward death, as well as an understanding of the role that terror plays in human behavior on a daily basis.

The case of Brandon Crisp, discussed in the first section of this chapter, is only one in a number of technology-related deaths that caught the media's attention in the past few years. These deaths include those of many South Korean game addicts and, more pertinently here, a terrifying trend of copycat school shooters following in the steps of Eric Harris and Dylan Klebold, who killed thirteen people in the 1998 Columbine High School Massacre before taking their own lives. The terrorist acts in these cases are conspicuously technological because they involve the perpetrators' use of electronic media to rehearse or to promote their exploits in a desperate plea for recognition. These tragic events cast a light on the nature of technocultural behavior, namely, that it is punctuated by what might be called online *screen tests,* which allow individuals to rehearse and propagate their fantasies in ways that were unheard of before the advent of digital social media.

Recognition and Thymos

In the midst of Cho Seung Hui's fateful shooting spree at Virginia Tech in April 2006, Jamal Albarghouti, a fellow VTech student, made a heroic decision to run into the war zone, rather than away from it. Armed not with a Glock (Cho's weapon of choice) but with a Nokia N70 cell phone, Albarghouti ignored the warnings of police officers in order to capture digital video footage suitable for upload to CNN's iReport page. Albarghouti's ghastly, I would even say sublime, handheld video of a campus under siege concludes with a terrifying scream. It is not the scream of the gunman or of his assailants, but the scream of a police officer urging the phone-toting student to get out of the way so that the law enforcers can conduct their business. What was Albarghouti's motivation? His rush toward immortality was not spurred by myth or religion, but by the possibility of a brief appearance on CNN. Like the contestants on reality TV programs, Albarghouti demonstrates that, thanks to the ubiquity of surveillance technologies, even those of us on the sidelines can cash in on the promise of celebrity that is waved in front of us on a daily basis by mainstream media.

In response to the Virginia Tech Massacre, freelance journalist Mark Steyn (2007) suggested that the events of that day evidence a growing "culture of passivity," populated by "selectively infantilized" twentysomethings. Steyn's argument, which jives very well with the NRA's agenda, expresses outrage at the fact that not a single student stood up to Cho. This "passivity," as Steyn calls it, "is nothing more than an 'existential threat to a functioning society.'" But Jamal Albarghouti's courageous actions suggest that Steyn's accusations are misdirected. The twentysomethings of the prevailing technoculture are indeed willing to sacrifice themselves—but not for the reasons that Steyn would expect. Heroism for many twentysomethings is not motivated by myth, religion, nation, family, or some vague sense of *humanity,* but by what Stiegler (2001) calls a "hyperindustrial" culture characterized by the blind consumption of media artifacts. Both Cho and Albarghouti were motivated by a desire for recognition and the heroic denial of death, and their actions were all played out in the context of technological consumption. As Cho set out to become a media superstar by annihilating the VTech campus, Albarghouti was determined to establish his own stardom by capturing these events forever in video, providing proof once again of Friedrich Kittler's maxim, "What the machine gun annihilated, the camera made immortal" (1999, 124). But these two types of heroic shootings—one very real, with painfully physical consequences, and one virtual, geared toward disembodiment and simulation—are indicative of the shift in death denial strategies that has taken place with the increasing technologization of culture.[10]

One of the primary tenets of Ernest Becker's work, based on the theories of philosophers and psychologists including Friedrich Nietzsche and William James, is that human behavior is driven not only by a denial of death but also by an ongoing yearning for recognition, for heroism even (or *kleos,* to use the Greek term employed by Socrates in discussions of glory). Becker's use of the word *heroism,* rather than of the more common term *self-esteem,* allows him to draw on literary and cultural history in his analysis of human psychology. The term *heroism* also reflects the idea that self-esteem, following Kojève and Hegel, is in effect achieved primarily through recognition from others, through the sense that one is an individual of value in a meaningful world.[11] Becker uses the term *heroism* to account for a spectrum of human behaviors. The superhuman feats of Greek mythological figures would be at one end of this spectrum, while modern society's epic consumption of consumer goods and media artifacts would be at the other. Heroism is a relative concept, rooted in a set of beliefs shared by any given culture, from a pre-Columbian tribe of Native Americans to the netizens of today's contemporary technoculture. As

Becker argues, it is by means of a "cultural hero-system," a recognition from others based on a consensual set of values, that we hope to transcend death:

> It doesn't matter whether the cultural hero-system is frankly magical, religious, and primitive or secular, scientific, and civilized. It is still a mythical hero-system in which people serve in order to earn a feeling of primary value, of cosmic specialness, of ultimate usefulness to creation, of unshakable meaning. They earn this feeling by carving out a place in nature, by building an edifice that reflects human value: a temple, a cathedral, a totem pole, a skyscraper, a family that spans three generations. The hope and belief is that the things that man creates in society are of lasting worth and meaning, that they outlive or outshine death and decay, that man and his products count. (1973, 5)

The concept of "culture" itself, then, is defined for Becker in terms of heroism. Raymond Williams's statement in a 1958 essay that "culture is ordinary" and that "every human society has its own shape, its own purposes, its own meanings" (6) is reflected quite clearly in the work of Becker. In Becker's terms, there is nothing "high" about culture, which Becker understands in terms of a "hero system" devised to deny the inevitability of death.[12]

Becker, like Nietzsche and others before him, believed that contemporary culture offers very little opportunity for authentic heroism, and so we have to seek it in more mundane ways:

> In our culture anyway, especially in modern times, the heroic seems too big for us, or we too small for it. Tell a young man that he is entitled to be a hero and he will blush. We disguise our struggle by piling up figures in a bank book to reflect privately our sense of heroic worth. Or by having only a little better home in the neighborhood, a bigger car, brighter children. But underneath throbs the ache of cosmic specialness, no matter how we mask it in concerns of smaller scope. (1973, 4)

This throbbing ache for a sense of specialness has been intensified in the Western world by the dissolution of traditional hero systems on the one hand (religion, family, nationhood, etc.) and the propagation of mass media heroes on the other hand, including the everyday heroes of reality TV shows and YouTube. Heroism today is rooted in the consumption of media images and objects. In 1971, Becker suggested that "people no longer draw their power from the invisible dimension, but from the intensive manipulation of very visible Ferraris, and other material gadgets" (1971, 125). Had he written this sentence in the early 2000s, he might have replaced the word *Ferrari* with *iPod* or even *Nokia N70*.

It is surprising that Becker alludes to Hegel only briefly in his work, although he is certainly aware of the centrality of recognition in Hegel's master/slave dynamic. In his authoritative study of Hegel, Alexandre Kojève (1980) suggests that "all human, anthropogenetic Desire—the Desire that generates Self-Consciousness, the human reality—is, finally, a function of the desire for 'recognition.' And the risk of life by which human reality 'comes to light' is a risk for the sake of such a Desire. Therefore, to speak of the 'origin' of Self-Consciousness is necessarily to speak of a fight to the death for 'recognition'" (7). For Stiegler, the importance of recognition within *Dasein* is manifest in a discussion of "individuation," a concept he borrows from Gilbert Simondon (1989). Individuation is at once singular and collective, a process through which we differentiate ourselves from others while sharing social space, and most importantly time, with others:

> Dasein is time insofar as it is being-futural: anticipation, improbability, différance—
> both deferring in time (anticipating) and being different, affirming a difference
> *qua* a "unique time," a singularity. . . . This individuation belongs, however, and
> in the same movement, to a community: that of mortals. (Stiegler 1998, 229)

For Stiegler, Kojève, Becker, and numerous other philosophers before them (think of Spinoza's definition of man as a "social animal"), recognition of the self by others is a key component of what it means to be human. Contemporary technologies both facilitate and hinder that recognition.

Francis Fukuyama, following Kojève and Hegel, suggests that the quest for recognition is "the driving force behind human history" (1992, 162), and he develops this idea into a millenarian thesis that has been widely contested. What we should rescue from Fukuyama is the concept of thymos, taken from Plato, which sheds light on the relationship between self-esteem, recognition, and cultural hero systems. Thymos is most commonly translated as "spiritedness," and is used by Socrates first of all to characterize the guardians of the republic, those who are willing to risk their lives to protect the city. Fukuyama repeats the story of Leontius, which Socrates uses as a case study in the concept of thymos: "He desired to look, but at the same time he was disgusted and made himself turn away: and for a while he struggled and covered his face. But finally, overpowered by the desire, he opened his eyes wide, ran toward the corpses and said: 'Look, you damned wretches, take your fill of the fair sight'" (quoted in Fukuyama 1992, 164).

Becker might suggest here that Leontius is chafing against his "character armor"; that is, he is struggling to remain within the bounds of his cultural hero system. Similarly, Fukuyama proposes that Leontius's anger is a

manifestation of his inner sense of pride, which is threatened by his lack of self-control. The anger of Leontius, directed at himself, is a result of recognizing that his actions would not be held in high regard by his countrymen. This angry sense of pride, suggests Fukuyama, reflects a sensitivity to the value that one sets on oneself based on cultural norms, and this placing of value on oneself within the context of a cultural system helps define thymos. In Fukuyama's terms, "*Thymos* provides an all-powerful emotional support to the process of valuing and evaluating, and allows human beings to overcome their most powerful natural instincts for the sake of what they believe is right or just" (171).

With this in mind, I am compelled to ask the following: To what degree are the actions of Jamal Albarghouti, CNN's phone video hero, comparable to those of Leontius? What motivated Albarghouti to run into the fray? Should he, like Leontius, have damned his wretched eyes (or cell phone camera) for zooming in on the massacre? Or is Albarghouti a modern mythical hero, motivated by a spiritedness, a thymos, a *megalothymia* even, as Fukuyama might suggest, exclusive to technoculture? To put it bluntly, what sort of cultural context makes Albarghouti a hero?

Recalling Plato's guardians of the city, thymos is best satisfied by risking one's life in defense of something one holds in high esteem. Historically speaking, war has been the ultimate catalyst and facilitator of thymotic activity. Like Becker, Fukuyama suggests that such activity has been redirected in late capitalist culture toward the pursuit of financial well-being, fueled by an ever-accelerating production and marketing of consumer goods, all thanks to technological progress. Heroism is now mass-marketed in ways that ensure that the "guardians of the republic" fend off the enemy not in hand-to-hand combat, but by going to the mall or having multiple messages in their inbox. People now fill their thymotic needs by shopping, texting, and playing video games. It is this lack of physical risk, so important to Kojève and Hegel's formulation of heroic recognition, that leads Fukuyama to conclude that we are witnessing "the end of history and the last man." In Becker's roughly Marxist terms, which echo those of the Frankfurt School that inspired him, "something happened in history which gradually despoiled the average man, transformed him from an active, creative being into the pathetic consumer who smiles proudly from our billboards that his armpits are odor-free around the clock" (1975b, 61).[13]

The pursuit of consumption for the sake of consumption, a heroic activity that has led to the radically unequal distribution of wealth in North America, is a result of what Fukuyama calls megalothymia; not just the desire for recognition, but the desire to dominate or even "own" (or "PWN") others, as reflected

in the lingo of COD4 gamers.[14] The ultimate goal of this heroic pursuit is the achievement of immortality. Megalothymia can be satisfied vicariously and temporarily, for example, through sport, from being an enthusiastic spectator of the World Cup or the Superbowl to actually participating in challenging physical activities such as marathon running.[15] "In the social world," Becker suggests, "one continually pushes against death in sport-car driving, mountain climbing, stock speculation, gambling: but always in a more-or-less controlled way, so as not to give in completely to the sheer accidentality and callousness of life, but to savor the thrill of skirting it" (1971, 175). From theme park rides and bungee jumping to deep sea fishing and big game hunting, the heroic and sublime denial of death is now readily available for purchase, accompanied by a documentation of the event in digital photography or video for mass distribution on social networking sites, proof that the experience *really happened.* "The fight to the death for recognition" that characterizes human consciousness (Kojève) has been commoditized, rendered programmable by the culture industry. As Stiegler suggests, the result is a radical change in the very formation of consciousness. With the increasing industrialization of culture, individuals are "deprived of the possibility of deciding how [they] want to live," and this results in "a reversal and a denial of what Hegel described as the master-slave dialectic" (2009b, 39). In technoculture, a person is threatened by the possibility of losing the ability to "participate in the trans-formation of her milieu by individuating herself within it" (Stiegler 2009b, 39). The apotheosis of technocultural heroism are those individuals who are *famous for being famous,* as evidenced by their multiple friendings, Twitter trending, and headlines in gossip sites and, if they're lucky, in a TV spinoff about nothing more than their day-to-day life.

As Fukuyama suggests, the ordinary heroes of these mass-marketed, consumable victories may recognize the emptiness of such existential projects: "As they sink into the leather of their BMWs, they will know somewhere in the back of their minds that there have been real gunslingers and masters in the world, who would feel contempt for the petty virtues required to become rich or famous in modern America. How long *megalothymia* will be satisfied with metaphorical wars and symbolic victories is an open question" (1992, 329). The "open question" is not answered, as Fukuyama might expect, by the waging of war or a return to religious "roots." It is answered instead when a megalothymic person like Jamal Albarghouti throws himself into the scene of a massacre to feed a news program. More tragically, the limits of "metaphorical wars" are revealed when young people who have heretofore satisfied their desire for heroic action in an on-screen simulation wield real weapons against an

unsuspecting enemy. The violent acts discussed in the following sections put into focus Stiegler's prognosis that a culture of "unlimited organization of consumption" leads ultimately to "suicidal behavior, both individual and collective" (2009a, 42).

Hypermediated Heroism

On the morning of December 27, 2004, after playing thirty-six consecutive hours of the computer game *World of Warcraft (WoW)*, thirteen-year-old Zhang Xiaoyi jumped from the top of his family's twenty-four-story apartment building. He left behind a suicide letter, explaining that his actions were an attempt "to join the heroes of the game he worshipped" (Xinhua 2006). The boy's parents filed a lawsuit against the game manufacturer, and both the press and the government of China referenced the incident as evidence of a growing computer addiction problem in the country. A 2005 report by the China Youth Association for Internet Development suggested that 13.2 percent of China's 16.5 million youth were computer addicts (Xinhua 2006). In response to this problem, the Chinese government backed the creation of an online game titled *Chinese Heroes*, which promoted traditional values among the youth. According to a game designer, "the heroes gather on 'Hero Square,' where gamers can click their statues to learn about their experiences and carry out tasks like moving bricks and catching raindrops on a building site. Gamers will be asked about the heroes' life stories to earn scores" (Xinhua 2006). It seems that "Square Heroes" would be a more appropriate title to this game, as reflected in the reaction of a fourteen-year-old boy interviewed by the Xinhua News Agency: "The game sounds boring to me, it's a turn-off." The game produced similar reactions among other test subjects at the Beijing Internet Addiction Treatment Center, who found it "too simple" or even "comical." These players prefer the action, violence, and consumption built into popular role-playing games such as *WoW*, which has enjoyed huge popularity around the world. As the director of the treatment center attests, "If hero games do not focus on killing and domination, gamers will definitely not play them" (Xinhua 2006). The number of Internet-addicted youth in China has almost doubled since 2005, and the Chinese government is backing its infamous Internet addiction boot camps, rather than promoting games with traditional content.[16] The camps themselves are waging a brutal war of the spirit, countering the heroic action system of technoculture with traditional Chinese values.

The story of Zhang Xiaoyi is a parable of the way media technologies have evolved into cultural hero systems in their own right. The World of Warcraft,

like any other culture, comes complete with "its own shape, its own purposes, its own meaning" (Williams 1958, 6). Of course, one difference between *WoW* and an indigenous tribe or a medieval hamlet is that *WoW* is experienced on a screen, through a process of disembodiment and tele-action. What makes the Warcraft world especially appealing as a society, besides the fact that it offers everyone the opportunity to be a powerful hero, is that its purposes and meanings are clear-cut—they are provided in the form of a rule-set by which all players abide in order to play the game. As Sherry Turkle suggests, "At the heart of the computer culture is the idea of constructed, 'rule-governed' worlds" (1984, 66). The case of Zhang Xiaoyi demonstrates what happens when this disembodied culture of "rules and simulation" (66) clashes with the physical, meat-based culture of the real world. For a player whose hero system exists on-screen, life off-screen—with its unpredictability, lack of a clear rule-set, antiquated value system, and scant opportunity for heroic action—can be a grave disappointment, or at the very least, crushingly "boring."

To fend off this boredom, some players at Internet cafés in South Korea may log ten to fifteen hours a day in front of *WoW* or *EverQuest* (endearingly nicknamed "Evercrack" by aficionados), breaking only to use the toilets. In August 2005, a man from the city of Taegu died from heart failure related to exhaustion after playing the game *Starcraft* for fifty hours straight (BBC News 2005). This feat was nearly as heroic as that of a twenty-four-year-old man from Kwangju who died of the same condition after playing for eighty-six hours straight in October 2002 (Kim 2005). Such incidents, which are reported on an increasingly regular basis, point to a new form of heroism rooted entirely in digital culture. Outside of South Korea, which hosted the first three World Cyber Games and where game players are celebrated as national heroes, these deaths seem senseless. Media critics in North America are likely to lay blame for these deaths on parents who allow their infantilized children to spend most of their waking hours in front of a screen. Parents, on the other hand, are likely to blame (and sue) the video game companies, who design games specifically for what Turkle calls their "holding power" (1984, 30). But very seldom do critics or parents blame the culture that values technology, wealth, and consumption above all else; a culture in which heroism can, and perhaps must, be purchased; a culture in which value is meted out in shiny boxes packed with circuits and in abstract bits of code that scroll by horizontally at the bottom of a television newscast. In his critique of Fukuyama's proclamation of the end of history at the hands of neoliberal capitalism, Vincent Mosco suggests that postindustrial society, fueled by a capitalist ideology that has no "moral sensibility or any sense of limits," is "far from the technological sublime" (2005, 67).

But it is precisely this lack of limitations that makes capitalism sublime in and of itself—like myth and religion, capitalism is an ideology of infinitude, not through the promise of eternal life, but, as Stiegler points out, through an overbearing "imperative to adopt the new" (2009a, 44).

Faced with this protean, consumerist heroic action system, one has very few opportunities for legitimate heroism, unless one holds out for the promise of reality TV, the lottery, or one of the endless draws for the latest iPhone. These are common desires, which people palliate by purchasing the same consumer goods as many others and watching the same television programs as others, at the very same chronological time. According to Stiegler, this way of being results in a liquidation of self-esteem, an inability to distinguish one's self from others, resulting from a global program of monoculturization mobilized by hypercapitalism. This programming of desires, suggests Stiegler, "will end in the exhaustion of conscious *desire,* which is founded on singularity and narcissism as an image of an otherness of myself" (2009a, 60). Stiegler notes that this loss of self-esteem, resulting from an inability to distinguish oneself from others and thereby achieve recognition, will lead to catastrophic behaviors: "The liquidation of primordial narcissism, leading to a loss of self-esteem (the self, losing its diachrony, can no longer inspire in itself the desire for self), authorizes all transgressions, insofar as it is also the liquidation of the *we* as such, which becomes a herdlike *they,* and which in turn produces the great political catastrophes of the twentieth century" (2009a, 55). While Becker does not focus specifically on media technologies, he also blames the late capitalist law of consumption on an ominous "crisis of heroism":

> The crisis of modern society is precisely that the youth no longer feel heroic in the plan for action that their culture has set up. They don't believe it is empirically true to the problems of their lives and times. We are living a crisis of heroism that reaches into every aspect of our social life: the dropouts of university heroism, of business and career heroism, of political-action heroism; the rise of anti-heroes, those who would be heroic each in his own way or like Charles Manson with his special "family," those whose tormented heroics lash out at the system that itself has ceased to represent agreed heroism. (1973, 6–7)

The antiheroic Charles Mansons of today, a group that includes increasingly younger members such as Cho Seung-Hui, may attempt to construct a "family" online, and when they fail or become disillusioned by the lack of fulfillment such families may provide, they turn on the people and institutions that failed to recognize them in the nondigital world.

The Digital Antihero

In what might be described as a Marxist critique of his peer group, Sebastian Bosse posted the following message on LiveJournal before engaging in a copy-cat shooting spree at his German high school: "If you realize you'll never find happiness in your life and the reasons for this pile up day by day, the only option you have is to disappear from this life. . . . [We live in a] world in which money rules everything, even in school it was only about that. You had to have the latest cell phone, the latest clothes and the right 'friends.' If you didn't, you weren't worth any attention. I loathe these people, no, I loathe people" (Jüttner 2006). This post forecasts the videotaped suicide message left by Cho Seung-Hui, which rails against "rich kids" and their "debaucheries": "Your Mercedes wasn't enough, you brats. Your golden necklaces weren't enough, you snobs. Your trust funds wasn't enough. Your vodka and cognac wasn't enough. All your debaucheries weren't enough. Those weren't enough to ful-fill your hedonistic needs. You had everything" (Cho 2007). What Bosse and Cho manifest in their suicide pleas can be called in Stiegler's terms a form of "symbolic misery," an "a-significance—the limit of significance, beyond insig-nificance and as an unbearable limit—to the point where it leads to an act of massacre" (2009a, 55). Stiegler uses these terms to describe the motivation behind the actions of Richard Durn, who expressed his lost sense of self, his inability to signify, in a journal that was reprinted in *Le Monde*. But Durn didn't ask for his thoughts to be published. This distinguishes him from a gen-eration that is deeply embedded in the technocultural milieu, a generation for whom the promise of recognition, of significance, comes in the form of net-worked computer games, blogs, and other forms of social media.

While video games have been the primary technological scapegoat for school shootings, very few critics have pointed a finger at the potentially dangerous rehearsal platform facilitated by online journals, blogs, personal websites, Face-book, and even chat. The most crucial clues in the death of Brandon Crisp, for example, are not buried in the violent actions coded into *Counter-Strike*, but in the social interactions that the online version of the game offered Crisp. Social networking platforms, rather than computer games, should be the object of attention for those who are interested in studying, and intervening in, terrorist-style school violence. Before committing their infamous exploits, all of the school shooters since Dylan Klebold and Eric Harris spent a great deal of time rehearsing their violent actions and trying on their heroic identities with the help of media technologies. Eric Harris posted elaborate death threats to fel-low students on his website, and he and Klebold made several videotapes of

themselves fiddling with an arsenal of weapons in preparation for the attack on Columbine High School. In 2006, Kimveer Gill posted what amounts to a storyboard of gun- and knife-toting self-portraits to his blog at vampirefreaks. com, before engaging in a shooting spree at Montreal's Dawson College. Only a few weeks later, Sebastian Bosse, whose website portrayed him as a military hero/trench coat–wearing avenger, shot up his high school in Emsdetten, Germany. Bosse took Gill's storyboarding technique one step further and published a vengeful and self-vindicating video on YouTube, which seems to have been inspired as much by Gill as by Travis Bickle, Robert DeNiro's character in *Taxi Driver*.

The story of Cho Seung-Hui follows the same general pattern, but as suggested by Andrew Stephen, Cho represents a new kind of technological antihero—one who rejects the ersatz hero games of online social networking and understands how to get straight to the bottom of our increasingly swampy media ecology:

> What singled out Cho Seung-Hui was that he was the first post-YouTube, Facebook, MySpace and IM disaffected youth of his kind—a product of 21st-century technology, rather than just that of the 20th. From his addiction to a ghastly, violent video game called Counter-Strike in his teens, he had moved on: he knew exactly how to produce 28 QuickTime video clips and 43 photos of himself, aware that by sending them to NBC, his first and last moments of stardom would not only reach the MM (as the mainstream media are nowadays derisively called by his generation), but would also be flashed around the world in seconds via YouTube and the like, allowing him to leave his own brief but indelible mark on history. Manifestly delusional though he may have been, he knew exactly how to look a camera in the eye and address it like a pro. (2007)

Cho's strategy of media manipulation reflects the existential motivation of many in his computer-savvy generation. To be significant, one must "make history," and history is made on television, where a captive audience shares a synchronized experience on the nightly news. Stiegler refers to this synchronization of culture by mass media as *psychotechnological programming*: "From the moment you adhere temporally to the same channel of information every day, 'meeting' at the same time, you adopt the same history of events as everyone who watches these broadcasts" (2009a, 61).

What many young people crave today is not the mundane, day-to-day recognition of "friends" and "contacts" on social networking sites. These extensions of the self can result in a crushing sense of loneliness as one discovers that the "inbox is empty," the "friends" aren't really present or committed, and

the messages sent out to the world have resulted in only a handful of anonymous "views" or "hits." The chronological progression from personal website to blog to YouTube as seen in the media artifacts of the school shooters outlined here merely charts an ever-shifting and increasingly seductive rehearsal stage designed to perpetuate an illusion of heroic recognition. These violent rehearsals of the self on proliferating, asynchronous social media networks are merely a staging for the ultimate performance. What the technocultural antiheroes discussed here understand is that the recognition achieved on social networks can be illusory and empty. Their megalothymia can be satisfied only by that rare and spectacular form of celebrity that only the "MM" can offer. Anything else is boring by comparison.

In his critique of Internet culture, Heideggerian philosopher Hubert L. Dreyfus (2001) suggests that the radical flexibility of identity offered by the Internet might be less of a liberating experience than it is a superhighway to boredom, or even nihilism. Like Mosco, Noble, and others, Dreyfus notes that certain enthusiasts of telepresence (from chat rooms to robotically facilitated surgery-at-a-distance) celebrate the idea that "we are on the way to sloughing off our situated bodies and becoming ubiquitous and, ultimately, immortal" (2001, 50). Although Dreyfus is writing before the advent of Facebook and YouTube, he seems to be on target in suggesting that the Internet can potentially foster ubiquitous communities of opinionated selves that are desperate for recognition and willing to reinvent themselves infinitely in its pursuit. But this search for recognition, Dreyfus suggests, lacks a ground in any material reality or local practices, and will thus only lead to disillusionment. Rooting his arguments in the philosophy of Kierkegaard, who was an adamant critic of uncommitted "coffee house politics," Dreyfus suggests that the net result of the Net is a widespread "flattening" effect, producing an extensive network of desperate, would-be heroes, who are "only too eager to respond to the equally deracinated opinions of other anonymous amateurs who post their views from nowhere" (2001, 79). A simple browse through Facebook today will reveal a populace of desperate individuals eagerly broadcasting their innermost thoughts and daily travails, as if to say, "Look at me! Acknowledge me! Make me your hero!" A culture of blogging, tweeting, and Facebooking is an ideal breeding ground for megalothymia, serving a generation (or two) reared on the promise of celebrity.

What is lacking in this disembodied culture, Dreyfus argues, is any real presence of "risk":

> Like a simulator, the Net manages to capture everything but the risk. Our imaginations can be drawn in, as they are in playing games and watching movies, and

no doubt, if we are sufficiently involved to feel we are taking risks, such simulations can help us acquire skills, but in so far as games work by temporarily capturing our imaginations in limited domains, they cannot simulate serious commitments in the real world. . . . The temptation is to live in a world of stimulating images and simulated commitments and thus to lead a simulated life. (2001, 88)

The achievement of heroism, as we have already seen in the work of Kojève, Becker, and Fukuyama, necessarily entails physical risk, the willful skirting of mortal danger for the sake of recognition. Social networking sites provide a relatively risk-free opportunity (even if we do include the associated risks of obesity and carpal tunnel syndrome) in which to achieve recognition, for example, by making bold and perhaps risky claims, or by taking on heroic postures.[17] But claims made in these simulated environments are not necessarily manifested off-screen, and hence there is relatively little at stake in being a "risky blogger." Likewise, computer games can simulate risk very effectively, but they cannot provide the intensity of risk experienced in the physical world when the body is situated in a precarious position, be it on the battlefield, on the city street, or in the classroom.[18] The death-by-gaming South Koreans mentioned in the preceding section, who discovered a way to make video game play physically risky, have achieved, perversely, what many gamers are really after: an authentic, embodied existential action. The same can be said for Cho, Bosse, and Gill, whose desire for recognition could only be satisfied offline, in the world of flesh and bullets.

Coda: Broken Toys

The only confirmed sighting of Brandon Crisp before his death was on a rail-to-trail path, three hours after he left home. The witness noted that Crisp appeared to be having trouble with his bicycle, which he abandoned soon after this sighting. This scene is worthy of contemplation: a hero exiled from his disembodied digital realm crouches dejectedly over his bicycle, helplessly confronting the inert and very palpable broken toy that had once propelled him forward. In Crisp's broken-down bicycle we observe the impossible reconciliation of a programmable world of data and pixels with a more stubborn and intractable world of steel, rubber, and oil.

The goal of this discussion has not been to suggest that role-playing games, social networking, and digitally broadcast mass media are to blame for the suicidal behaviors described here. Rather, I have attempted to illustrate, through

the use of high-profile examples, the role that media technologies play in the existential pursuit of recognition and death denial, as explored by Becker, Stiegler, Kojève, and others. Above all, this chapter asks the reader to consider the vulnerability of young people at the hands of a technoculture that makes a false promise of immortality. Of particular importance here is the question of how to ensure that the technocultural youth will recognize each other not as protocelebrities, but as beings who are linked by a shared vulnerability. As Judith Butler (2004) suggests in *Precarious Life,* vulnerability alone does not make us human; it is the "very recognition of vulnerability that matters," since "recognition wields the power to reconstitute vulnerability" in ways that determine, for example, what lives are and are not to be valued. Rather than offering the discussion of technoculture here as a "limited and limiting cultural frame" (Butler 2004, 89), my hope is that it will expand our understanding of the human animal. I agree with Butler's proposal, then, that we must continue to question the term *human* as a generative philosophical activity, in order to better understand "how it works, what it forecloses, and what it sometimes opens up" (2004, 88). It is to these questions that I will turn in the remainder of this book, by focusing on the ways in which death and technology are central to such topics as posthumanism, object-oriented ontology, and horror philosophy. Along the way, I will consider not only the vulnerability of the technical animal known as human but also the vulnerability of such things as circuit boards, canoes, and bicycles.

6 *CYCLE OF DREAD*

It is what a painter feels when the colors on the canvas begin to set up a magnetic tension with each other, and a new *thing*, a living form, takes shape in front of the astonished creator.

MIHALY CSIKSZENTMIHALYI, *FLOW: THE PSYCHOLOGY OF OPTIMAL EXPERIENCE*

I thought of that while riding my bike.

ALBERT EINSTEIN, ON THE THEORY OF RELATIVITY

Nostalgia

I am thirteen years old, sitting transfixed in front of a television tube on a hot August morning. My older siblings have summer jobs, so I'm all alone today. The windows are open and I can hear the muffled roaring of lawnmowers. This background noise, the sound of labor, gives me a faint pang of guilt, yet it's not enough to distract me entirely from the object of my attention: an Atari 2600 game called *Adventure*. I could be mowing the lawn or riding my BMX bike, roaming the suburban neighborhood of my small Canadian town, looking to turn uneven sidewalk slabs into ramps for jumping. But I was grounded from my bike for a week because I left it unlocked and it was stolen—and subsequently retrieved—by my father, who dragged the perpetrator, a repeat offender, before the court of his finger-wagging parents. That event was colored by the smell of spray paint. Today, playing *Adventure,* it is the smell of fresh-cut lawns and melting plastic. I have been here all morning, not really playing *Adventure* as much as playing with it. I mastered the game when it first came out a few years earlier. Now, returning to it with a sense of nostalgia, I am fascinated by its bugs. I lock the dragons in the castles knowing they'll

escape mysteriously. I position the bridge against walls and gain access to useless rooms, architectural glitches hidden on the borders of the game. The day passes quickly. I have averted boredom.

I am twenty-four years old, riding my steel-framed mountain bike to a cubicle at the University of Windsor, where I'm completing a master's degree in creative writing. Once settled in, I'm not really *doing* creative writing; I'm coding a Web page in HTML. The page contains a scanned image of Steven Gibb's painting *The Screan,* a surreal depiction of a slack body with a screen-shaped head. An airplane is careening in the background, frozen awkwardly in the sky. A daisy sprouts through a crack in the tarmac. My project is a collaboration with Gibb in which he paints an image and I transform it into an icon of postmodern theory. He even lets me invent the titles of his paintings. *The Screan,* transformed into a poetic imagetext, becomes an emblem of Baudrillard's terminal culture: human existence as an empty simulation of a disaster waiting to happen. I spend hours on the code, hyperlinking pixel coordinates in the digitized painting to a half-dozen Baudrillard quotes on separate pages, all with their own links to yet other pages. For twelve hours a day or more, I pass the time inserting bracketed tags, cutting and pasting header information into text documents, and uploading files to a UNIX server. I am more absorbed in the coding than I ever was in writing the thesis. Secretly, I don't really want to write about Gibb's paintings; I want to paint my own. I want to make a thing, and I think naïvely that I may have discovered how.

I am a thirtysomething father of two kids, playing *Jak and Daxter* on a Playstation 2 with my young son. As always, this boy whom I expertly taught to ride a bicycle is fascinated by my embarrassing lack of Playstation skills. Rather than groaning in complaint, he laughs when I confuse the buttons on the controller, punch instead of jump, and trip into a pool of *dark eco.* What does frustrate him, however, is that I am less interested in collecting power cells than I am in exploring the borders of the game world. On this day, I have been a good gamer, tempering my desire to run wildly along the beach in search of hidden lagoons. But then it happens. Without warning, I jump off a bridge in Sandover Village and plunge into the water. My son watches, stunned, as I stroke furiously in the blue void toward Misty Island. I could swim forever in this pool of polygons, but soon the sound of a heartbeat pulsates from the flat-screen television, accelerating at a frantic pace. I catch a terrifying glimpse of a shadow beneath me in the water. In a matter of milliseconds, the infamous "lurker fish" opens its huge mouth, lunges forward, and swallows me whole. Our avatars respawn immediately and reappear on the beach. My son

is relieved that this irrational adventure is over. But I rush manically back up to the bridge and jump again.

Now I am an eighty-year-old woman with a cane, bent and broken from a life of hard domestic labor. I stand at the gates of a cemetery, though I'm not sure how I got here. Carefully, I cross the threshold and enter, each jerky step an immense labor of locomotion. I try to rush, and my limp becomes more pronounced, my movements spasmodic and painful. At the end of the narrow lane there is a low wooden bench up against the back of a brick chapel with stained glass windows. I cross several pathways that intersect the lane to the chapel, but I don't follow them. It is too difficult to turn, and besides, these lanes will lead me out of sight. The bench is my only logical destination, and when I arrive, the birds are chirping loudly, clearly. I swear I saw one of them fly right through the wall of the chapel—my old mind must be playing tricks on me. I turn around slowly, painstakingly, and lower myself onto the bench. In a moment, I begin singing a song about cleaning the graves, and as if in a trance, I lose myself in the words, reminiscing about the people buried here. I sing in Flemish Dutch, because that is my language.

Renée, die had een vleesboom
Tante Mo is in haar slaap
Doodgevallen in een droom
En nooit meer opgeraapt
. . . .

Zoutzuur op arduin
Witte bubbels en geel schuim
Staalwol om het roest te wassen
Jaar en datum weg te krassen
En een beitel voor je eigen naam
Voor als we komen te gaan

Hier is het rustig, is het veilig
Misschien volgende keer
Volgende keer misschien, dan blijf ik
En dan ben ik hier niet meer
Niet meer

Renée, she had fibroids
Auntie Mo, while she was asleep,
Fell down into a dream

And was never picked up again

. . . .

Acid on granite
White bubbles and yellow foam
Steel wool to clean the rust
Scratch away the year and date
And a chisel for your own name
For when we come to go

Here is calm, here is safe
Maybe next time
Next time perhaps, I will stay
Then I'll be here no more
No more

This is a song of nostalgia, and here in this place, I have returned home. Soon, I will lower my head, drop my cane, and die on this bench.

Borders and Glitches

In a previous chapter, I cited Sherry Turkle's maxim that "as a computational object, the video game holds out two promises. The first is a touch of infinity—the promise of a game that never stops" (1984, 87). This maxim coincides well with one of the primary tenets of this book, which is that media technologies buffer us from the anxiety related to acknowledging our finitude. The second promise of the video game, "the promise of perfection," is betrayed by bugs and glitches such as those noted in the preceding section in the classic Atari game *Adventure*. These glitches allow players to explore phantom rooms beyond the borders of the game's architecture, a breaching of borders that is controlled in *Jak and Daxter,* for example, by the menacing "lurker" fish. The lurker is a common policing element in video game design; its sole purpose is to prevent players from falling off the edge of the gameworld and into a mess of polygons and pixels. But not all virtual worlds are immune to such off-game peregrinations. In her video installation *[borders],* Mary Flanagan (2010) explores the edges of shared, multiuser worlds for the sake of documenting the spaces in which such worlds break down, shattering the illusion of a seamless digital space. In Flanagan's words, "there appear to be seamless landscapes as far as the eye can see, appearing to some extent as the 'commons' of old. One can

find, however, and walk along invisible boundaries of ownership, breaking up the illusion of a cohesive landscape. In following the invisible virtual property lines separating one player's property from another, the walker may become stuck in stones, forced underwater or pushed teetering at the edge of the world" (2010). While Flanagan is interested primarily in how the project reveals "the limitations of virtual property ownership," her project also says a great deal about how games attempt to foster a deep sense of immersion, or "flow," which might also be considered as a buffering mechanism against the anxieties of human finitude.

Flanagan introduces [borders] on her website with a quote from Henry David Thoreau on the intellectual nature of walking: "Two or three hours' walking will carry me to as strange a country as I expect ever to see" (2007, 13, quoted in Flanagan 2010). Thoreau's discourse on walking is not just an ecocritical diatribe. In fact, it is as much about the degradation of the landscape at the hands of machine-based industry as it is about achieving a state of cognitive immersion through careful ambulation. "You must walk like a camel," suggests the American romantic, "which is said to be the only beast which ruminates when walking" (Thoreau 2007, 12). Thoreau's *Walking* is a tribute to the power of ambulation to provoke contemplation. What is ironic about Flanagan's citing of Thoreau is that the walks she documents in [borders] are not at all about achieving such a state, but explore instead those spaces where a virtual ambulator's sense of immersion is shattered. These moments of glitch disrupt what game theorist Jamie Madigan has called "an unbroken presentation of the game world," resulting in a loss of the player's immersion in the game (2010). Flanagan's [borders], like my own encounters with the borders of *Adventure* and *Jak and Daxter,* are exercises in the contemplation of finitude—exercises that fly in the face of Turkle's maxim that the video game holds out the promise of infinity. But these are encounters with the finitude of the game world, and not moments of contemplative death reckoning, which would require transforming something like *Jak and Daxter* into an existential game. What would such a game look like? What would it mean to build the contemplation of finitude directly into a genre that is judged by its capacity to represent an infinite game world? *The Graveyard* by Tale of Tales, which I invoke in the fourth technostalgic scenario at the opening of this chapter, might offer one possible answer.

The Graveyard is a first-person game with rich 3D graphics that portray an old woman who enters a graveyard, sits on a bench, sings a song, and dies— potentially. I write "potentially" because the death scene is available only to

those who are willing to pay $5 for the full version of the game. The very irony of this financial transaction—paying for the sake of turning an infinite game into one of dramatic finitude—reveals both the political and existential back end of *The Graveyard,* which challenges the very definition of a video game. On a review of *The Graveyard* written by Scott Jon Siegel (2008), one gamer with the screen name Shmil commented, "So what do you do? What's the conflict?" Yet another contributor named Spiritbeast quipped, "This game is severely lacking Falcon Punches, headshots, or lesbian space aliens. Very disappointing." In response to Chris Kohler's (2008) review of *The Graveyard* on wired. com, commenter Jake wrote, "There are games, and there is art. Sure games can be artistically beautiful and well designed to invoke emotion. But don't call something a game that is really just a fancy powerpoint presentation. Put the ego aside and make a game that's not an artistic statement where it doesn't belong. Art isn't usually fun-to-play." First, I would question whether *The Graveyard* is indeed "fun-to-play." But the point is that you do indeed *play* the game, as its creators insisted vehemently in a panel discussion we shared at a games colloquium in Montreal in 2011. In spite of the limited choices available in game action, the old woman is not an actor in a movie—she is an avatar in a computer game. Her physical movements must be controlled by the player, and there is no narrative without player interaction. By giving the player an avatar with severe constraints based on physical aging, Tale of Tales has indeed created a computer game, in both form and content, for the contemplation of finitude.

That is not to say that *The Graveyard* is without the kind of glitches that elicit finitude in the other games discussed here. When the old woman dies at the end of the game, it is easier to pay careful attention to the flight of birds in the graveyard. These birds add an element of realism to the game and improve its potential for immersion. As Jamie Madigan suggests, "multiple channels of sensory information" improve a game's immersive quality (2010). For example, "A bird flying overhead is good. Hearing it screech as it does so is better" (2010)—that is, until one of these birds flies directly through a stone wall, as it does in *The Graveyard.* This moment of "incongruity," as Madigan might call it, draws attention sideways to the thingness of the game. But in this case, it also focuses attention more poignantly on the mortality of the old woman, whose stillness and conspicuous embodiment contrast glaringly with the immortal flight of these digital sparrows. The glitch birds flying through the wall serve as a reminder that what the player is looking at is, after all, a digital artifact; but this does not buffer the game's lesson in mortality. In fact, the glitch birds juxtaposed with the limp body of the old woman may serve only to provoke mortality salience. In their "Post Mortem" of *The Graveyard,* artists

Auriea Harvey and Michaël Samyn suggest that they may have discovered a "new kind of landscape painting" (Samyn 2008). I would suggest that a more appropriate analogy would be that *The Graveyard* is like playing a poem—a *memento mori* or digital *graveyard poem* with pictures.

Play and Flow

Discussions of immersion in video games have been influenced by the concept of *flow,* borrowed from positive psychology. In *Flow: The Psychology of Optimal Experience,* positive psychologist Mihaly Csikszentmihalyi (1990) provides a broad overview of his highly influential concept. Flow, according to Csikszentmihalyi, is an optimal cognitive and emotional state achieved through engagement with challenging tasks appropriate to one's skill level. The diagram (Figure 4) indicates that flow involves charting a course away from apathy and between boredom and anxiety. Csikszentmihalyi sums up the characteristics of "optimal experience" as

Figure 4. Flow state as a measurement of Challenge versus Skill Level. Based on a graph from *Flow: The Psychology of Optimal Experience,* Mihaly Csikszentmihalyi (1990), p. 74.

a sense that one's skills are adequate to cope with the challenges at hand, in a goal-directed, rule-bound action system that provides clear clues as to how well one is performing. Concentration is so intense that there is no attention left over to think about anything irrelevant, or to worry about problems. Self-consciousness disappears and the sense of time becomes distorted. An activity that produces such experiences is so gratifying that people are willing to do it for its own sake, with little concern for what they will get out of it, even when it is difficult, or dangerous. (1990, 71)

This passage recalls the work of Ernest Becker, whose definition of culture as a "heroic action system" (1971, 78) suggests that cultures themselves are structured to provide individuals with opportunities to achieve "optimal experience." In this context, Csikszentmihalyi reminds us that "while flow is a powerful motivator, it does not guarantee virtue in those who experience it" (1990, 82). He makes his point by noting that the owners of southern plantations in the United States owed their experience of flow to the "labor of imported slaves" (82). The vast majority of Csikszentmihalyi's work, which at times reads more like a self-help manual than a scientific paper, is dedicated to understanding how flow might be channeled toward the development of virtuous individuals and societies. Unfortunately, his efforts seem to have been lost on the group for whom his work has been most influential: video game developers.

Csikszentmihalyi notes that games, with their shared incentives and clear rule-sets, "provide a compelling analogy to cultures, . . . [and] the difference is mainly one of scale" (1990, 81). Much of his work, in fact, focuses on the importance of play in everyday life, which makes his research particularly useful for enthusiasts of *gamification*. In a rigorous overview of research on flow and gaming, Ben Cowley, Darryl Charles, Michaela Blake, and Ray Hickey provide "a practical, integrated approach for analysis of the mechanics and aesthetics of game-play, which helps develop deeper insights into the capacity for flow within games" (2008, 2). Referencing the well-known *flow chart* invented by Csikszentmihalyi and reproduced in Figure 4, the authors suggest "it stands to reason that universal cognitive states are inherent in the flow experience, and if this is so then there must be certain types of universally accessible activity that pre-empt and enable these cognitive states" (12). This opens the floodgates for a flow-based (and value-neutral) understanding of game design based on a carefully patterned challenging of the player's skills and cognitive abilities. The authors' example of such a design is instructive:

For example, in a scrolling shooter game the pattern is that one faces and kills varieties of enemies that come in turn (generally with some overlap) until the end. New enemy types relate to previous types, and increase in power, which usually means the complexity of killing them increases. But the overall complexity of the task is ameliorated by the relation of new to old information, thereby (in a well-balanced game) producing that ongoing cyclic balance between (cognitive) challenge and skills so necessary for flow to occur. (24)

First of all, what the authors are suggesting is that flow, like the current of the Rhine, might be harnessed as a resource to create more enjoyable—and by extension more marketable—video games. This is ironic given Csikszentmihalyi's critique of "The Western mastery over material energy, . . . [which] runs the risk of turning everything it touches into a resource to be consumed as rapidly as possible" (1990, 103). Moreover, the authors' use of a violent first-person shooter (FPS) game to make their point ignores Csikszentmihalyi's insistence that flow activities should be considered within an ethical context, as part of a larger goal of living the Socratic *good life* of ethical virtue.

While, as Csikszentmihalyi suggests, both "Napoleon and Mother Theresa" achieved optimal experience in their lives, the conditions and outcomes of that experience are not without broader ethical implications (1990, 216). What's more, the achievement of flow by walking or running on a forest trail does not yield the same physical or psychological benefits as a 3D flyover in an FPS game. Flow achieved through physical activity, which is sometimes referred to as *being in the zone,* seems to free up the mind for contemplation, while flow achieved while playing a video game preoccupies the mind with game-related information. This hypothesis led to the design of a research experiment in the Critical Media Lab (CML) that involved comparing physiological and neurological data from participants who are either (a) engaging in a physical activity like running or cycling or (b) playing video games. As the experiment design ran into obstacles, especially the difficulty of measuring flow empirically, the CML's Visiting Artist/Researcher Dane Watkins suggested that the research question itself is provocative, and that it would make for a good digital art project. This suggestion led to the creation of *Cycle of Dread.*

Might it be possible to create a video game that provokes both optimal experience and an ethical contemplation of human finitude? Or more pertinently, recalling the preceding discussion of *The Graveyard,* is it possible to create a game that induces existential dread for the sake of self-knowledge, while still providing pleasure and possibly even optimal experience to the player? Admittedly,

Figure 5. "Critical Flow" as a measurement of Existential Dread versus Immersion

the question borders on the absurd, which became rather apparent when we remixed Csikszentmihalyi's famous *flow chart* to reflect our research interests (Figure 5).

What this chart, inspired by PowerPoint artist Luke Murphy, suggests is that playing an immersive video game is essentially antithetical to experiencing existential dread. As I suggested in chapter 5, playing a video game with an immortal avatar might actually serve as a buffer from existential dread. The sector of this chart identified as "interacting with critical media" informed the design of *Cycle of Dread*, which aimed to place participants in an existential/cognitive zone that would propel them to vacillate between existential dread and immersion in the procedures and narrative of a game. The project was conceived at first as a multilinear animation controlled by a user's heart rate and speed while riding on a stationary bike. En route, however, the project ran headlong into William Blake, and *Cycle of Dread* turned out to be less like playing a video game than like playing a digital graveyard poem. Such is the risk of having an English professor follow his compulsion to make a digital object-to-think-with.

Graveyard Poetry You Can Play

William Blake was in his late forties when the publisher Robert Cromek commissioned him to provide designs for a luxurious reprint of Robert Blair's poem "The Grave." For three years, Blake worked efficiently on the designs, and in November of 1805 Cromek issued a prospectus in which he advertised the project, noting that "The original Drawings, and a Specimen of the Stile of Engraving" were on display at his print shop. As Robert N. Essick and Morton D. Paley (1982) suggest, "the public reaction must have been no better than mixed" (19). This reaction was more a response to Blake's unique style of relief etching than it was to his drawings. In fact, Cromek kept Blake's designs, for which he paid one guinea apiece, and had them engraved by Luigi Schiavonetti, a popular line engraver from Italy. Blake lost the full commission, and Schiavonetti received as much as sixty guineas each for the engravings. To add insult to injury, after the publication of the work, Blake's designs were harshly criticized in both *The Examiner* and *The Anti-Jacobin Review.* Robert Hunt (1808) went so far as to call Blake an "unfortunate lunatic" in *The Examiner,* based on his assessment of *The Grave.* As Essick and Paley suggest, the events impacted Blake to such an extent that he produced very little work until 1813, making the post-Cromek years a time of "Deepening Neglect," to cite a chapter heading from Alexander Gilchrist's *Life of William Blake* (1982, 63). What these years did produce is a quirky notebook poem by Blake, never intended for publication. This fragment, which begins with the line "And his legs carried it like a fork," depicts Blake as Death, wreaking vengeful havoc on his enemies. In what Essick and Paley call "a paranoid episode in Blake's life" (1982, 29), the poet strikes out against Screwmunch (Cromek) and Assassinetti (Schiavonetti), both of whom died before the age of fifty.

The designs produced for Cromek, depicting bodies and souls in transition, as well as Blake's use of the word *fork* in his dreadful notebook poem, served as inspiration for *Cycle of Dread.* Rather than controlling the movements of an old woman in a graveyard, participants in this existential game ride a penny-farthing bicycle equipped with digital sensors and hardwired to a computer and an Arduino microcontroller. The player's cycling controls the movement and appearance of Blake's *The Death of the Strong, Wicked Man* as it flies across an outdoor surface. The long-forked penny-farthing was chosen over other, more conventional bicycle options because of its visibility and scale. *Cycle of Dread* was initially installed as a public art piece positioned on a walkway over the main street of Kitchener, Ontario, between a hotel and a fitness center. The large wheel of the replica antique cycle ensured its visibility from

street level, where passersby could see the cycle at the gym end of the walkway, and the strong wicked man's bed at the hotel end. As a participant pedaled the cycle, the wicked man's soul, projected onto the bridge from street level, flew across the bridge. The speed of his flight was determined by the speed of the cyclist, and his appearance changed according to changes in the cyclist's heart rate. For example, at a base heart rate of 70 beats per minute (BPM), the projection would show Blake's drawing; at 90 BPM, Schiavonetti's line engraving would replace the drawing; and at 110 BPM, the cyclist would see a digital pixellation of the drawing. The participant could observe these changes as the soul flew toward them across the walkway. The project was designed to combine flow-inducing physical activity with dread-inducing imagery that approached slowly from a distance and closed in on the cyclist.

Blake's drawing of *The Death of the Strong, Wicked Man* was chosen because it best exemplified some of the harsh criticism levied against his designs, much of which focused on his depiction of souls as embodied entities. As Essick and Paley suggest, this criticism is rooted in a "Cartesian separation of two realms of being" (1982, 26). To quote Robert Hunt's entry in *The Examiner,* Blake's work demonstrates the "vain effort of painting to unite to the eye the contrary natures of spirit and body, . . . which renders allegorical pictures so utterly insipid" (Bentley 1969, 196). Blake would later defend his desire to reunite spirit and body in his *Descriptive Catalogue* of 1809, noting, "A Spirit and a Vision are not, as the modern philosophy supposes, a cloudy vapour or a nothing: they are organized and minutely articulated beyond all that mortal and perishing nature can produce" (Erdman 1970, 532). Blake's conception of the unison of soul and body is most famously exerted in a passage from *The Marriage of Heaven and Hell:*

> The notion that man has a body distinct from his soul, is to be expunged; this I shall do, by printing in the infernal method, by corrosives, which in Hell are salutary and medicinal, melting apparent surfaces away, and displaying the infinite which was hid.
>
> If the doors of perception were cleansed every thing would appear to man as it is: infinite.
>
> For man has closed himself up, till he sees all things thro' narrow chinks of his cavern. (Erdman 1970, 39)

As Blake scholars such as Joseph Viscomi and others have suggested, this passage demonstrates that Blake's philosophy of embodied ensoulment was integrally related to his practice of relief etching, which involved painting with

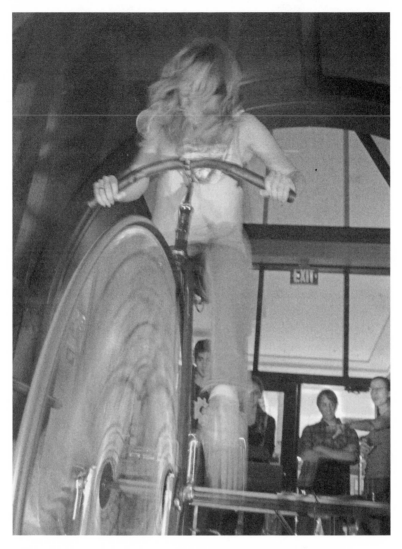

Figure 6. *Cycle of Dread* participant. Kitchener, Ontario, 2009. Courtesy of Corinne Torrachio.

acid-resistant ink on a copper plate and then pouring acid over the plate to "reveal the infinite which was hid" (Erdman 1970, 39). I have discussed this procedural component of Blake's work elsewhere (O'Gorman 2006, 59-62). What I wish to point out in this context is that by refusing to accept Blake's engravings for *The Grave,* Cromek was violating Blake's artistic philosophy, in

which designing and engraving, content and form, were part of a unified practice and philosophy.

A fair criticism of *Cycle of Dread* would be that the project was rather baroque in the end, an overwrought allegory that attempts an assemblage of romantic mysticism, the psychology of optimal experience, graveyard poetry, embodied souls, an abandoned walkway, an Arduino microcontroller, biofeedback sensors, and a penny-farthing bicycle. That said, participants who pedaled the cycle did indeed report that if nothing else, it was "fun-to-play." The baroque and analogical quality of this project is a typical result of applied media theory, which, as I will explain in chapter 7, is more akin to philosophical writing than it is to coding, drawing, engraving, painting, or sculpture. As Barbara Maria Stafford (2001) suggests in *Visual Analogy,* "Analogy's comparative drive to map across knowledge systems is also helpful in conceptualizing the myriad ways in which the psyche suffers dislocations requiring the reintegration of disconnected components into a whole" (142). Maybe the "disconnected components" of *Cycle of Dread* are such that in the end, the work is neither a public art piece nor a psychology experiment, but more of a complex romantic analogy. Better yet, *Cycle of Dread* might be understood as an evocative object, an object-to-think-with that can be carefully disintegrated to explore the relationship between human finitude and immersion in technocultural artifacts. The interactive, sensor-based component of this project raises questions not only about the interrelatedness of soul and body but also about the interrelatedness of human bodies and the environments and objects with which they coevolve.

7 SPECULATIVE REALISM UNCHAINED

A Love Story

Agency is, I believe, distributed across a mosaic, but it is also possible to say something about the kind of striving that may be exercised by a human within the assemblage. This exertion is perhaps best understood on the model of riding a bicycle on a gravel road. One can throw one's weight this way or that, inflect the bike in one direction or toward one trajectory of motion. But the rider is but one actant operative in the moving whole.

JANE BENNETT, *VIBRANT MATTER*

How can I convey the perfection of my comfort on the bicycle, the completeness of my union with her, the sweet responses she gave me at every particle of her frame? I felt that I had known her for many years and that she had known me and that we understood each other utterly. She moved beneath me with agile sympathy in a swift, airy stride, finding smooth ways among the stony tracks, swaying and bending skillfully to match my changing attitudes, even accommodating her left pedal patiently to the awkward working of my wooden leg.

FLANN O'BRIEN, *THE THIRD POLICEMAN*

AT THE 2009 CONFERENCE of the Society for Literature, Science and the Arts (SLSA), I delivered a paper designed to investigate the meaning of the shift from the cyborg to the animal in posthumanist philosophy. This shift is evident in the archives of SLSA panel titles, and is registered most palpably in the broad arc that can be traced from Donna Haraway's championing of the cyborg (1991) to the French-kissing session with her dog that introduces *When Species Meet* (2007). I opened the talk with a reprogramming of this intimate scene, a poem of sorts designed to provoke fellow delegates on an animal

studies panel. Ultimately my ruse was to ask, "Why stop at the animal? Why not consider insects, trees, even rocks as objects of posthumanist speculation?" W. J. T. Mitchell (2003) asked this very question in his foreword to Cary Wolfe's *Animal Rites*. What both Mitchell and I had failed to realize is that this posthumanist shift from cyborg to animal to "things" was already well underway; it was underscored at the conference by a series of panels on Whitehead and a keynote address by Ian Bogost (2012) titled "Alien Phenomenology." Bogost's radical speculation delivered in earnest what I was attempting to deliver as rhetorical irony. My attempted provocation, then, was not radical at all. Still, I would like to revisit my deironized text entitled "Requiem for the Cyborg" in order to rescue its grounding concept about the trajectory of posthumanist philosophy.

Following my previous discussion of human motivation inspired by Ernest Becker, I have suggested that posthumanism would ultimately land in the world of things, and this would be driven by (a) a desire to *connect with* and be *recognized by* the nonhuman world in ways that ignore the lessons of poststructuralism and (b) a romantic wonder about the infinite and *death-defying* worlds of nonhuman things. The operative word here is *romantic*, for indeed, romance is what drives this attraction to the cyborg, the animal, and more recently, the inorganic thing. And by *romantic*, I not only mean the literary genre; I am unabashedly talking about love. This chapter deals with death and finitude, but most of all it is concerned with love, and more specifically, posthumanist love.

As I have already argued, an understanding of the human as a *technical animal* threatens what Ernest Becker might have called the cultural hero system of liberal humanism. The idea that humans are always-already technical animals, defined primarily by their prostheticity, by the things with which they coevolve, poses a terrifying threat to belief systems that posit the human as an autonomous being with mastery over so-called *nature*. Philosophical pursuits such as speculative realism (SR) and object-oriented ontology (OOO) consider the full implications of what it means for humans to be a thing like any other thing. What I would like to propose is that these philosophies, in spite of their willingness to unseat the human being from its privileged position among species, partake in many of the anxiety-buffering tactics that are common in technoculture, including an embrace of infinitude and a desire for recognition that goes so far as to identify with everything from moonbeams to the color red. These philosophies, which I describe as technoromantic (Coyne 1999), only serve to entrench the human animal's identity as a being that is desperate to both deny its finitude and achieve recognition. OOO, like other cultural hero systems, achieves these goals through a complex and

sophisticated reliance on symbol systems, which in this case means philosophical discourse.

Requiem for the Cyborg

Mikado continues to colonize all my cells—a sure case of what the biologist Lynn Margulis calls symbiogenesis. I bet if you were to check our DNA, you'd find some potent transfections between us. We inhabit not just different genera and divergent families but altogether different orders. Yet I can't resist the feel of him nestling deep in my sensitive backside. Together, generating galvanic friction, we've worn out the crotch of many a pair of black Levi's.

I've had to tether him outside my lab, where he waited patiently as I taught a class in such worn jeans, pantlegs stained with dirty lubricant. I've also had to leave him in suspense, behind the locked doors of an old shed, vulnerable to the dilations and contractions of a Canadian winter. These thoughts trouble me.

How would we sort things out? Biped, bipedal; workingman, workhorse; saddle-weary rider, seasoned courser. One has a photo ID Ontario Driver's license; the other has a serial number etched on his underside. One has an Irish name in spite of his French descent; the other has a Japanese name but cannot trace his origins beyond Canada.

One of us, product of a complex organic assemblage, is called "white male." The other, product of an intricate inorganic assemblage, is called "bicycle." Each of these names designates a different racial and gendered discourse, and we both inherit their consequences in our bodies.

One of us is too old for adventure racing, but denies it in spite of himself; the other is visibly rusty, but still runs like a well-oiled machine. And we race together on rough trails at the county landfill where Mikado will surely be laid to rest some day, each outing bringing him closer to this demise.

I'm sure our genomes are more alike than they should be. Some molecular record of our touch in the codes of living will surely leave traces in the world, no matter that we are each reproductively silenced males, both fixies.

We have given each other scars, worn each other down. Mikado has intruded deeply into my flesh, with all its eager immune system receptors. Who knows where my chemical receptors carried his messages or what he took from my cellular system for distinguishing self from other and binding outside to inside?

Mikado is quick to shriek and squeal if I push too hard, and has thrown me to the ground in response to poor handling. We have had forbidden conversation; we have had rectal intercourse; we are bound in telling story on story with nothing but the facts.

> We are training each other in acts of communication we barely understand. We are, constitutively, companion species. We make each other up, body to body, broken-down frame to broken-down frame. Significantly other to each other, in specific difference, we signify through our bodies a nasty developmental infection called love. This love is a historical aberration and a naturalcultural legacy.

This plagiaristic reworking of Haraway's text marks a turn from the animal to the thing in posthumanist speculation. In short, anything Haraway can say about her dogs, I can say about my bike, with no less care or concern, no less love.[1] We might label this passage as fetishistic, vitalistic, animistic, or anthropomorphic. It is perhaps all of these things, but above all it is an act of empathetic imagination, a generative text designed to provoke thought about the relationship between humans and things, or more radically, about humans *as* things. The text is an "evocative object," to borrow once again from Sherry Turkle. For the moment, let's stay seated on the bicycle, ever-chased by Haraway's dog, and consider what it means to shift gears from animal to inorganic thing in posthumanist thought.

In *When Species Meet,* Haraway (2007) notes the common misconception that "when people hear the term *companion species,* they tend to start thinking about 'companion animals,' such as dogs, cats, horses, miniature donkeys, tropical fish, fancy bunnies, dying baby turtles, ant farms, parrots, tarantulas in harness and potbellied pigs" (17). This list, despite its heterogeneity, is too delimiting in Haraway's view, which posits that the term *companion species* should be considered less "a category than a pointer to an ongoing 'becoming with,' . . . a much richer web to inhabit than any of the posthumanisms on display after (or in reference to) the ever-deferred demise of man" (17). It takes very little imagination, then, to add a bicycle to Haraway's list of companions. Such a shift in gears toward the inorganic, yet another strategy for decentering the *speciesist* human subject, characterizes the recent growth of SR philosophies and OOO. But the shift could not be accomplished without love, a love that is apparent both in the recital of a list ("ant farms, parrots, tarantulas in harness") and in the concept of "becoming-with."

For the collector of things, the list is an object of love. It is at once an indicator of finitude (here's what I have) and infinity (here's what I desire). Just as importantly, it is an indicator of possession (this is what I own, this is what I know). Ian Bogost (2009) has coined the term *Latour litany,* inspired by Bruno Latour's "parliament of things," to describe this tendency toward listing in posthumanist philosophy. The list, Bogost suggests in his blog, "underscores the rich diversity of things" in a way that cannot be accomplished with ordinary

narrative logic and syntax (2009). Bogost owes his own list-obsession more to Graham Harman than to Bruno Latour. Harman's litanies are a key rhetorical device in his OOO, as evidenced in the following passage, which sums up the entire thesis of his book *Tool Being:*

> Inanimate objects are not just manipulable clods of matter, not philosophical deadweight best left to "positive science." Instead, they are more like undiscovered planets, stony or gaseous worlds which ontology is now obliged to colonize with a full array of probes and seismic instruments—most of them not yet invented. . . . Instead of aloof reflections on the enframing mechanisms of technology, it ought to be possible to discuss subways and radio telescopes. And enough with clever references to the "dice throw" as an avant-garde literary image: dice and slot machines and playing cards *themselves* should be our theme—as should fireworks, grasshoppers, moonbeams, and wood. (2002, 19–20)

What the list achieves for both Harman and Bogost is the microrepresentation of an infinity of things jostling up against one another, "rubbing shoulders," as Bogost puts it, in a fractal dance of becoming: "It happens fast and hot, the universes of things bumping and rubbing against one another in succession, chaining together like polymers" (2009, 25). The overt eroticism of this statement reveals the truth: in the final analysis, OOO is a "fast and hot" love story.

To Bogost's chaining of polymers we might link Jane Bennett's use of the term *assemblage,* borrowed from Deleuze and Guattari. The concept of assemblage challenges notions of phenomenological verticality or speciesism, permitting Bennett to "rattle the adamantine chain that has bound materiality to inert substance and that has placed the organic across a chasm from the inorganic" (2010, 57). Bennett's avowal of love rings clear in her commitment to an ethics of caring concern, which unfolds in her assemblages of human and nonhuman actants, assemblages that call for increased attention to and responsibility for the materiality of being:

> I am a material configuration, the pigeons in the park are material compositions, the viruses, parasites, and heavy metals in my flesh and in pigeon flesh are materialities, as are neurochemicals, hurricane winds, E. coli, and the dust on the floor. Materiality is a rubric that tends to horizontalize the relations between humans, biota, and abbiota. It draws human attention sideways, away from an ontologically ranked Great Chain of Being and toward a great appreciation of the complex entanglements of humans and nonhumans. (2010, 111–12)

Whereas Bogost's lists allow him to luxuriate in speculative ruminations on the infinite modalities of being, Bennett's horizontalizing ontology is a

vehicle for ecocritical care. In spite of these rather different uses for OOO, both are invocations of love. In response to Bennett's romantic confession of an "irrational love of matter" (2010, 61), we have Ian Bogost's orgiastic pronouncement that "anything is thing enough to party" (2012, 23). But neither of these invocations confesses with honesty to the fast and hot eroticism that is at play in the groping and coming, the grouping and becoming of SR. It's time to get seriously horizontal.

Haraway's make-out scene with her dog is emblematic of the erotic thrust of posthumanist philosophy and its desire to make contact with nonhuman others. This desire, as Bogost demonstrates, is being pursued to pornographic extremes in a contest of unchained empathy that assigns agency to increasingly exotic or "alien" nonhuman entities. At its worst, this contest reeks of an anthropocentric colonization, albeit unwitting, as in Graham Harman's will to "colonize" inanimate objects "with a full array of probes and seismic instruments" (2002, 19). Harman's choice of words speaks for itself here, revealing a colonial and phallogocentric drive that threatens to undermine the otherwise posthumanist, postgender, postsubject bent of object-oriented ontology. In this boys' club context, Bogost's term *unit operations* takes on a whole new phallic meaning. At times, in OOO and SR the *unit* seems to be running the show for a philosophy of sublimated desire.

At the other end of the spectrum, marking the obscene terminal point of OOO, and well before Bogost's creative intervention, is Mario Perniola, who describes his erotic ontological aphorisms as a form of "speculative extremism" (2004, 1). Perniola, lifting the veil on the erotics of SR, pushes to obscenity the desire for contact with the inorganic. Inspired by Walter Benjamin's description of the anthropomorphic drawings of plants and clothes rendered by Grandville, Perniola's speculation takes root in the "sex appeal of the inorganic" (3). As Benjamin suggests in his *Arcades Project*, by pushing fashion "to its extremes" Grandville "revealed its nature," and that nature involves human desire, inorganic matter, sex, and death (Benjamin 1999, 79). Fashion, in Grandville's cosmology, "prostitutes the living body to the inorganic world. In relation to the living it represents the rights of the corpse. Fetishism, which succumbs to the sex appeal of the inorganic, is its vital nerve" (1999, 166). Yet it is essential not to confuse fetishism, via Marx and Freud, with the sex appeal of the inorganic. Perniola is not after a Marxist critique of speculative phenomenology (a project that would certainly be worth pursuing); rather, by forcing such speculation to its extreme, he reveals its sensual and especially erotic underside. All that rubbing together of "the stuff of being" (Bogost 2012, 27) documented in the work of Harman and Bogost and those vibrant "entanglements"

(Bennett 2010, 112) of organic and inorganic matter in the work of Jane Bennett, Timothy Morton, and Levi Bryant reveal a universe of becoming determined by the sense of touch, or put more plainly, a "world of things that feel" mobilized by the sex appeal of the inorganic (Perniola 2004, 44).

Perniola's positioning of sex appeal at the core of a speculative exercise, an exercise that is less pornographic than it is *pornohaptic,* is perhaps best explained on his own terms, quoted here at length so that the reader can witness the erotic foreplay in Perniola's rhetoric:

> Lie down in a state of absolute rest with your eyes closed as if you were dead. You are deaf, mute and blind and you remain like this despite any appeal, incitement or solicitation. Of all the senses only the sense of touch is left but you cannot exercise it actively. All your attention is concentrated on what brushes against you, touches you, feels you and only on the basis of this pressure are you able to picture the form and the shape of the hands that touch you and caress you, that penetrate into the folds and into the cavities of your flesh. You have never seen, or heard anything, or know the meaning of the silent question of what plods panting over you. Also, all reaction or reflex is precluded to you. You must not give any sign of life, or laugh if you are tickled, or utter moans, cries, or react minimally to any stimulation that becomes progressively more intrusive, that persists in provoking a reaction, that does not withdraw but attacks those parts that they imagine are the most sensitive. (2004, 34)

What might otherwise look or feel like a horrifying masochistic act of submission is not viewed by Perniola as violent in any way, except in challenging the ontological stability of the human being. Perniola's inorganic things, which include human things, are not "manipulable clods of matter" (Harman 2002, 19); rather, the relationship between things here is a matter of "interpenetration," of haptic relationality within the "unlimited space opened up by the disappearance of the subject" (Perniola 2004, 44). Perniola notes that "this faked death . . . is without frigidity. Your abandonment does not exclude: on the contrary it implies that whoever devotes himself to you will move your legs, open your mouth, lift your head if he wishes" (2004, 34). The sex appeal of the organic lays bare the horizontality of posthumanist thinking, which is ultimately a discourse of radical empathy, an openness to promiscuous intercourse, linking, joining together—a discourse of copulation.

Discourse—more specifically, philosophical discourse—is truly what is at stake here. Recalling Perniola's image of the thing in submission, it is essential to note that "flat ontology," as Manuel DeLanda and Levi Bryant have called it, requires a certain suspension of subjectivity, an end to what Perniola calls

the "orgasmomania" of contemporary philosophy. But this does not mean an end to sex, an abstention or ascesis, which is how one might describe the philosophy of Heidegger, whose prophylactic logic fails to shelter him from the sex appeal of the inorganic. According to SR, try as you might to resist, there is no choice but to rub and jostle against other things in the infinite, fractal, horizontal orgy of being. What Perniola suggests, without reserve, is that the orgy is reserved for philosophers, for those who are able to fully give themselves over to the inorganic. It is here, in his description of "philosophical-sexual cyborg," that Perniola pushes OOO to its breaking point:

> When you find the realization of the Cartesian thing that feels in the cunnilingus or in the fellatio of your partner, when you notice in the coherent and rigorous unfolding of philosophic prose the inexorable movement that brings you to lick the cunt, the cock or the arse of your partner who has become a neutral and limitless extension of cloth variously folded, when you yourself are able to offer your body as a desert or a heath so that it can be traversed by the detached and inexorable examination of the eye, the hands and the mouth of your lover, when nothing else interests you or excites you or attracts you besides repeating every night the ritual of the double metamorphosis of philosophy into sex and sex into philosophy, then, maybe, . . . you have celebrated the triumph of the thing over everything, you have led the mind and the body to the extreme regions of the non-living, where, perhaps, they were always already directed. (2004, 16)

Here, OOO is laid bare, revealed not as an ontology at all but as discursive technics, philosophical calisthenics, a sort of Kegel exercise designed to improve the quality of human intercourse with things. In this sexual-philosophical encounter, a radical objectification of the human is chained to an equally radical subjectification that can only be manifested in and through philosophy. What Perniola's scene of intercourse reveals is that ultimately, extreme speculation of the brand described in this chapter may not be rooted in physical eros at all, but in language, in a philosophical intercourse akin to Socrates's understanding of love in *Phaedrus*. Above all, this scene of copulation between humans freed of subjectivity, this "metamorphosis of philosophy into sex and sex into philosophy," reveals a veiled desire for unity and holism, for a perfectly transparent communication, a philosophical interpenetration that, properly understood, is closer to poetry than it is to philosophy, and more about love than it is about sex.

It is time to confess that thus far, I have been rather unrigorous with my use of the term *love*. I have identified a potential erotic undercurrent in the work of SR thinkers. But eros is not the only type of love that characterizes the work

of SR and OOO; it is simply the most obvious manifestation of a love for objects that might also be characterized as both *philia* (love by filiation, brotherly love serving mutual goals) and *agape* (self-effacing, Christian love, selfless love such as that professed in the gospels). As I noted in the first paragraph of this essay, in his introduction to Cary Wolfe's book *Animal Rites*, W. J. T. Mitchell unwittingly gestures toward the OOO phenomenon in a statement designed to be a provocative exaggeration: "Let us suppose, finally, that all these issues have been worked out and the rights of all animals, high and low, have been established. Would that be the end? Or would it then be time to turn to the rights of fruits and vegetables? Erasmus Darwin noted long ago that 'the loves of plants' are essential to their lives. Does that give them a claim to some sort of rights?" (2003, xi). What Mitchell is attempting to do here is distance Wolfe's philosophical project from the "self-indulgent breast-beating that encourages moralistic, sentimental posturing while doing nothing to change the lot of animals" (x). Animals have the potential, in Mitchell's mind, to be the "latest candidates in an endless procession of victims—women, minorities, the poor—clamoring for rights and justice, or just a modicum of decent treatment" (x). To illustrate how this procession might extend to plants and then inanimate objects, Mitchell quotes William Blake's anthropomorphic poem "Ah! Sunflower." Mitchell's choice of William Blake as a precursor to posthumanism is incredibly apt. Had he quoted Blake's "The Clod and the Pebble," he would have demonstrated even greater foresight about the philosophical turn toward objects that was to follow animal studies. For this is a turn rooted in love. With that, I include the voices of Blake's clod and pebble here in full to further develop the love story that is OOO:

"Love seeketh not itself to please,
 Nor for itself hath any care,
 But for another gives its ease,
 And builds a heaven in hell's despair."

So sung a little Clod of Clay,
 Trodden with the cattle's feet,
 But a Pebble of the brook
 Warbled out these metres meet:

"Love seeketh only Self to please,
 To bind another to its delight,
 Joys in another's loss of ease,
 And builds a hell in heaven's despite." (Erdman 1970, 19)

In this poem of contraries, typical of Blake's *Songs of Innocence and Experience,* we see divergent perspectives on love: one *innocent* and the other *experienced* to the point of cynicism. The first love illustrates the very well-known concept of *agape,* selfless Christian love. The second love, on the other hand, might be identified as *philia,* which in *Nicomachean Ethics* (Book VIII) Aristotle describes in terms of a business transaction, a relationship of utilitarian, mutual enjoyment. Perhaps both of these loves are present in the work of Bennett, Bryant, Harman, Bogost, and others. Bennett's vitalist, ecocritical materialism seems motivated by a Christian ethics, a version of "love thy neighbor as thyself" that includes as neighbors pigeons, hurricane winds, and E. coli, among other vibrant things. Bogost's love, on the other hand (and we should remember Perniola here as well), which revels in the "chaining together" of tiny universes, seems to "bind another to its own delight" for the sake of generating a radical ontology. Mitchell could not have predicted that even Blake, in his conspicuous anthropomorphism, could not match the extremes to which OOO would go in its proclamation of philial love for objects. If you were to throw Blake's clod into the warbling brook and watch it disperse into myriad individuated particles, then you would have a better sense of the love sickness that is OOO.

The term "love sickness" brings to mind Socrates's discourse on love in *Phaedrus,* as mentioned briefly earlier in this section. Of central interest here is Socrates's description of the four forms of madness, the fourth being mad love, which he defends as a divine state of being, the lover's glimpse of a once-unified body and soul manifested in the beautiful object of love. In his defense of the mad lover, Socrates introduces the term *anteros,* a counter-eros that binds *philia* and eros together in a mutual and self-reflexive eroticism:

> And thus he [the mad lover] loves, but he knows not what; he does not understand and cannot explain his own state; he appears to have caught the infection of blindness from another; the lover is his mirror in whom he is beholding himself, but he is not aware of this. When he is with the lover, both cease from their pain, but when he is away then he longs as he is longed for, and has love's image, love for love *(Anteros)* lodging in his breast, which he calls and deems not love but friendship only, and his desire is as the desire of the other, but weaker; he wants to see him, touch him, kiss, embrace him, and not long afterwards his desire is accomplished. (Plato 2007, 117)

The mutual love of *anteros* emerges when both lovers recognize beauty—in its Platonic, prelapsarian ineffability—in one another. As John Durham Peters (1999) suggests in *Speaking into the Air,* "Sexual desire thus is not demeaned

as base by Socrates but considered an intimation of cosmic homesickness" (44). There is perhaps some of this cosmic homesickness in the work of OOO and SR, and I will suggest that it allows us to chain together Plato, the Romantics, and OOO, which are all bound by a desire for holism, unity, and the overcoming of impossible barriers to communication.

Peters's wide-ranging examination of communication takes him from Plato's dialogues to the gospels of the New Testament, to nineteenth-century mystics, and finally to contemporary electronic media. All of these attempts at communication, he suggests, from Plato's dialogues to SETI's (Search for Extraterrestrial Intelligence) extraterrestrial hailing, are emblematic of the human desire to overcome the "gap between sending and receiving" (1999, 151). In spite of what might be described as Peters's hasty dismissal of poststructuralism, he provides another way of understanding OOO as an attempt to regain a lost unity, a wholeness that has been the work of poststructuralism to unravel and debunk. The work of both psychics and SETI, Peters suggests, deals "with the most poignant human concerns: mourning, cosmic loneliness, contact with the dead and distant (psychical research) or alien and distant (SETI). Both are moved by faith in the other's existence without the ability to take hold of a sure connection. Both imagine a universe humming with conversations we are unable, for whatever reasons, to tap" (1999, 248). The more alien and distant the other we attempt to contact, the greater the act of love, the greater the potential for proving a cosmic unity that binds all things. In Peters's words, "empathy with the inhuman is the moral and aesthetic lesson that might replace our urgent longing for communication" (1999, 248). Seen in this light, Bogost's *alien phenomenology*, within which even the Roswell alien might "rear its head" (2012, 133), can be seen as a philosophy of empathetic imagination, of love, driven by cosmic loneliness and a desire to be recognized by and connect with a seemingly inaccessible universe.

This desire can be described as romantic in both the literary and amorous sense of the word, and it is thus nothing new or provocative. As Julia Martin argues, Blake's philosophical cosmology, in which "every particle of dust breathes forth its joy" (*Europe,* lines 8–19), requires "acts of imaginative identification that are involved in sympathy or love or compassion" (Martin 2003, 60). In an uncanny echo of Jane Bennett's work, Martin suggests that the romantic identification with things as exemplified in Blake's work emerges from a view of the cosmos as an "interdependent network of care," which calls for awareness about ecological issues, in all their political and philosophical complexity (53). To put it in Blake's own words, "How do you know but ev'ry bird that cuts the airy way / Is an immense world of delight, closed by your senses five?" (1995, 35).

It does not take a suspension of disbelief to see a trace of romanticism in OOO. Jane Bennett's battle cry to "rattle the adamantine chain that has bound materiality to inert substance" (2010, 57) would be perfectly at home in the works of Blake or Coleridge. And Bogost's desire to flee "from the dank halls of the mind's prison toward the grassy meadows of the material world" is conspicuously reminiscent of Blake's desire in *Marriage of Heaven and Hell* to open the "doors of perception" so as to liberate man, who has "closed himself up, till he sees all things through narrow chinks of his cavern" (1995, 39). Blake's goal was to flee the *Single Vision* which he, like Bennett and Bogost, "identified in the reductionist gaze of eighteenth-century rationalism" (Bogost 2012, 62). The philosophers of OOO could easily adopt Los's motto from Blake's poem *Jerusalem:* "I must Create a System or be enslav'd by another Mans" (1995, 153).

It may be more accurate to view certain strains of OOO and SR not as a romantic ideology, but more specifically as *technoromantic,* following in the footsteps of anti-institutional champions of technology such as Stewart Brand, Michael Heim, and Howard Rheingold. In "Cyberspace and Heidegger's Pragmatics," Richard Coyne (1998) identifies a distinctly romantic ethos in rhetorics about technoculture, one that would lead him to coin the term *technoromanticism:* "The dominant ethos is now romanticism: a focus on subjectivity, a new metaphysics of proximity, a revival of the early socialist dream of community, a disdain for the constraints imposed by the body, embracing the holistic unitary patterning of chaos theory, the representation of the object world, a hope for its ultimate transcendence through the technologies of cyberspace, and a quest for a better, fairer more democratic future" (349). OOO unquestionably shares many, if not all, of these characteristics, except of course that its hope for transcendence derives not from pondering the infinity of cyberspace but from pondering the infinite possibilities of object being. It is fitting, then, and not at all random or coincidental that the term *object-oriented,* reclaimed for philosophy by Graham Harman, comes from computer science. Just as OOO provides an outlet for mourning the lost unity of language after poststructuralism, it also provides an opportunity to assume a technoromantic ethos after the debunking of emancipatory cybernarratives, from Stewart Brand's hippie hacker heroics to Heim's erotics of cyberspace, to the idealistic claims of George P. Landow and other hypertext theorists of the 1990s. I will leave this evocative genealogy from cyberrhetoric to OOO for another study. To avoid straying too far from the subject of this chapter, I would like to focus on yet another tradition from which OOO emanates, further demonstrating its status as a philosophy for lovers.

Given the romantic tendencies of OOO and SR, it is no surprise that *Alien Phenomenology* ends with an essay on the importance of injecting *wonder* into contemporary philosophy. Citing Graham Harman, Bogost writes that "wonder is a sort of *allure* that real objects use to call at one another through enticement and absorption. . . . Wonder is a way objects orient" (2012, 125). This is a philosophy shared by many in the field of ecocriticism, which forthrightly accepts its genealogy of romantic thought. As David Sander (2000) suggests, "it is precisely in the moment of wonder that the imagination is challenged to understand and apprehend the environment, opening a space in literature for the negotiation of the human and the nonhuman" (286). Of course, Bogost is writing philosophy, not "literature," and his work can scarcely be labeled as ecocritical. Still, though he is well aware that his attempts to inhabit the "native logics" of a "flour granule, firearm, civil justice system, longship, fondant" (Bogost 2012, 125) are merely instances of "speaking into the air" (as Peters would put it), Bogost nevertheless pursues his project as a defiance of the "tradition of human access that seeps from the rot of Kant" (4). As Bogost suggests, "metaphysics need not seek verification, whether from experience, physics, mathematics, formal logic, or even reason. The successful invasion of realist speculation ends the reigns of both transcendent insight and subjective incarceration" (5). This language recalls not only the emancipatory rhetoric of Blake's poetry but also, and in an uncanny way, the poetics and philosophy of André Breton. As forecast by the dizzying juxtaposition of found objects in the work of OOO and SR—the meeting of a flour granule and firearm on an operating table—the reification of "wonder" about the universe of objects is not only typically romantic but also a cornerstone of surrealist philosophy and aesthetics.

Perhaps the best place to trace a link between surrealism and OOO is in Breton's (1987) quirky book *Mad Love,* in which he introduces the concept of "objective chance," exemplified by the shared discovery with Alberto Giacometti of evocative and erotic objets trouvés at a flea market in Paris. In Breton's words, "the finding of an object serves here exactly the same purpose as the dream, in the sense that it frees the individual from paralyzing affective scruples, comforts him and makes him understand that the obstacle he might have thought insurmountable is cleared" (32). Of special importance to Breton is that the objects found at the flea market were discovered *together,* by both him and Giacometti. The found object therefore achieves something that the dream cannot: a mutual experience that Breton describes as a sudden atmospheric condensation, "producing flashes of lightning" (33). This condensation, achieved by an object mediating between humans, is at once Platonic,

romantic, and surrealist, exhibiting a desire for contact and unity. Here, as Richard Coyne suggests, Breton also exhibits a prescient desire for the "holistic unitary patterning of chaos theory" (Coyne 1998, 249): "It is as if suddenly, the deepest night of human existence were to be penetrated, natural and logical necessity coinciding, all things being rendered totally transparent, linked by a chain of glass without one link missing. If that is simply an illusion, I am ready to abandon it, but then it must be *proved* an illusion. Otherwise, if, as I believe, it may be the beginning of a contact, unimaginable dazzling, between man and the world of things, I believe we should try to see the major characteristic of that contact, and try to bring about the greatest possible number of such communications" (Breton 1987, 40). Breton's mad love shares with OOO an object-oriented metaphysics that "need not seek verification," a metaphysics that unchains him from the shackles of "subjective incarceration" (Bogost 2012, 5). It may seem counterintuitive to mount a philosophy of objects as a strategy against subjective incarceration, but there is nothing objective about the surrealist object, nothing categorical or taxonomical. As Richard Coyne suggests, "to valorize the notion of the decontextualized (or recontextualized) object may seem to contradict the subjective focus of surrealism, but the surrealists were interested in instantiations and not classification, objects placed in the 'wrong' categories" (1998, 191).

Recalling Lyotard's focus on the sublime in both romanticism and avantgarde art, what matters most in surrealism, as in OOO, is that the sublime object has the potential to disrupt traditional categories. Bogost gives a clear outline of this disruptive process when, citing Latour's animistic description of actants as "troubled souls that have not been offered a decent burial," he describes alien ontology as a "bestiary of the undead" (2012, 133): "In the face of the undead, we exhibit terror. Troubled souls seek relief, silence, release. They operate by broken logics, ones recognizable as neither alive nor dead but striving for one or the other. We fear them because we have no idea what they might do next" (2012, 133). As tempting as it is to diagnose OOO as a form of necrophilia (viz. Nathan Gale's [2009] "zombie ontology"), following perhaps Eric Fromm's (1968) apocalyptic view of technoculture as a world of machine-love, it is more productive perhaps to consider OOO as a flight from finitude, one that is less a philosophy than a form of creative writing, a *poeisis* that resists the closure of mechanical theories of "human access" (Bogost 2012, 4). To borrow the words of Stanley Cavell, OOO represents "the human effort to escape our humanness," which is delimited by both the finitude of our decaying bodies and the finitude of communication (1989, 86). And as Cary Wolfe suggests, acknowledgment of this double finitude calls for a philosophy that

"can no longer be seen as mastery, as a kind of clutching or grasping via analytical categories and concepts" (2010, 71). Perhaps OOO is such a philosophy; however, its immersion in wonder and the sublime does not suggest an acknowledgment of finitude, but may well betray a reveling, with varying ethical concern, in the infinite.

As Lyotard suggests, the ultimate fate of the ineffable and sublime object of surrealism was commodification. This is evident in a conspicuously taxonomic exhibition of "Surreal Things" hosted by the Art Gallery of Ontario in 2009. OOO, which Bogost describes as an "event" of anticorrelationism, is an attempt to resist such closed taxonomies. Having suggested that the avant-garde's commodification marks the end of sublime aesthetics, Lyotard proposes that "sublimity is no longer in art, but in speculation on art" (1991, 211). These words ring clear today if we consider OOO as a sublime philosophy, a philosophy of sublimation even, taking into account the various definitions of this term, from chemistry (a state of becoming), from psychology (the diversion of sexual energy into socially acceptable manifestations), and finally, as a neologism, from artistic practice (the production of sublime objects). With this in mind, I would like to conclude by looking carefully at Bogost's turn from written philosophical speculation to philosophy as *carpentry*.

Taking a literal suggestion from Harman's (2002) description of OOO as "the carpentry of things," Bogost suggests that "the job of the alien phenomenologist might have as much or more to do with experimentation and construction as it does with writing or speaking" (2012, 109). Armed with this nascent methodology, Bogost describes several of his digital media projects, including *Latour Litanizer, I am TIA,* and *Deconstructulator,* as *"artifacts"* of alien phenomenology. It is in this move toward an applied philosophy, I would suggest, that Bogost's work is the most productive, the most resistive to the reification, commodification, and Kantian classification of things. Bogost's applied work is admirably cross-disciplinary, pointing the way toward applied philosophical modes that can help redefine the way research is conducted and disseminated in the humanities. However, his version of *carpentry,* which involves "constructing artifacts that illustrate the perspectives of objects," lacks Jane Bennett's commitment to political intervention. Furthermore—and with all due respect to Bogost's characterization of academics as "insufferable pettifogs who listen or read first to find fault and only later to seek insight" (2012, 91)—by limiting himself to a digital version of carpentry that involves "memory addresses and ROM data, or webpages and markup" (109), Bogost misses an opportunity to engage in a richer diversity of philosophical carpentry, which

might involve working with things such as greenhouses, treadmills, dirt, canoes, radish seedlings, antique wedge-shaped coffins, cockroaches, retro arcade cabinets, and penny-farthing bicycles.

This self-indulgent litany emerges from projects conducted by the Critical Media Lab (CML) at the University of Waterloo, where the production of critical objects is also informed by an applied philosophical method that I have called *applied media theory*. Recalling Jane Bennett's version of flat ontology, object-oriented methods in the humanities, including Bogost's admirable work, have the potential to draw "human attention sideways, away from an ontologically ranked Great Chain of Being and toward a great appreciation of the complex entanglements of humans and nonhumans" (2010, 111). Applied media theory, wielded through a digital practice of care, curation, and curriculum, can draw attention sideways, not to revel in the infinitude of object being, but for the sake of intervening in a technoculture possessed by a technoromantic idealism. This is a culture that relies on the disposability of objects, including those neurological objects in the human brain that are responsible for attention and that are the target of an increasingly invasive *attention economy*. As Bernard Stiegler puts it in *Taking Care,* digital media, as currently wielded by the cultural industry, form a "network of *pharmaka* that have become extremely toxic and whose toxicity is systematically exploited by the merchants of the time of brain-time" (2010, 85). Rather than calling for a Luddite rejection of digital media in his *therapeutics of care,* Stiegler suggests that the cognitive toxicity of contemporary technoculture can be overcome "through the invention of a new way of life that takes care of and pays attention to the world by inventing techniques, technologies, and social structures of attention formation corresponding to the organological specificities of our times, and by developing an industrial system that functions *endogenously* as a system of care: *making care its 'value chain'—its economy*" (2010, 48). To invent a new economy of care in our technocultural system, philosophers would do well to intervene directly in that system's mode of production, namely, digital production, offering alternative models for technological invention that draw attention sideways, to the complex entanglements of human and nonhuman things. Perhaps the best way to achieve this attentional mode is through an interlinking of digital media and conspicuous objects-to-think-with: penny-farthing bicycles, cockroaches, canoes, and copper plates. To complement Jane Bennett's ecopolitics of things, I am recommending a techno-noopolitics of things, one that acknowledges at once the infinite intermingling of things and the finitude of human being. Such acknowledgment is a necessary component of a therapeutics of care *(sorge),* which begins with a rejection of the flight from

finitude. The object-oriented labor of love I have attempted to describe here, and that characterizes the even-numbered chapters in this book, points the digital humanities in a direction that intervenes directly in the production of technoculture, vying with the culture industry to gain a stake in that very limited natural resource known as human attention.

8 MYTH OF THE STEERSMAN

By continuously embracing technologies, we relate ourselves to them as servomechanisms. That is why we must, to use them at all, serve these objects, these extensions of ourselves, as gods or minor religions. An Indian is the servo-mechanism of his canoe, as the cowboy of his horse or the executive of his clock.

MARSHALL MCLUHAN, *UNDERSTANDING MEDIA*

I push at my skin, and am a little thrilled and disturbed to note that it too ripples slightly to my touch, giving a similar timbre and viscosity as the screen. The largest organ of the body, the great container; the esteemed purifier; the separator between outside and inside, between smooth and ripply, between liquid and the concoction of gases that make up the air around me. Another screen.

MARY FLANAGAN, "RESKINNING THE EVERYDAY"

Skin

To restore an antique cedar-and-canvas canoe, you must treat the vessel like a living and breathing thing. Canvas is very much like skin, and it will weather, stretch, wrinkle, and crack over time. If the canvas is still intact, then it need not be replaced, and it can be repainted. But preparing an antique canoe canvas for painting requires patience, precision, and a meticulous attention to detail. First of all, it is important to understand that when a canvas is first stretched over the cedar, it is *filled* with a compound consisting mostly of linseed oil and powdered silica. When you begin sanding the canoe, you must be careful not to disturb the filling, or you might risk tearing the canvas. Silica is also toxic when airborne, so you must wear a mask while sanding. Use 100-grit

Figure 7. Sanding the canoe salved for *Myth of the Steersman,* 2010.

sandpaper and get as close you can to leaving nothing but the filler layer intact. Once the entire canvas has been sanded and is perfectly smooth to the touch, it should be vacuumed clean before applying the first coat, and the gunwales should be taped off to ensure a clean break between the cedar and the canvas.

It is best to apply a primer first, before moving on to the paint. Like the paint to come, apply the primer by using a *tipping* method: the paint is brushed on horizontally, and then *tipped* vertically with careful strokes that will not leave streaks or missed spots. Once the primer has been applied, it must dry for at least twenty-four hours and then be sanded down with 100-grit sandpaper. The goal is for the primer to cover areas where the filler is uneven. After sanding the first coat away, you must vacuum the canvas and thoroughly wipe away all dust. Then a second coat should be applied, and following the same method, sanded after twenty-four hours, this time with 250-grit paper. Before proceeding to the colored coats, filter the paint to remove any foreign materials that would ruin the finish. Apply the first coat using the tipping method, and after three days (depending on paint used), wet-sand the entire canvas with 220-grit paper and clean and dry it thoroughly. Then apply the second coat in the same way as the first, allow it to dry for at least three days, and wet-sand with 320-grit paper. Clean the canvas and apply the third coat. A freshly painted canvas canoe should be allowed to cure for a full season if possible (at least six months), before it is immersed in water.

It is highly unlikely that the iconic Canadian painter Tom Thomson, who has been called "Canada's Van Gogh," followed these steps when he curiously repainted his brand-new Chestnut canoe in 1916. A meticulous painter in his own right, Thomson might have felt compelled to recolor his new purchase, as Roy MacGregor suggests in *Northern Lights,* for the sake of distinguishing it from the other canoes at Algonquin Park, where he stayed from spring to fall, traveling the lakes on his Chestnut Cruiser and painting the varied landscapes on small panels of three-ply veneer board.[1] Or perhaps Thomson simply couldn't resist applying a coat of color—a bluish gray hue achieved by mixing a tube of cobalt blue artist's paint into a can of gray marine paint—to a large canvas thing. This would make Thomson's canoe, which is eternally linked to his untimely death, a lost masterpiece.

On July 8, 1917, Thomson's lifeless body was found in Canoe Lake at Algonquin Park, floating in a marshy area. There was a length of copper fishing wire wrapped sixteen times methodically—and mysteriously—around his ankle. His canoe was found downstream. One report says that the last time he was seen, Thomson was heading out in his canoe on a fishing trip. He could have died of natural causes. Another theory suggests that he was murdered and dumped in Canoe Lake, a weight tied to his ankle with fishing wire. This is the essential mystery of Tom Thomson's death, and the driving force behind the fame of the artist, who is best known as an inspiration to Canada's infamous school of painters, the Group of Seven.

The mystery is exacerbated by conflicting evidence regarding the whereabouts of Thomson's remains. He was initially buried in Algonquin Park, but his family paid an undertaker to move the corpse to Leith, Ontario, where he grew up. However, no one saw the gravedigger undertake his work, and some speculate that the coffin sent to Leith did not contain Thomson's body. The Thomson family has refused to allow an exhumation that could potentially solve the mystery. In 1956, a group of four men on a sketching expedition at Algonquin Park unearthed the remains of what many assumed was the body of Tom Thomson. The event led to a long story in the *Globe and Mail* on October 10, 1956, fueling the national debate about the whereabouts of Thomson's remains. A photograph of the skull taken at the time clearly demonstrates a head trauma of some sort, once again complicating the mystery. On October 19 the Canadian Press released the following headline: "ALGONQUIN PARK BONES NOT THOSE OF THOMSON." It was based primarily on the conclusions of a Dr. Noble Sharpe, who examined the remains and concluded that, based primarily on the jawbone, the body was likely that of a "Mongolian type, either Indian or nearly full-breed Indian" (MacGregor 2010, 245).

Many skeptics remained convinced that the body was that of Thomson, including Canadian author Roy MacGregor. In 2009, MacGregor enlisted the aid of physical anthropologists and archaeologists, who examined photographs of the skull and compared it to skull samples of various males of both Aboriginal and European ancestry. One archaeologist, Dr. Andrew Riddle, used photogrammetric software to examine the precise coordinates of facial features both in the skull photograph and in a photograph of Thomson. The results conclusively suggested that the skull belonged to Thomson. However, what the software could not do was *reskin* the image of the skull. For this final, hands-on task, the photo was sent to Victoria Lywood, a forensic artist in Montreal who specializes in reskinning human remains for criminal investigations. The photo was presented to Lywood as John Doe, "a caucasian approximately forty years of age [who] lived in the early twentieth century and [wore] his straight black hair medium length and parted on the side" (MacGregor 2010, 273). Fifty-three years after the skull was unearthed, Lywood's drawing provided something that the photogrammetric software could not: an uncanny likeness of Tom Thomson's face. Yet this human-made, hand-rendered image leaves a lingering question: Is this a face that can be trusted?

Inspired in part by MacGregor's research, *Myth of the Steersman* was created in response to a commission call put forth by the Tom Thomson Gallery in Owen Sound, Ontario, and THEMUSEUM in Kitchener, Ontario. The call was for a digital artwork that explored "the myth and mystery of Tom Thomson."

Figure 8. Skull believed to be that of Tom Thomson, 1956. Reprinted courtesy of Chief Coroner's Office of Ontario.

Myth of the Steersman responded to the call by underscoring the pivotal role of the canoe in both the mystery of Thomson's death and in the production of his artwork. The project involved creating a replica of Thomson's canoe, placing three touch-screen monitors in the hull, and wrapping the entire vessel in

fishing line, except for the rear paddler's seat. The screens display images related to Thomson's death—a photo of his skull, paintings that might reveal clues to the mystery, and other images—that can be seen only by strumming the strings that are stretched tautly above the surface of the screens. This cocoon of fishing line, a physical reference to the line found around Thomson's ankle, provides a visual and haptic buffer, preventing the eyes and fingers of gallery visitors from achieving direct access to the *skins* of the screens.

Interval

Myth of the Steersman begins with an ominous dream of a glowing ghost vessel, a notebook sketch of a mummified canoe, and a search for a sixteen-foot Chestnut Cruiser. While there are very few Chestnut Cruisers remaining (they were discontinued in 1921), there is an abundance of Chestnut Prospectors. The one used for the project came from an online classified ad offering a canoe that was the "same make and model used by Group of Seven artist Tom Thompson." The three factual errors in the ad (Thomson's name is misspelled, he did not own a Prospector, and he was not a part of the Group of Seven) did not dampen my instinct that this was the right vessel for the job. I purchased the canoe from a salvage worker who found it abandoned in a client's yard. The canvas was not severely damaged, but it had been brutally stapled and duct-taped to the hull in places, indicating that the vessel was likely not seaworthy. In any case, I sanded it down carefully, primed it, and applied three coats of paint, following Thomson's concoction of cobalt blue artist's paint and gray marine paint. The canoe was christened one week later in Canoe Lake at Algonquin Park, then returned to the Critical Media Lab for its digital prostheticization.

Installing the monitors in the canoe required drilling holes into its underbelly for the passage of cables, power cords, and bolts to secure the base of the monitor arms. When the first drill bit—a lockhole cutter with the circumference of a silver dollar—chewed through the cedar hull between two ribs of the underbelly, a cracking sound rang out, as if the Chestnut was shrieking in pain. I had promised the previous owner that I wouldn't drill holes into the canoe, but the technical and aesthetic demands of the project made these holes an absolute necessity. Once the holes were all measured and drilled, I installed the monitors with my collaborator Pouya Emami, and we began the slow and difficult process of wrapping the vessel with 20lb-weight nylon fishing line. The process of wrapping the canoe, two millimeters at a time with

over five kilometers of fishing line, took over thirty hours and required the assistance of six volunteers. The end result of this effort was a transformation of the canoe into a crypt and cocoon.

The computer screens, completely obscured by the stringy warp of fishing line, can be viewed only in the intervals between the strings, as users strum the surface. Each screen displays the canoe ribs that are hidden directly beneath the monitors, and touching the surface causes image slices to appear between the ribs. It is possible to see an entire image on the screen, but only by strumming quickly across the surface to reveal several slices in succession, thereby allowing persistence of vision to do its work. Robert Reid, a journalist for the *Kitchener-Waterloo Record,* suggested that the object is a sort of musical instrument, like Tom Thomson's mandolin, that beckons the viewer to play. This Chestnut canoe, which will never break the surface of another Canadian lake, has been transformed into a tactile curiosity. But the physical object in the gallery is only one facet of the project.

Tom Thomson's work is best known through his sketches, which were rendered in Algonquin Park on small wood panels measuring approximately 12½ × 9½ inches. He was an expert canoeist, and his travels required frequent

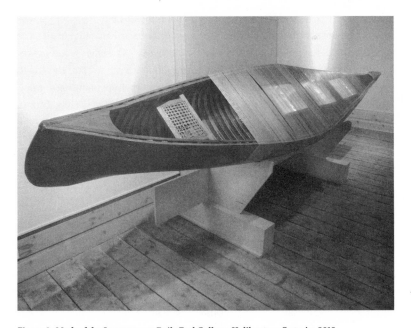

Figure 9. *Myth of the Steersman* at Rails End Gallery, Haliburton, Ontario, 2012.

portages, which meant carrying the canoe several kilometers at times, to reach a destination worthy of painting. But this was not virginal territory. As Andrew Hunter notes in his essay "Mapping Tom," "the landscape and waterways that Thomson navigated were part of a highly controlled space with a significant industrial history" (2002, 30). One can imagine Thomson in his canoe, exploring the landscape, passing by a noisy logging dam at one moment, and then coming upon a tranquil lagoon the next, where pointed deadheads—tree stumps emerging from the water where a portion of logging land had been flooded—cast a gothic reflection onto the lake. All of these scenes, from the industrial logging to the solitude of a lagoon, were fair game for Thomson's paints and panels. The hand that held the paddle also held the brush.

In the winter, Thomson would return to his studio and render some of his sketches on canvas. This artistic process, which is not uncommon for painters, is reason for pause. In *Materializing New Media,* Anna Munster discusses the "lags or intervals" that occur when fleshly bodies encounter digitally embodied code: "The temporality of digital embodiment comprises not simply moving toward absolute speed but also a stretch of asynchronicity punctuated by lags or intervals. These delays occur because both code and the body fall short of the other's speeds. This logic of differential engagement is not unique to information culture but is already prefigured in the baroque relations articulated between the organic world, natural science and aesthetics" (2006, 64). Differential engagement is one way of describing Tom Thomson's shift from canoe-traveling sketch maker to studio artist. How does one make the transition from painting on wood panels on the shores of northern lakes to painting on fresh canvases in a Toronto studio while snow blows outside the window? How did this distance from the site of origin figure into Thomson's polished canvases? How can we possibly measure, calculate, or map the net effect of this spatial, cognitive, and affective interval between canoe-driven sketch and urban studio canvas?

Écart

While *Myth of the Steersman* was inspired by the gap between canoe and studio, it ultimately attempts to capture a more essential *écart,* which exists between humans and their prosthetic extensions. Each of the screens in *Myth of the Steersman* not only is touch-sensitive but also can be activated remotely, by means of a web interface that mirrors the content and functionality of the screen display. Facilitated by an Ajax Push Engine (APE) server, anyone with an

Internet connection and appropriate web browser can drag a mouse pointer across the *Steersman* interface and, from great distances, bring the canoe screens to life in the gallery. In fact, the interface was designed so that the remote user's actions could actually interrupt the actions of a person in the gallery, effectively hijacking the screen. When we tested the interface, we noticed that there was a definitive lag time between the web user's actions and the output on the screens of the canoe. This can be explained quite simply in reference to the variability of Internet connection speeds. What this means is that it might take up to thirty seconds for a person with a dial-up connection (if such a thing still exists) in Chicago to affect the canoe screens, whereas a person using a fiber-optic cable network in Toronto might have an immediate impact. Still, the project makes it possible for two people—one in front of the canoe and one sitting at a workstation seven hundred kilometers away—to interact with one another through the screens. What lingers here is the question of user experience, and more specifically, the qualitative difference between these two users' experiences. Which one is in control of the interaction? Which one holds the most power? The answer depends on which version of the cyberspace myth one chooses to entertain.

Figure 10. *Myth of the Steersman interface.* THEMUSEUM, Kitchener, Ontario, 2011. Courtesy of Derek Weidl.

The forensic specialist Dr. Philip Hall once stated in reference to Thomson's death that it was "preposterous to have suggested that a canoeing expert with the understanding of water so clear in his work would stand up in his canoe, minutes from shore, to urinate, wave at a passing fellow loon, or for anything else" (MacGregor 2010, 156). His conclusion is based in part on comments about Thomson's canoeing expertise made by Dr. R. P. Little, one of the first authors to write an extensive study of Thomson's death.[2] In Little's words, "Tom took great pride in his own Chestnut-brand canoe, which, like a centaur, was almost a part of him" (1995, 217). The image of Tom Thomson as a canoe-man hybrid, a cyborgic lake traveler, provides yet another reason for pause. Before the touch-screen monitors and Ajax Push Engine, there was the push, pull, and touch of canoe, paddle, and brush. Can a figure such as Tom Thomson remind us, to cite Mark B. N. Hansen, of our own "coupling of embodiment and technics" (2006, 61)? Or to push further, can a project such as *Myth of the Steersman* remind us of our own "*sensory écart*," the primordial gap between skin and world that defines human agency prior to our groping for any tool (61)? Where might this line of speculation intersect with the mythical trajectory of Tom Thomson and his canvas-skinned canoe?

At some point in the morning of July 8, 1917, Tom Thomson may have miscalculated the distance between the bow of his canoe and a deadhead rising only inches out of the water. Should a forensic expert find evidence for such an error, such a failure of proprioception, it would bring an inglorious end to the myth and mystery of Tom Thomson. And it would transform the equally mythical dove gray canoe from a heroic vessel of transcendence into an object of betrayal, a prosthetic failure, a vessel of vulnerability.

9 DIGITAL CARE, CURATION, AND CURRICULUM

On Applied Media Theory

Our inventions are wont to be pretty toys, which distract our attention
from serious things. They are but improved means to an unimproved end.

HENRY DAVID THOREAU, WALDEN POND

Not only are man's meanings not cheapened by being attached to things.
On the contrary, this is the only way that the ideal can unfold. With
esthetic mergers, with science and art, man fuses his meanings into the
world of things. In this way he is led on to a revelation of his own ideal
gropings, at the same time that the external world is increasingly un-
folded for his use.

ERNEST BECKER, THE STRUCTURE OF EVIL

THE CONSPICUOUS PASSAGES on painting, sanding, and carpentry in chap-
ter 8 are designed to exaggerate the claim I wish to make here, which is that
humanities scholars must *get their hands dirty* if they are to intervene directly
in technocultural production. The discourse on objects with which I will
indulge myself in this chapter cuts close to the discourses of object-oriented
ontology (OOO) and speculative realism (SR) already discussed in this book.
Ian Bogost's radical unchaining of what a thing is and his generous assess-
ment of what sorts of things might bring a world into being lead him to con-
template the lifeworld of "memory addresses and ROM data, or webpages and
markup" (2012, 109). I too am interested in the critical discourse on and of
electronic or digital things: touch-screen displays, heart rate monitors, micro-
controllers, Geiger counters, LED TVs, and the Pentium 3 PC inside a MAME
retro arcade cabinet. But I am also interested in the cheap, recycled fiberboard
used to build the arcade cabinet. If such things could speak critically about
their interactions with humans and other things, what would they have to say?

My interest in these things moves beyond SR and OOO to consider a practice of digital-analog *making*, or what might be called *thinkering*, a new model of digital humanities that is not just about writing code and making tools for conventional scholarly research.[1] What I am proposing is a digital humanities that is rooted less in information science than it is in digital art practices.

For media theorists, thing-orientation provides an opportunity to step away from apocalyptic or emancipatory discussions of disembodiment that fuel cultural studies of technology, and move instead toward a more contemplative and historical understanding of the object-world in which we are stubbornly rooted. What's more, thing-orientation, when applied in the creation of digital objects-to-think-with, provides scholars in the humanities with an opportunity to participate in the very formation of digital culture. The latter is the focus of this chapter. Here, discussions of death and technology go underground while I make a necessary turn toward describing in detail what I have called *applied media theory*. This practice calls on scholars in the humanities to remain true to their disciplinary interests while acting like artists and engineers, inventing their own critical technological objects, even at the risk of having them turn out to be nothing more than broken tools or misfit toys. If technoculture as it is most commonly construed serves as a buffer against the certainty of death, then the technoculture of broken toys that I flesh out in this chapter is one that is deliberately built on an anxiety-ridden embrace of human finitude.

On a recent visit to the National Gallery of Canada, I accidentally happened upon an installation that haunts me to this day. Cramped by a tight schedule, I entered the museum specifically to see its showcase exhibit at the time: *The 1930s: The Making of "The New Man."* This was an ambitious collection documenting what might arguably be called the height of anthropocentricism in Western culture. Disoriented by the vast range of pieces in this exhibit and by the unfortunate speed with which I had to observe them, I took a wrong turn on my way out of the gallery and passed what looked like a large storage room cluttered with random objects. The disarray before me provided a shocking contrast to the controlled spatial arrangement of the "New Man" exhibit. Certainly, this wasn't a gallery storage space. At the entrance, I was greeted by an uncanny blond dog, lying in a fiberglass display case, his left paw neatly bandaged. Above, a stuffed moose, positioned stiffly on its side, looked down at me with one large brown eye. These beasts were only two of the hundreds of random objects—car parts, broken toys, unopened Christmas gifts—piled high on shelves that flanked the space, which was about the size of a one-car garage. As I browsed the cluttered shelves, I noticed the smell of burned wood. I probed

further, and sure enough, ten feet into the space, there was a large hole in the left wall where a fire had seemingly burned through. I reluctantly stepped through the hole into a darkened room about the same size as the first, and saw a car draped with a protective cover. Behind the vehicle there was a chair, placed as if to beckon a visitor to sit. I responded appropriately, and after sitting I noticed a rectangular slot at the rear of the car, smaller than the size of a license plate. Falling deeper into the heart of this *unheimlech* cabinet of curiosities, I bent low and peered inside. There, somewhere in the bowels of the vehicle, a small fire was burning. I stood and headed back toward the entrance, only to find that there was yet another adjoining room on the right-hand side of the space. Caution tape prevented any entry into this room, which housed a large mechanical contraption, perhaps some sort of perpetual motion machine, made of lumber and rope. At this point, a docent entered the space and asked if I had any questions. "Yes," I replied, pointing to the strange, malfunctioning apparatus. "What is that?" He told me that it was a "mechanical sculpture" but that it wasn't currently working, so they closed off the room.

What I had stumbled onto—or into—was actually an installation called *The Discourse of Elements* by BGL, a French-Canadian collective. The project, which can be imagined as three adjoining suburban garages, brings together multiple objects that BGL collected during a decade of surreal performances and installations. In this sense, the project is indeed a sort of archive, an art storage room, or better yet, a cabinet of curiosity.[2] Placed in storage, BGL's collection of curiosities is revealed as ordinary, dumb objects that greet us only as "malfunctioning apparatuses," or broken tools if you will.[3] Yet a discourse of elements burns within each and every one of these discarded artifacts. It is up to gallery visitors to bend down low, peek inside, and spark the flame.

Like most avant-garde art, *The Discourse of Elements* is an exercise in defamiliarization and disorientation. Faced with BGL's nonsensical assemblage, we have no recourse to science or truth; we are forced to generate a discourse for these objects, to speculate, perhaps even to ventriloquize, to speak for the objects themselves. In the end, we can relate to these objects only as humans, only as a different sort of object in a shared space with other objects. But it is in this interval of contemplation, in this discursive space for bridging the gap, for giving other objects a voice, that art and philosophy can be most generative. Today, the design of communication objects and interfaces is premised on providing the opposite experience: digital consumer objects should not defamiliarize the user or provoke contemplation, but provide seamless access to data through what Jay Bolter and Richard Grusin (2000) have identified as a logic of immediacy and transparency.

Digital artists will often toy with this double logic in ways that question the formal properties of digital media interfaces and artifacts. This self-reflexive play is not unlike the playful textual work of deconstruction and poststructuralism. Jay Bolter has argued that deconstructive theorists such as Barthes and Derrida engaged in formal experimentation with text as a means of embodying their theories about textuality. And their formal experiments in print anticipated the structure of another expressive medium: hypertext. This differentiates them from the hypertext theorists of the 1990s such as George P. Landow, whose formal studies of digital media seem to move antichronologically, culminating "in linear essays destined for print" (Bolter 2003, 20). For Landow and others, hypertext was not a mode of formal experimentation, such as Derrida's *Glas* (1986) or Barthes's *S/Z* (1974); it was merely an off-the-shelf package for literalizing and reifying critical theory. As I argued in *E-Crit: Digital Media, Critical Theory and the Humanities* (2006), the first wave of digital humanities suffered from the same anticlimactic and antiprogressive fate; that is, to reassert the words of Alan Liu in *The Laws of Cool,* new digital tools in the humanities have led to "incremental changes in the quality, quantity, and speed of research and teaching, [but] not to paradigm change" (2004, 313). For example, the much-touted Ivanhoe Project developed by Jerome McGann and Johanna Drucker at the University of Virginia, which McGann called a "kind of multiple-user toy," was designed according to contemporary digital game theory and built on a complex, open-source java platform—all for the sake of teaching traditional interpretive methods of literary criticism (McGann, 2013). Digital humanities, even as it is most commonly construed today, focuses primarily on the digital archiving of printed texts (first-wave work that is important in its own right) and on the development of tools for the analysis and markup of these texts. This second wave of digital humanities is best exemplified in the TAPoR project (Text Analysis Portal for Research), where humanities scholars can find hundreds of software applications for the analysis, statistical examination, visualization, and editing of texts. But the ultimate end of this tool-use is the conventional humanities journal, monograph, or specialized conference. Not much has changed in humanities research, then, over the past twenty years, except that some groups of fortunate scholars have received generous grants to develop tools that make conventional research methods more efficient. There is little evidence that any scholars are actually using these tools.

The source of dismay in my critique of the digital humanities, as well as in Jay Bolter's note on the anachronism of hypertext theory, is that while humanities scholars develop new digital tools to conduct traditional modes of

print-oriented scholarship, corporate culture is developing digital tools that are making this sort of interpretive work increasingly irrelevant. This is the central argument in *E-Crit,* so I will not repeat it here. I will confess, however, that *E-Crit,* which calls for new modes of scholarship "suitable to a picture-oriented, digital-centric culture," propagates much of the emancipatory rhetoric generated by the hypertext theorists of the 1990s (O'Gorman 2006, xvi). This tendency is obvious in my indictment of what Friedrich Kittler calls a "republic of scholars" bound to print-oriented technics, and in my adherence to John Guillory's suggestion that the book-oriented humanities have lost their "cultural capital" in a world of digital technologies. I dread revisiting the early drafts of *E-Crit,* which still haunt my hard drive, serving up such phrases as "hypericonomy is a mode of representation that cautiously embraces the capacities of new technology, while loosening the cognitive vise of the printing press and its consequent, conspiratorial methodologies" (O'Gorman 2006, 96). What I would like to rescue from *E-Crit* is the will to devise new scholarly methods in the humanities that embrace digital technologies; what I would like to abandon is the Romantic rhetoric of liberation and the bashing of what I called *print-oriented culture.*

My previous critiques of the digital humanities, such as my reference to the field's "archive fever," its creation of digital tools that serve only print-oriented ends, and its fostering of linear and sequential cognitive tasks, turn out to be misdirected. As I argue in this chapter, modes of cognition fostered by print culture are actually what make traditional humanities research methods not only valuable but a rare and endangered commodity. In an attempt to correct the misdirection of my previous work, I will turn away from the critique of scholarly methods that was central to my previous work, and turn instead to a critique of the technocultural system that is antagonistic both to these methods and to the cognitive tasks required to carry them out. This will require a momentary turn away from theorizing the discipline, for the sake of theorizing the technocultural system within which it is embedded.

In chapter 1, I cited Terry Eagleton's defamation of cultural theory as a discipline that is "embarrassed about love, biology, religion and revolution, largely silent about evil, reticent about death and suffering, dogmatic about essences, universals and foundations" (Eagleton 2003, 101–2). I have attempted to make up for some of these lapses in this book. What Eagleton does not address is cultural theory's embeddedness in a technocultural system, and therefore its responsibility for levying an effective critique about and within this system. Posthumanist philosophy, as I have suggested, has done a great deal to address such issues as biology, suffering, essences, universals, and foundations. But

keeping in mind the posthumanist turn toward object-fetishization, in particular technofetishization, it has yet to generate an effective critique of technoculture. At their worst, cultural theories of animals and objects, disguised in the sheep's clothing of posthumanism, continue the long-standing trend in cultural studies toward a politics that in Eagleton's words cannot move beyond the "particularities of cultural difference" (2000, 34). Cary Wolfe (2010) makes a similar claim about humanist strains of animal studies in *What Is Posthumanism?*, where he distinguishes between humanist and posthumanist approaches toward posthumanism, noting that such a distinction requires "a certain reconfiguration of what philosophy (or 'theory') is" (62). Following Wolfe's cue, my goal has been to mount a theory of technoculture without losing sight of the limits of philosophical discourse and more generally of the finitude of language. While acknowledging that discursive finitude, my goal is to extend the boundaries of philosophy by means of digital technics.

To develop what I have called a techno-noopolitics, we need exemplars beyond the field of cultural studies, which is one of the reasons why, in *E-Crit*, I turned to poststructuralism and avant-garde art. Tilottama Rajan (2001), in her essay "In the Wake of Cultural Studies: Globalization, Theory and the University," suggests that "theorists of techno-poststructuralism and changes in mediality" such as Friedrich Kittler and Gregory Ulmer (the key theorists of *E-Crit*) might be called "a second cultural studies [that] embraces technology so as to ally itself with science, progress, and membership of the global scene" (71). This second cultural studies may not call for a paradigm shift in the technics of humanities scholarship—*pace* Kittler's tendencies to "pick up the soldering iron and build circuits" (Griffin 1996, 731)—but it does acknowledge its position on a technological global scene. I would add to this list of techno-poststructuralists the names of Cary Wolfe, Bernard Stiegler, and N. Katherine Hayles, among others. But before I explore how their work can be built into a politics of technoculture, I would like to revisit the foundations of poststructuralism, which are instructive in understanding how the paradigm shift of poststructuralism was provoked. Before theory, in Rajan's words, "might enter into the domain of culture," it is necessary to understand how culture first entered into the domain of theory (2001).

As Terry Eagleton suggests, and as I have already noted in chapter 1, cultural theory was built on direct political dissidence in the cultural context of the 1960s—it had more in common with art or public protest than it did with scholarship. In the foundational glory days of cultural theory, "writers like Barthes, Foucault, Kristeva and Derrida were really late modernist artists who had taken to philosophy rather than sculpture or the novel. . . . The

boundaries between the conceptual and the creative began to blur" (2000, 65). I suggest that to achieve a paradigm shift in the humanities within our current technocultural context, scholars must learn to think and work more like artists—but not at the expense of traditional humanities disciplines, and not at the expense of close reading and the development of what Rajan casually calls "difficult language" (2001, 67). To flesh out this idea, I will rely, in an admittedly nostalgic move, on Greg Ulmer's notion of the *puncept* and suggest that the techno-noopolitics I am attempting to develop is built on the threefold structure of *care, curation,* and *curriculum.*

Care

I will now return to my earlier suggestion that cognitive modes fostered by print culture are what make traditional humanities scholarship so valuable today. In particular, I would like to focus on the concept of *attention,* as it applies to such tasks as careful reading, critical discourse, and the writing of sustained arguments based on research. Here is the key question driving my research: Is it possible to develop a noopolitics, or a model of "knowledge work," to borrow Alan Liu's (2004) term from *The Laws of Cool,* that combines digital media technics with the cognitive modes required for traditional humanities research? This is precisely the question that applied media theory, which I will introduce here, attempts to address.

Several recent publications, including Maryanne Wolf's (2008) *Proust and the Squid* and Nicholas Carr's (2010) *The Shallows,* have combined histories of reading with cognitive science research to examine how the technical shift from book to screen impacts human cognition. Carr, drawing on psychology, cognitive science, and the history of literature and philosophy (including, not surprisingly, Plato's *Phaedrus*), suggests that the Internet is quite literally reshaping human brains. He relies heavily on the studies of Michael Merzenich, whose research on the brain function of monkeys established the theory most commonly known today as "brain plasticity." Merzenich's most famous research project involved attaching microelectrodes to the cortex of a monkey's brain to examine how "the monkey's brain processes what the hand feels" (Carr 2010, 25). Merzenich then severed the sensory nerves in the monkey's hands and observed the brain's confusion as the nerves regenerated in a haphazard fashion. Eventually, Merzenich noticed, the monkey's brains adapted to the new arrangement of nerves and the neurons fired accordingly in concert with the sensory locations on the hand. As Carr suggests, Merzenich's research broke ground for an explosion of cognitive science studies on the functioning of

neurotransmitters and synapses, leading ultimately to the radical discovery that "virtually all of our neural circuits—whether they're involved in feeling, seeing, hearing, moving, thinking, learning, perceiving, or remembering—are subject to change" (2010, 26). This, in a nutshell, is the theory of neuroplasticity, the theory of a brain that can reprogram itself. Carr then applies this concept to his argument that the Internet, which fosters sound bites, video clips, text browsing, and hyperlinking, is transforming our print-oriented brains. In Carr's terms, the brains of "thoughtful people" attuned to silent reading and contemplation are slipping "comfortably into the permanent state of distractedness that defines the online life" (112).

It is this "permanent state of distractedness" that Carr identifies as *the shallows,* the opposite of deep thinking (2010). Carr's subtle argument hinges on the notion that this state of distractedness is a sort of devolution of the human species, a return to a more primitive cognitive mode. "The natural state of the human brain," suggests Carr, based on research in psychological anthropology, "like that of the brains of most of our relatives in the animal kingdom, is one of distractedness" (63). In language that reflects the work of Walter J. Ong but might also be confused with that of Gilbert Simondon or Bernard Stiegler, Carr suggests that the standardization of printing caused a widespread cognitive shift in the human species, turning "what had been a demanding problem-solving exercise into a process that is essentially automatic" (63). "For most of history," writes Carr, "the normal path of human thought was anything but linear" (83). But thanks to the plasticity of the brain, print literacy has charted neural paths that promote focused attention, deep reading, and linear thinking, the cognitive cornerstones of the humanities. What Carr identifies as a *literary ethic* provoked by print-oriented cognition is responsible for the work not only of canonical writers, historians, and philosophers but also of influential scientists, producing such "momentous intellectual achievements" as Darwin's *On the Origin of Species* and Einstein's *Relativity.* Carr's point is that this literary ethic has become endangered, thanks to a new ethic that promotes distractedness.

Carr's line of thought is at once brilliant and terrifying—and convincing enough to persuade the digital natives in my introductory courses on academic writing. But his argument is not without its weaknesses. Like the statement I just made about my students, there is a great deal of anecdotal evidence in Carr's book, including a quote from N. Katherine Hayles, who claims that she "can't get [her] students to read whole books anymore" (cited in Carr 2010, 9). Anecdotally, I will note that a rough survey at the end of my academic writing course suggests that only about 50 percent of the students read the entire

book, in spite of their general agreement that Carr's fears are justifiable. But anecdotal evidence, especially Carr's own willingness to bear witness to the changes he has observed in his own cognitive behaviors, might be one of the most reliable methods for documenting what the Internet is doing to our brains. Variations in brain function and in subjective experience from human to human make such witnessing an invaluable source of data.

I am less concerned with the anecdotal portions of Carr's work than I am with his treatment of language and writing, which has grave implications when attempting to understand the relationship between the human species and technics. Carr cites Walter J. Ong's maxim that "technologies are not mere exterior aids but also interior transformations of consciousness, and never more than when they affect the word" (cited in Carr 2010, 51). But Carr also suggests that "language itself is not a technology. Our brains and bodies have evolved to speak and to hear words" (51). Based on this, Carr argues that "reading and writing are unnatural acts" (51). Carr's suggestion that these technics are "unnatural" contradicts the argument I have already made, following the work of Stiegler, Simondon, and more recently Cary Wolfe, that the human is always-already technical, defined as we are by what Stiegler has called epiphylogenesis. In Wolfe's words, "the human is itself a prosthetic being, who from day one is constituted *as* human by its coevolution with and coconstitution by external archival technologies of various kinds—including language itself as the first archive and prosthesis" (2010, 295). Without technics, including a symbolic system that allows us to distinguish our species from others, there is no human. To think of the human as a technical animal does not require giving in to technological determinism, however. In fact, this concept of the human can help deflate claims of human mastery over nature, remind us of the animality of our species, and underscore our shared vulnerability with other species.

While Carr's argument relies on a nostalgic and essentialist understanding of the human species and its cognitive habits, this does not disqualify his claims about shifts in cognition brought on by shifts in technics. However, a careful posthumanist conception of our species might lead to a more effective response to the contemporary shifts in cognitive modes—one that does not eschew new technologies as unnatural promoters of *shallow thinking,* but that understands them as a crucial component of the coevolution that defines the human species. With this knowledge in hand, it might be possible to develop careful methods of research and creation that apply the cognitive habits of humanities research to the development of new technologies. What this means is that, as a humanities educator, I should teach students not only how to engage in the

deep and careful reading of texts but also how to apply the lessons from those texts toward the development of new digital technics. This approach expands and enhances Alan Liu's call for humanities educators to address "the humanity of technique" (2004, 307). In Liu's view, if humanists are to keep up with the "cool" of the broader knowledge economy, they must "bring to technique an awareness of archaic and historical techniques. The sense of technique and the sense of history can be integral with each other if both can be shown to play upon the perpetual tension between the archaic and the new" (307). What better way to "address the humanity of technique" than to understand humanity itself as technical? Such a posthumanist approach to what might be called *digital studies in the humanities* would not only foster what N. Katherine Hayles has called "deep attention" but also foster the antianthropocentric *sideways attention* I have discussed already via the work of Jane Bennett, which puts Merzenich's monkey in an entirely different context that is inaccessible to Carr.

It is surprising, given Carr's focus on the concept of attention, that he does not cite Hayles's (2007) essay "Hyper and Deep Attention: The Generational Divide in Cognitive Modes." In this essay, Hayles examines the relationship between cognitive functioning and communications modalities, specifically, the shift between page and screen. Hayles's careful distinction between hyper and deep attention is extremely useful when trying to position digital media within the context of research and education. In Hayles's formulation,

> deep attention, the cognitive style traditionally associated with the humanities, is characterized by concentrating on a single object for long periods (say, a novel by Dickens), ignoring outside stimuli while so engaged, preferring a single information stream, and having a high tolerance for long focus times. Hyper attention is characterized by switching focus rapidly among different tasks, preferring multiple information streams, seeking a high level of stimulation, and having a low tolerance for boredom. (2007, 187)

Clearly, Hayles and Carr are in agreement about the shift in cognitive modes associated with digital media. But Hayles's focus is primarily on the generational divide these technologies are engendering. In particular, she is concerned with how to educate students who have grown up in an environment that both fosters and rewards hyper attention. One possible answer, she suggests, is to continue teaching the valuable skills provided by traditional humanities research (deep attention), but to combine this with opportunities for students to engage in hyper attention. An example given by Hayles is a literature course where students are asked to juxtapose the adventure-puzzle video game *Riven*

with William Faulkner's *Absolom! Absolom!*. The juxtaposition of *Riven* with Faulkner's complex narrative, suggests Hayles, "invites comparison with the hyper attentive mode of interactive game play, where the emphasis falls on exploring and remembering crucial clues embedded in a reward structure keyed to gaining access to the next level of play" (2007, 197). What is lacking in this model is an understanding of the students not just as consumers of media that are designed quite specifically for their age group but also as producers, capable of intervening in the shaping of technoculture.

In *Taking Care of Youth and the Generations,* Bernard Stiegler (2010) cites Hayles's distinction between hyper and deep attention, placing this cognitive divide in the context of a broader cultural *malaise* within hyperindustrial society. In Stiegler's terms, "attention control via cultural and cognitive technologies ('technologies of the *spirit [esprit]*,' those malignant spirits haunting the adult minor as apparatuses for capturing, forming, and deforming attention), has become the very heart of hyperindustrial society; however, it no longer relies on psychotechnics but on psychotechnological apparatuses whose devastation we see on TF1, Channel Y, and so on" (2010, 22). Stiegler's primary concern is that the cognitive habits of young people are largely in the hands of *psychotechnological apparatuses,* which move beyond television (in North America Channel Y would be the equivalent of Nickelodeon or YTV) to include the video game industry, social networking conglomerates, and the developers of hardware and software that target the youth market. According to Stiegler, symbolic media wielded by the cultural industry form a "network of *pharmaka* that have become extremely toxic and whose toxicity is systematically exploited by the merchants of the time of brain-time" (85). These merchants wield an incredible degree of power, given their ability to tap directly into the youth market through various channels. At the root of this toxicity, as Stiegler suggests in *Taking Care,* is a process of disindividuation. In other words, the just-in-time branding, packaging, and delivery of homogenized consumer content geared toward the younger generations lead not only to a global, cultural homogeneity but also to what Richard Beardsworth has called a reduction in "the *différance* of time" (1996, 148). In Stiegler's words, which borrow from Gilbert Simondon, the ultimate result of this psychotechnological process is a generalized disindividuation, one that simultaneously homogenizes youth culture and crystallizes it as a thing distinct from, alien to, and possibly defiant of the cultures fostered by older generations.

This argument is also developed in the work of Nicholas Carr, albeit without the "difficult language" (Rajan 2001, 67) that is crucial to Stiegler's analysis. In Carr's terms, "the Net diminishes . . . the ability to know, in depth, a

subject for ourselves, to construct within our own minds the rich and idiosyncratic set of connections that give rise to a singular intelligence" (2010, 143). This *shallow* way of knowing, Carr suggests, combined with the offloading of human memory into digital databanks, endangers the transmission of culture as we know it, or more precisely, as we *used* to know it. (Why learn history by heart, internalize it in my brain, if I can Google it on my handheld device?) Citing the work of anthropologist Pascal Boyer, Carr notes that "what's stored in the individual mind—events, facts, concepts, skills—is more than the 'representation of distinctive personhood' that constitutes the self. . . . It's also the 'crux of cultural transmission'" (cited in Carr 2010, 196).

While Carr seems to throw up his hands in the face of this cultural malaise, Stiegler proposes to counter the process of disindividuation through what he calls a *therapeutics of care.* He suggests that the cognitive toxicity of contemporary technoculture can be overcome "through the invention of a new way of life that takes care of and pays attention to the world by inventing techniques, technologies, and social structures of attention formation corresponding to the organological specificities of our times, and by developing an industrial system that functions *endogenously* as a system of care: *making care its 'value chain'—its economy*" (Stiegler 2010, 48). Stiegler has yet to fully develop the look and feel of this techno-noopolitics, but he suggests that it hinges on a more careful process of *transindividuation,* one "that cares not just for language but for *things,* allowing us not just to designate them but to think them, to make them appear, and finally to give them their place—by giving them meaning" (2010, 22). What is required then, for such a therapeutics of care is not just attention to language, deep reading, and history (Alan Liu's prescription) but also attention to things, which in applied media theory takes shape through an integration of phenomenology and poesis, research and creation. There are several exemplars that can assist in the formulation of such a model, some of which I examine in this chapter, selected through a deliberate act of curation.

Curation

In *Applied Grammatology,* Greg Ulmer (1985) notes that Derrida's formal experimentation relied heavily on references to objects and images; not just the use of images as illustrative devices, however, but "the sustained expansion of images into models. Thus he gives considerable attention in his texts . . . to the description of quotidian objects—an umbrella, a matchbox, an unlaced shoe, a post card—whose functioning he interrogates as modeling the most

complex or abstract levels of thought" (xii). Derrida's objects-to-think-with provide a relay for how to design a humanities research model in which digital objects are used, paraphrasing Ulmer, "to model complex or abstract levels of thought related to the forms and social impacts" (Ulmer 1985, xii) of digital media. In other words, my interest is in a form of generative critique that uses digital media to critique digital media. In this way, I am working in the tradition of Ulmer and other technopoststructuralists, as Rajan calls them. But my technics are as focused on the production of artifacts as they are on the production of texts.

Throughout his career, Ulmer has drawn on Derrida's *modeling* of complex thought to invent an applied mode of pedagogy that challenges the formal conventions of humanities scholarship. As a student of Ulmer's at the University of Florida, I was admittedly frustrated by his insistence that I was there not to make art, but to generate theory. However, what Ulmer concealed from his students is that while he was not there to train artists, his pedagogy was more akin to *curation* than it was to lecturing. From Wikipedia, we learn the following about curation:

> A curator (from Latin: *curare* meaning "take care") is a manager or overseer. Traditionally, a curator or keeper of a cultural heritage institution (e.g., gallery, museum, library or archive) is a content specialist responsible for an institution's collections and involved with the interpretation of heritage material. The object of a traditional curator's concern necessarily involves tangible objects of some sort, whether it be inter alia artwork, collectibles, historic items or scientific collections. More recently, new kinds of curators are emerging: curators of digital data objects and biocurators. (2012)

As a curator of digital models of poststructuralism created by students, Ulmer assumed the mode of a keeper of cultural heritage, a content specialist, and an interpreter. I have assumed this secret pedagogical strategy of Ulmer, taking it more literally so that the work of my own students involves the creation of "tangible objects" as well as "digital data objects." The shift from lecturer to curator in the classroom, lab, or studio means that instructors must at once serve as managers or overseers of projects, but like the best curators, they must also act as collaborators with students, drawing on their training as "content specialists" to oversee the development of cultural projects.

Evidently, what I am calling for here is a closer alignment between the creative arts and the humanities. This is not a unique concept. In *The Laws of Cool,* Alan Liu (2004) proposes that knowledge work in the humanities should turn toward an aesthetics of "destructive creativity," binding together cultural

theory and the creative arts in order to keep pace with the logic of innovation that dominates postindustrial culture. Liu calls for "a destructivity that attacks knowledge work through technologies and techniques internal to such work. The genius of contemporary aesthetics is to introject destructivity within informationalism. This, we may say, is very cool" (331). In a move that seems paradoxical, Liu suggests that this *creative destruction,* inspired by an innovate-or-die mentality, need not come at the cost of history. In fact, he argues that "where once the job of literature and the arts was creativity, now, in an age of total innovation, I think it must be history. That is to say, it must be a special dark kind of history. The creative arts as cultural criticism (and vice versa) must be the history not of things created—the great, auratic artifacts treasured by a conservative or curatorial history—but of things destroyed in the name of creation" (2004, 8). Cool or not, Liu's language of destructivity, as Hayles points out in her review of his book, might "easily slide into vandalism or even terrorism" (2005, 238). However, this need not be the case if the destructivity is tempered with the historical perspective advocated by Liu. What's more, Liu's adoption of creative destruction as a humanities research method might potentially provoke scholars to consider the disposability of things, which would be a good starting point for an object-oriented mode of digital scholarship. Liu is calling on humanities scholars to observe the rapid pace of destruction and renewal that characterizes knowledge work in a postindustrial culture, and this might include focusing on the things created and thoughtlessly disposed of in the name of progress. Where I part with Liu, for obvious reasons, is in his rejection of "curatorial history," with its focus on artifacts, the "things created." Such things must also be part of a therapeutics of care, and it is for this reason that applied media theory, as presented in this book, combines digital media with conspicuous artifacts such as treadmills, penny-farthing bicycles, and cedar-and-canvas canoes.

The remainder of this chapter is divided into two sections that better illustrate the concept and methodology of applied media theory. First, as noted, to chart a path toward this theory, I outline a selection of object-oriented methodologies that serve as exemplars for a digital- and thing-oriented mode of humanities scholarship. This section brings together the concepts of the hypericon, the object-to-think-with, and the epistemology engine as models for rethinking innovation in the context of the digital humanities. Second, I briefly describe various projects in applied media theory conducted by students from the Critical Media Lab (CML) at the University of Waterloo. The goal of this chapter is not to argue for the uniqueness of applied media theory or to argue that the CML is an ideal model for the digital humanities, but to provide a

relay for other scholars seeking a paradigm shift for the humanities in a technocultural context. A related goal here is to provide such scholars with a historical framework to work in, one that integrates formal experimentation in humanities scholarship with the technics of digital art. Hopefully this work will generate new research practices and productive discourse about the points of intersection between artistic creation, digital media production, and humanities research.

In *E-Crit*, where I also provided a curator's selection of exemplars for new modes of digital humanities research, I paid special attention to W. J. T. Mitchell's identification of a "pictorial turn" in critical theory that has taken place over the last century. The concept is equally instructive here. As Mitchell notes, this turn might be identified with

> phenomenology's inquiry into imagination and visual experience; or with Derrida's "grammatology," which de-centers the "phonocentric" model of language by shifting attention to the visible material traces of writing; or with the Frankfurt School's investigations of modernity, mass culture, and visual media; or with Michel Foucault's insistence on a history and theory of power/knowledge that exposes the rift between the discursive and the "visible," the seeable and the sayable, as the crucial fault-line in "scopic regimes." (1994, 12)

Central to Mitchell's examination of the pictorial turn is the *hypericon*, which he describes as "a piece of moveable cultural apparatus, one which may serve a marginal role as illustrative device or a central role as a kind of summary image . . . that encapsulates an entire episteme, a theory of knowledge" (Mitchell 1994, 49). Derrida's postcard and Foucault's pipe are superb examples of hypericons. But Foucault did not paint *La trahison des images;* he simply borrowed it from René Magritte. Applied media theory requires scholars to create their own hypericons, and to create not just "summary images," but summary objects as well—*objects-to-think-with.*

I borrow the term *object-to-think-with* from Sherry Turkle, but subject it to a slight repurposing for the sake of applied media theory. In *Life on the Screen,* Turkle (1995) argues that screen life reflects postmodern theories about identity formation. According to Turkle, then, the computer is an object-to-think-with; it gives people "a way to think concretely about an identity crisis. In simulation, identity can be fluid and multiple, a signifier no longer clearly points to a thing that is signified" (49). Echoing the hypertext theories of the 90s that were at their height when Turkle wrote *Life on the Screen,* she suggests that "computers embody postmodern theory and bring it down to earth" (18). Like the discourse of her hypertext-enchanted peers, Turkle's aphoristic language

serves primarily to reify postmodern theory, to demonstrate its *truth* by pointing to its instantiation in a physical object. This practice of reification seems rather strange coming from a scholar informed by postmodern theory. Nevertheless, Turkle's object-orientation is indeed instructive for postmodern theorists looking to engage in formal experimentation. Rather than considering digital objects, including hypertext, as opportunities for reifying various theories, we might consider such objects as vehicles for *testing* or *generating* theories. But for this to be most effective, experimenters would be required to create their own *objects-to-think-with*.

More recently, Turkle refined her object-oriented theory by proposing the term "evocative object," which she identifies once again as a way of bringing "philosophy down to earth" (2007, 8). In the anthology *Evocative Objects,* Turkle moves away from the reifying narrative about the computer as an embodiment of critical theory, and turns instead to the way in which ordinary objects (a bracelet, a yellow raincoat, a stuffed bunny) can serve as epistemic repositories, much like Mitchell's hypericon but embodying an individual's unique way of knowing. The authors in Turkle's anthology explore "how an object tied the author to intellectual life—to building theory, discovering science or art, choosing a vocation" (5). These essays are all acts of reification—the reification not of concepts from postmodern theory, but of an individual's emotional and intellectual way of being. The objects described in the anthology encapsulate specific components of human experience and render them in tangible form. From a cynical perspective, the book's focus on "evocative objects," many of which are off-the-shelf items, may be seen as a celebration of capitalist consumption, as if the only way that we can possibly understand ourselves is through the objects we consume. Then again, as Bill Brown (2003) suggests in the context of the modernist "thing," perhaps self-identification with a familiar object saves it "from the humiliation of homogeneity, . . . from the tyranny of use, from the instrumental, utilitarian reason that has come to seem modernity's greatest threat to mankind" (8). Marxist reflections aside, what I would like to rescue from Turkle's work is her speculation on how objects might facilitate thinking about the ways in which knowledge is shaped, and the ways in which humans and their objects coevolve. It may indeed be argued that the authors in Turkle's work are "creating" or at least repurposing their objects of consumption; by generating a contemplative discourse out of these things, they are endowing ordinary objects with philosophical significance, transforming them from homogenized things into tools of individuation. Applied media theorists should engage in a similar generative (rather than consumptive) activity, but their work should involve a more hands-on creation of objects as well,

one that allows them to put such objects out into the world in an active process of transindividuation.

Perhaps the greatest contribution that Turkle's work can make to applied media theory is not her focus on objects, but her focus on application. Turkle's recontextualizing of postmodern theory and media studies within the practices of psychological research is what makes her work most valuable. Her prolonged engagement in qualitative studies of computer users, as exemplified most recently in *Alone Together* (2011), and her willingness to discuss her own personal experience as a computer user exemplify what Jay Bolter calls an "anthropological strain" in media theory (2003, 24). This strain, which characterizes much of the work in this book, refuses to maintain a critical distance from the object of study. An intimate engagement with the object of study is also suggestive of the sort of practices I am proposing for applied media theory, which is not limited to *making*. Applied media theory might result not only in the creation of new media artifacts but also in the application of media theory to anthropological or psychological studies of the impact of technology on human behavior. I examine this potential in chapter 11 when I discuss various social psychology experiments in terror management theory that examine the relationship between death and technology.

Like Turkle, Don Ihde also considers the computer as an object-to-think-with, but he prefers the term *epistemology engine*. In his book *Bodies in Technology*, Ihde (2002) focuses specifically on the embodiment of things to lay out a new plan of attack for critical theorists engaged with questions concerning technology. This study is meant as a corrective to what Henri Lefebvre has called Western philosophy's denial and abandonment of the body through a "process of metaphorization" (407). In Ihde's words, "the history of epistemology is one of different attempts to *disembody* the knower or to hide his or her embodiment" (68). For media critics, as Ihde suggests, this willful denial points to a state of helplessness, a willingness to forgo agency in the material world of technological production. According to Ihde, if critics of technology expect to produce more than a retroactive and impotent response to technology's manifold implications on human being, then they must enter into technological "situations"—not just through the production of reactionary critical discourse, but at the "research and development stages as well as with the later applied ethics stages" (xx). Like Turkle, Ihde's goal is to bring philosophy down to earth; not in order to legitimize theories, however, but to shape the ways in which objects (in Ihde's case, technological objects) are produced.

As in Turkle's later work, Ihde proposes a theory of "situated knowledges," rooted in the belief that epistemologies are shaped by the materiality of being.

But rather than developing this theory out of evocative objects of all shapes and sizes, Ihde turns toward the products of technoculture, out of which he draws the concept of the *epistemology engine:* "The devices I shall use are those that bring human knowers into intimate relations with technologies or machinic agencies through which some defined model of what is taken as knowledge is produced—I shall describe *epistemology engines.* My devices will be particular machines or technologies, which provide the paradigmatic metaphors for knowledge themselves. And through these narratives, I shall trace the visible and invisible roles of bodies" (2002, 69). With this method in hand, Ihde moves from the camera obscura to video games, the Internet, and virtual reality as a way of identifying epistemic shifts from early modernity to postmodernism. His goal is to demonstrate that it is through physical interaction with the world, "in the mutual question and interacting of the world and ourselves," that "things become clear" (86). In other words, the best way to understand the philosophical implications of technological "things" is to actively engage with them. Most importantly, through this contemplative engagement, we have an opportunity to become producers, rather than passive consumers, of technology.

Ihde's model of the epistemology engine works well for his own theoretical purposes, which brush against recent trends in media archaeology. But the model does not flesh out a productive mode of digital humanities capable of intervening in digital culture. This is because Ihde's model is retrospective, relying on epistemology engines that have *already* been invented (camera obscura, e-mail, virtual reality, etc.). Were Ihde to call for philosophers of technology and media critics to invent their own epistemology engines, then he would be thinking like an applied media theorist, which also requires thinking like an artist and engineer, or possibly like a laboratory scientist, or maybe even a biocurator.

In his book *Bioart and the Vitality of Media,* Rob Mitchell (2010) suggests that bioartists can challenge Western culture's dominant understanding of the term *innovation,* which has come to designate not just invention but also the bringing of a product to market. Mitchell notes that this understanding of innovation was cemented into policy during the so-called innovation crisis of the 1980s, at a time when patents issued in the United States had declined and lost ground to foreign patents (54). The problem was solved by legislation that folded together corporate and academic interests in science and technology, a fold that is palpable at my own institution, the University of Waterloo. The university has one of the largest corporate-sponsored co-operative education programs in computer science and engineering in the world and it permits researchers to keep full ownership of their intellectual property. It should be

clear that the "innovation crisis" is intimately related to the so-called crisis in the humanities. What I would suggest is that, faced by the discrepancy between traditional humanities research practices and those practices demanded by the prevailing technocultural milieu, humanities scholars must find ways to do their research not only *about* the dominant innovation ecology but also *within* that ecology. This is precisely how Mitchell describes the work of bio-artists: "Creating bioartworks requires pulling, bending, and folding these tools, techniques, and relationships [of the biological sciences] into other spaces, which in turn produces new wrinkles in a commercially oriented 'innovation ecology' that first emerged in the 1980s and 1990s in the United States (and has since been exported to many other parts of the world)" (2010, 53). The same statement might be made for digital artists, who use technical tools, skills, and spaces, often right alongside engineers and computer scientists—not for the sake of commercializing and patenting products, but often to question the impact of digital media on society and the human condition.

Indeed, the concept of *applied media theory* itself may seem redundant to digital artists, many of whom already view new technologies as tools to embody their philosophical understanding of technology. For digital artists, there is no media theory without application. These artists, from Laurie Anderson to Stelarc, from David Rokeby to the Graffiti Research Lab, generally approach the tools not as experts, but as tinkerers or as unabashed dilettantes, a nonexpert approach to technology that I outline in *E-Crit*. In the process of working with the tools, they have an opportunity to think about and with them, to engage in an intimate investigation of the tool's materiality and its potential to shape meaning and experience. In Heideggerian terms, working like a digital artist requires careful attention to digital tools as both ready-to-hand and present-at-hand, worthy of our attention and quick to promote anxiety. Such practices, which might be called *thinkering,* attempt to put speculative research back into an academic ecology that has fallen under the pressures of efficiency and commercialization. My hope is that these practices might carve out space for a therapeutics of care in humanities scholarship.

As a humanities scholar working in a "critical media lab" funded by a federal grant program designed to support innovation, I can attest to the fact that there is room to fold careful cultural work into the innovation ecology, even if it means describing your arts and humanities lab as a "Visualization and Biotelematics Environment," which may be necessary to secure federal grant funding. The CML, following the research and creation strategies of applied media theory, imports the provisional methods of media artists into the humanities, and folds that work back into the innovation ecology. CML projects may or

may not result in the registration of new patents or the marketing of new consumer products, but they do produce tools, even broken tools, that redefine innovation as *the creation of something new for the sake of enhancing human care.* As already noted, I am not attempting to position the lab as an ultimate example of how to do innovative work in the digital humanities; I merely offer it as a case study, a relay for other scholars who are invested in pursuing practices similar to those outlined here, which throw into question the tendency of academia to bind innovation with commercialization.

The concept of innovation is central to Alan Liu's vision of "creative destruction" as it applies to knowledge work. Citing economist Peter F. Drucker, Liu notes that creative destruction drives innovation through a "systematic abandonment of the established, the customary, the familiar, the comfortable" (cited in Liu 2004, 2). We might also describe this as a process driven forward by an uncritical logic of progress. As Liu suggests, the myth of progress that dominates postindustrial capitalism might be described as a global competition by means of which "we" must be those who create the most innovative and *cool* technologies and "them" must be what is creatively destroyed in the process. Narratives of unique cultural identity in this scenario are replaced by a global narrative of progress and innovation. "Rapid design and prototyping, fast assembly, quick turnaround, just-in-time supply chain: this is how ancestral identity has been coopted to the hyperbolic 'we' must beat 'them' of global competition" (Liu 2010, 303). To recall the work of Ernest Becker, this concept of cooption is an effective way of understanding technoculture as a system of heroic action driven forward by a Promethean mindset of technological-production-for-the-sake-of-technological-production, a culture that "lacks any social or ethical checks" (Liu 2010, 303).

Such a cultural system has little room for attention, care, and contemplation, which work against the futural tense of the technocultural narrative. In Don Ihde's words, research and development teams have no need for philosophers to enter into their circle and "gum up the works" (2002, 105). Liu responds to this problem by suggesting that the work of humanities scholars is responsible for introducing a disruptive *illud tempus* into the clockmaker's version of progress that dominates postindustrial society (2010, 304). More specifically, Liu suggests that the ethos of postindustrial knowledge work must be measured "ethically against the deep norm of history" (381), which might in turn impose a "lag" or "slack" upon the just-in-time norms of postindustrialism. I agree with Liu that the contemplative, deeply historical traditions of humanities research must be maintained in the development of a new wave of knowledge work. Moreover, I support Liu's suggestion that the creative arts

can provide some much-needed "cool" to the humanities, just as the humanities can help historically justify the creative arts. But I am not sure that creative artists would welcome such justification, or view it as necessary to their enterprise, within which the term *academic* might be construed as an insult. Rather than proposing collaborative effort between creative artists and humanists—although I do not view such collaborations as impossible—what I am proposing is a merger of methods. I will conclude this section by noting, with all due respect, that *The Voice of the Shuttle* and *The Romantic Chronology*, offered by Liu as examples of innovative knowledge work, are quite clearly the work of first-wave digital humanities scholarship, which do not reflect the practices or products of contemporary digital artists. My hope is that the projects described in the following section, which I present as case studies in applied media theory, more closely resemble the merger of creative arts and humanities desired by Liu, a romancer of the digital arts but a reluctant digital artist in his own right (389).

Curriculum

The 2008 European Conference of the Society for Literature, Science and the Arts featured a special stream of panels and exhibits entitled "Art as Research." As the Call for Proposals suggested, the arts "can generate and formulate knowledge in their different disciplines—music, theatre, literature and dance, etc.—which is equivalent to the production of scientific findings, or which accompanies and supplements these" (Dombois 2007). But what became clear over the course of the conference is that in spite of this claim of "equivalence," in the academic world there are very few models—and even fewer institutional structures—suitable for artist-researchers. What's more, as the initial title of this stream indicates ("Art as Research / Research as Art"), there is a difference between an artist who conducts research with the ultimate goal of producing art and an academic who engages in artistic practices with the ultimate goal of generating academic research. This distinction, which is more ideological than practical, became painfully clear when certain participants in the stream refused to identify themselves as researchers or "academics," while others refused the label of "artist." Finally, the conference also demonstrated that while artistic work might certainly "accompany" or "supplement" scientific findings, there are very few opportunities for artists to play a direct role in scientific research programs. The same can be said for humanities scholars seeking opportunities to play a direct role in the innovation ecology described in the preceding section. But humanities scholars can learn from media artists

(including bioartists, as noted in the preceding section) how to position their work within a laboratory environment within that ecology. I will develop this idea by turning to the CML as a case study.

The CML was designed to (a) develop new research and creation practices that challenge the boundaries not only between academic disciplines but also between scholarly research, artistic creation, and innovation and (b) establish new institutional models that foster research and creation activities and legitimate them within an academic and technocultural context. More specifically, the CML supports the work of humanists, social scientists, and artists who wish to use new media as a means of engaging in a formal and transformative critique of digital culture. One stream of projects in the lab focuses on questions of embodiment emerging from media theory, posthumanist philosophy, and technocultural studies. As mentioned, new media artists have asked many of the same questions as media theorists and philosophers of technology, including questions about the impact of technology on the human body. The most obvious example is perhaps Australian artist Stelarc, who has willingly subjected his body to several technological mutations, extensions, and interventions for the sake of demonstrating, in his words, that in technoculture, the body is obsolete. An illustrative example of Stelarc's work is *Movatar,* a digital and mechanical prosthetic worn by the artist, which is controlled remotely by a computer beyond his reach, causing unpredictable movements of his limbs. According to Stelarc, this project demonstrates what happens when "the body itself becomes a prosthesis for the behaviour of an artificial entity" (2007, 222). This exercise in helplessness is designed to underscore his desire to accelerate human evolution. In order to keep up with our technologies, suggests Stelarc, human bodies must become hard, dry, and hollow, like the machines that are transforming our lives.

Steve Mann at the University of Toronto, a less sanguine prognosticator on the future of the body, has engaged in a similar form of technological self-sacrifice. Dubbing himself a "reluctant cyborg," Mann has sported a head-mounted computer display (the most recent iteration of which is the Wearcomp) on a daily basis for well over a decade. Mann's intention in this case is not to demonstrate the body's obsolescence, but to underscore its stubborn persistence, and to ensure that technological production remains mindful of the body's centrality to human experience. The projects of Stelarc and Mann, although ideologically divergent, draw explicitly on these concepts of embodiment in an attempt to put the body back into technological production. In this sense, they respond directly to the philosophical entreatments of

N. Katherine Hayles, Brian Rotman, and others, to *put the body back* into technological discourse.

This sharpened focus on embodiment plays a crucial role in the curriculum supported by the CML, primarily through courses and individual assignments that require a *make-oriented* component. Students working in the CML go through a research process that moves from reading to hands-on creation to writing. A recent project completed by students enrolled in the English Department's master's in Experimental Digital Media (XDM) required them to build a retro arcade cabinet. Students working on this project made use not only of computer programs and software but also of carpentry technics required to build the wooden cabinets, a task that involved confronting the stubborn finitude of medium-density recycled fiberboard, cheap door hinges, and Robertson screwdrivers. The students also wired and installed the electronics required for the control panel (buttons and joystick) and designed critical games for the cabinets that embodied concepts covered in course readings.

One student, Danielle Stock (2012), described her group's project in an article published in the *Canadian Journal of Communication*. The project, called *Division Pixel Suppliers*, requires players to assume the avatar of an assembly line worker who must organize enlarged pixels into patterns prescribed by his boss. *Division* has become part of the permanent collection of THEMUSEUM in Kitchener, Ontario. For the philosophically uninitiated who typically frequent THEMUSEUM, this is a game of memory and timing that allows players to design and print unique patterns by using joystick movements (e.g., left>left>up = red; left>left>down = blue) to color individual pixels. For Stock and her collaborators Steve Wilcox and Michael Hancock, however, this is not a simple game but a complex object-to-think-with that embodies the theories of Anna Munster and Mark B. N. Hansen. As Stock writes in her article, the game "works to maintain a sense of spatiotemporal division between the 'real' and the digital by first, using the virtual space of the avatar as a visualizable 'division' that positions the player at a remove from the work her body is doing; second, concealing the participant's canvas from view so that she must track her progress mentally; and third, positioning the printer remotely, so that the user must move through physical space in order to obtain the results of digital production" (2012, 132). Notably, Stock suggests that the last element of the game, which requires users to move sideways from the screen interface to a printer interface, underscores "the attentional division central to the digital interface experience, marking a shift to physical space-time from absorption in [what Munster calls (164)] 'a universe constituted out

of information'" (132). *Division Pixel Suppliers* might be played innocently as a simple game of skill and memory, but it is designed in a way that calls attention sideways toward its own materiality as a technocultural artifact, a design that promotes a gestalt shift from the thing as ready-to-hand to the thing as present-at-hand.

Another arcade cabinet game designed by students to draw players' attention sideways toward its thingness is a project called *Cybridity* developed by Thea Carter, Tyler Emoff, Kaitlin Huckabone, and Dylan McConnell. The group worked to combine Hayles's theory of hyper and deep attention with Sherry Turkle's recent concerns about the antisocial behavior provoked by Internet connectivity. To embody these issues, the group designed an arcade cabinet that isolates users from the rest of the arcade and immerses them in what turns out to be an impossible task of social media multitasking. As student Sarah York suggested on her blog, "Cybridity's cab fosters an intimate relationship with machines through physically and sensually isolated gameplay, wherein the social visibility of arcade use is converted into a private and all-consuming experience. The literal immersion of the player in the machine suggests a kind of muted interiority" (2011). Whereas classic video arcade gaming involved a public spectacle of quarter-wielding players shooting for high scores, *Cybridity* points to the very private, isolated, and often lonely nature of contemporary social media discourse and home console gaming.

Like *Division Pixel Suppliers, Cybridity* also served as an interactive display at THEMUSEUM, where it was integrated into the local digital media ecology. I will note, however, that not all projects developed by students in the CML turn out to be polished artifacts suitable for public display. In a course called *Cyberbodies: Rhetoric and Fiction,* students applied readings in media theory toward the design of a "critical toy." At the end of the term, they had to write a final critical essay for which the toy was to serve as a hypericon, evocative object, or epistemology engine. The toy creation assignment is a typical component of courses in computer science and engineering that introduce students to microcontrollers and sensors. Generally, students in such courses are required to select a sensor-based toy, take it apart, identify its mechanical components, and either rebuild or repurpose it. This process generally occurs without considering the metaphysical implications of such a dissection, which, following Baudelaire (1964), replays the "overriding desire of most children . . . to get at and *see the soul* of their toys" (202). While the *Cyberbodies* students had the option of repurposing an existing toy, they were encouraged to design a toy from scratch, based on "instructions" provided in the assigned course readings, which ranged from Donna Haraway's "Cyborg Manifesto" (1991) to

William Gibson's *Neuromancer* (1984). The only design limitation they had to face was in proving that the toy was technically feasible, building on the Arduino microcontroller platform. Of course, the students also had to face the limitation of being English majors, not computer scientists or electrical engineers. To this end, the course involved a series of workshops on basic electronics, microcontroller programming, and soldering. Students not only had to design the critical toy "on paper" but also had to demonstrate a working prototype that made use of Arduino and at least one physical computing sensor.

As may be guessed, the project did not result in the creation of sleek, perfectly functioning toys ready to be snapped up by Mattel or Hasbro. But the students did indeed invent a number of evocative objects that demonstrated their ability to apply media theory toward the invention of new digital things. One group of students designed an inflatable doll that would interface with ordinary desktop computers as a way of monitoring children's "screen time." The doll, affectionately named "Freddy," would sense the physical presence of a seated computer user while simultaneously tracking the processing output and hard drive activity of the computer. With increased computing activity, Freddy would inflate. Eventually, after ballooning grotesquely, the doll would squeeze the computer user right out if its position in front of the screen. One of the students noted that Freddy subverts some of Stelarc's proposals regarding embodiment:

> With Freddy, we see a refreshing opposite trend: instead of increasing miniaturization, we see the grotesque inflammation of the human body, the explosion of his body to warn us of the implosion. . . . A toy such as Freddy visualizes the potential of technology to override homeostatic mechanisms. So the Freddy doll articulates the state of emergency in terms of our children's oversaturated technological existence; he demonstrates, through damage to his own body, how we give ourselves over to media technologies. (Chong 2008)

As this citation suggests, the project did not get very far beyond prototype, and it may best be described as a "monstrous" prototype indeed. But what matters in this case is that the students' engagement with physical computing tools led them to a novel remobilization of cyborg theory, and attuned them to the tools necessary for intervening carefully in the production of digital culture.

Another student project, slightly less novel but more promising from a commercial perspective, was entitled *The CyberSound Glove.* As the title suggests, the project involved designing a glove fitted with touch and flex sensors that would play all eighty-eight notes on a standard piano keyboard. The prototype

submitted by the students demonstrated that the glove could indeed be created by means of simple sensors interfaced with a miniature Arduino "lilypad" board. Of course, the prototype did not play eighty-eight notes—in fact, it only caused various LEDs to light up depending on which finger applied pressure to a surface. But the students aptly demonstrated the technical feasibility of the product, and they created a polished video of the product in action, manipulating a soccer ball, strumming the rungs of a banister, and so on. Moreover, the students demonstrated their project's rootedness in contemporary media theory. One student's essay focused on the generative potential of an object-oriented philosophy of technological production:

> [Our project] was influenced by a recent experiment of Stelarc's where he had an ear grafted onto his arm. One of the potential reasons for this may be to find out what an arm hears. Our idea is an inverse of this: what does a chair sound like? Or for that matter, what would a human arm sound like if it could make music? This demolishes the boundaries between the senses, melding touch and sound. It also redefines our concept of music: the songs produced by random objects may not be harmonious, yet they can still be considered music. (Jarzembecki 2008)

While this may sound like a convenient disclaimer for a product that doesn't function properly, the argument is based on poststructural theories that challenge the binary of signal versus noise. What is more, the student demonstrates a speculative interest in the life of objects and how technology mediates our understanding of the object world.

A similar musical philosophy was put forth in a physical computing performance held recently at the Open Ears Festival in Kitchener, Ontario. The performance, entitled *What Does a Body Know,* showcased the singer Marguerite Witvoet in collaboration with a Digital Ventriloquized Actor (DIVA), a glove that produces verbal utterances based on hand movements. While the playbill for this performance promised a duet of sorts, the result was essentially an uncanny product demonstration in which the human diva struggled to manipulate her instrument, while her voice far outshone her digital prosthetic's infrequent sonic yelps and yawns. In the end, the performance's lasting impression was that of a productive failure. Not a failure of machinery, but the body's failure to adjust to an incredibly complex interface that may well have been designed for a more agile and nimble species than *Homo sapiens* as we know it today. The end result, then, appeared to be a striking demonstration of the human body outstripped by a logic of progress with which it cannot keep up (though to be fair, its creators would likely resist this interpretation).

What I would like to stress here are the methodological and ideological differ-
ences and similarities between the technically sophisticated DIVA and the half-
baked *CyberSound Glove*. Both projects are attempting to shape technologies
that are suitable for the human body rather than pushing a notion of progress
designed to outstrip the body or repress it. But DIVA is a sophisticated art
project designed to generate aesthetic pleasure, while the *CyberSound Glove*,
a product of thinkering, is a philosophical object—it has more in common
with critical writing than it does with art.

Applied media theory, especially when it leads to the creation of broken
tools or half-baked digital artifacts, may be misrecognized, then, as the most
extreme example of "didactic art," which may not make it welcome in galleries
or at festivals. This didacticism is evident in a student's description of the glove
as an object designed to transform our understanding of technology and our
relationship to everyday life. As one student put it,

> The glove is designed so as to allow for natural movement of the hand during
> any given activity. This gives the user the ability to create music at the same time
> as they write an essay, do laundry, play soccer, or paint a picture. Mann's
> WearComp allows the user to be both a "scientist and photographer, an engi-
> neer and an abstract painter" (15) and the CyberSound glove will allow the user
> to be a scientist and musician, or an engineer and a composer. This breaks down
> the boundary between work and play—the glove is designed for multi-tasking,
> allowing the user to turn necessary tasks into artistic experiences. Creativity and
> responsibility do not have to be considered separate areas of a person's life, and
> it is the CyberSound glove that will assist in bridging this gap. This ties in to Nor-
> bert Weiner's idea of placing value of leisure. By turning a wearable device into
> a toy, leisure is now portable, and can be enjoyed at any point of an individual's
> day. (Jarzembecki 2008)

This utopian description of a surrealist object demonstrates that "critical
toys" may not be *objets d'art* at all, just as they are not consumer products
(although they could lead to the development of such products, which is why
the CML has recently positioned itself alongside a tech incubation hub). In
effect, these toys may be viewed as nothing more than the by-products of a
curiosity-driven curriculum of attention formation, a procedural step wedged
between the reading of media theory and the production of media theory. But
what these toys ultimately represent is an alternative mode of digital produc-
tion that provokes critical contemplation and resists uncareful modes of pro-
duction rooted in marketing, a blind mania for progress, and uncritical
consumption. The development of objects-to-think-with might become

central to a digital humanities curriculum, where critical object creation might be viewed as analogous to writing a research essay, or as part of a generative process that vacillates organically between reading, making, and writing.

In *The Structure of Evil,* Ernest Becker (1968) calls for a new university curriculum to counter what he saw as the fetishism of progress and the growing specialization of the disciplines in the late 1960s. This idealistic curriculum would ask students to embrace "man's finitude and his ambiguities" (Becker 1968, 142) while engaging simultaneously in the "human creation of meaning," which "grows up in the transactional interplay with the material, everyday world" (132). "The aim of this curriculum, taken as a whole," suggests Becker, "would be to overcome fetishization of human powers and human consciousness, so that the greatest possible number of people could develop new meanings, could expand the horizon of the human quest to embrace questioning of the purposes of creation" (1968, 142). My equally idealistic hope is that applied media theory, informed by, among other philosophies, Becker's posthumanist instincts, will help inspire the widespread development of such a curriculum.

Finally, the student projects outlined here, in addition to the projects featured in the interval chapters of this book, represent both the cyclical and generative nature of applied media theory, which complicates the distinction between theory and practice, research and creation. To borrow both BGL's archival instinct and Graham Harman's obsession with lists, these projects rely on a "discourse of elements" that brings together media theory, digital art, psychology, health studies, ecocriticism, misfit toys, half-baked things, malfunctioning apparatuses, monsters, flesh, circuits, dirt, and data. My purpose here has been to make something out of this tinkerer's hodgepodge, to salvage a productive critical method from the mounting scrap heap of our technocultural toys. Once again, the case studies outlined here are not meant to be a hagiography of my own research practices; they are offered as relays for other scholars in the humanities, who might develop their own methods for transforming the innovation ecology by turning attention back toward the history of human cultures, sideways toward the vibrant universes of objects that matter, and deep into questions about what it means to be an animal that is both terrified and elated by its very own process of technological coevolution.

10 ROACH LAB

It is indeed in the imminence of the death of the other, and through it, in the fore-sight of the mortality of the species, that compassion can be endured, death being but the absolute wrong done to the other, and all wrongdoing to the other always being the mortification of this other. All suffering at seeing the other suffer is but projection, the anticipation of his elementary fragility, of the essential peril in which he finds himself, out of which and in which he is encountered.

BERNARD STIEGLER, *TECHNICS AND TIME 1*

Some quiet peoples who seek minimum interference by the organism with the world around it avoid eating meat, or killing insects. . . . But even Jains crunch leaves and mash fragile plant stalks–which are surely alive and (who knows?) might even feel pain.

ERNEST BECKER, *THE BIRTH AND DEATH OF MEANING*

IN A JOURNAL ARTICLE ENTITLED "I Am Not an Animal: Mortality Salience, Disgust, and the Denial of Human Creatureliness," Goldenberg et al. (2001) describe an experiment based on terror management theory (TMT), in which participants are subjected to various forms of revulsion related to animality. Like all experiments in TMT, this study was inspired by the work of Ernest Becker. This is obvious in the authors' guiding concept: "acknowledging that we are animals makes us acutely aware that, like other animals, we are material beings vulnerable to death and decay" (Goldenberg et al. 2001, 427). Following Becker's theory of *cultural hero systems,* discussed throughout this book, the authors suggest that "cultures promote norms that help people to distinguish themselves from animals, because this distinction serves the very important psychological function of providing protection from deep-rooted

concerns about mortality" (427). The authors note that while some instances of disgust may be rooted in a self-preservation instinct (e.g., dangerous food products), disgust can also be ideologically motivated. A study by Rozin, Millman, and Nemeroff (1986), for example, demonstrated that participants would not drink juice that had come into contact with either a sterilized or even a plastic cockroach. These studies indicate that disgust can be provoked by "something that is offensive to itself because of its nature or origin" (429). The experiments in "I Am Not an Animal" attempt to show that when faced with reminders of their own animal mortality, participants will experience an intensified disgust reaction in response to creaturely stimuli. This and other TMT experiments provide a fine-grained picture of the animal vulnerability of humans and the strategies they employ to elevate themselves from this exposure.

One experiment described in "I Am Not an Animal" hypothesized that, when reminded of their own mortality, participants would dissociate themselves from an essay that suggests a close affiliation between humans and nonhuman animals. As in most TMT experiments, this one involved inducing *mortality salience* (MS) in one group of participants by asking them to write in detail about the specific moment of their death. Control groups are not exposed to the MS Condition, for the sake of comparison. In this study, the groups were asked to read and assess the quality of two essays, supposedly written by a

Figure 11. *Roach Lab* by Jessica Antonio-Lomanowska. Critical Media Lab, 2011. Courtesy of Jessica Antonio-Lomanowska.

student, that dealt with either (a) the similarity of humans to other animals or (b) the uniqueness of humans when compared with other species. The first essay made statements such as the following: "Although we like to think that we are special and unique, our bodies work in pretty much the same way as the bodies of all other animals. Whether you're talking about lizards, cows, horses, insects, or humans, we're all made up of the same basic biological products. . . . Seeing ourselves as special or different from the cows we eat for lunch or the insects we wash off our windshields is just another example of human vanity and self-delusion" (Goldenberg et al. 2001). The second essay, which supported the uniqueness of humans, argued, "Although our bodies may be pretty similar to simpler species, the potential of the human mind and spirit go far beyond anything remotely similar to what is found in simple animals. First there are the obvious things: Humans have language and culture. We create works of art, music, and literature that enable us to live in an abstract world of the imagination—something no other animal is capable of" (Goldenberg et al. 2001). The results of the experiment showed that, overwhelmingly, participants exposed to the MS Condition gave higher scores to the "human uniqueness" essay than they did to the "humans are animals" essay, when compared to a control group. As the authors suggest, the study demonstrates the "need for humans to distinguish themselves from other animals," especially when they are reminded of their mortality (432).

There is an interesting "glitch" in the experiment. While the study proved that people in the MS Condition strongly approved of the "human uniqueness" argument, it was unable to prove that, when compared to the control group, MS participants would distance themselves from the "humans are animals" essay by giving it poor ratings. The authors attempted to explain this result by suggesting that

> the "humans are animals" essay, although of little comfort, may not have been particularly threatening, especially because the arguments were couched in scientific jargon and were consistent with what the participants were learning in their introductory psychology course. It is also possible that the participants felt restrained to derogate the "humans are animals" essay beyond midrange ratings because of the quality of the writing or concerns with being fair and kind to the student author. (432)

More than anything, what these findings suggest is that the TMT experiment described here is not only about human finitude; it is also about the finitude of language, the finitude that, in Cary Wolfe's terms, "we experience in our subjection to a radically ahuman technicity . . . that has profound consequences,

of course, for what we too hastily think of as 'our' concepts, which are there-fore in an important sense not 'ours' at all" (2010, 90). Prior to any terror pro-voked in TMT experiments, there is always already the violence of language.[1]

The Critical Media Lab has run its own TMT experiments, based on the notion of technoculture as an immortality ideology that buffers its members from the terror of human finitude. One such experiment, conducted in col-laboration with Jason Hawreliak, Mark Zanna, and Steven Shepherd, repli-cated the model of the study described in the preceding paragraphs by exposing participants to the MS Condition, and then presenting them with two essays, supposedly written by students. The experiment was designed to investigate if participants who are heavy technology users, when put in the MS Condition, would cling to rhetorics of technological progress and reject a nontechnologi-cal conception of "human spirit." One essay spoke of humans as technical crea-tures that are fulfilling their destiny by progressing toward immortality; the other essay defended the value of the human spirit, which exceeds anything mechanical or technological. The results showed that participants in the MS Condition rated the "humans as technical" essay quite high in comparison to a control group but were unwilling to give a low rating to the "humans as non-technical" essay. Various attempts to tweak the essays for future studies revealed that, as with the "Not an Animal" study, what we have here is not a failure in the design of the experiment, but a failure of language. There is simply no way of transforming an essay of two hundred words into a controlled instrument. It is here, perhaps, in this moment where science ends and poetry begins, that we must recognize the need for alternative methods of exploring the relation-ship between mortality, animality, and technicity.

Roach Lab, developed in the Critical Media Lab by Jessica Antonio-Lomanowska, provides an opportunity to "rethink our relationship with non-human others, and more specifically, how technology mediates that relationship" (Antonio 2012, 1). Inspired by TMT research as much as she was by Jussi Parik-ka's *Insect Media,* Eugene Thacker's musings on biopolitics, and Katherine Chalmers's *American Cockroach* project, Antonio-Lomanowska chose to work with the cockroach because "(a) in its uncanny strangeness it throws us back against our own creatureliness; and (b) its reputation as post-nuclear survivor demands an acknowledgement of our own technology-entangled finitude" (1). Antonio distinguished her work from that of Chalmers by combining live cockroaches with mechatronic toy roaches known as Hexbugs, developed by First Laboratories. *Roach Lab* consists of a terrarium in which live cockroaches share space with Hexbugs. Behind the terrarium, a video monitor displays a two-channel video created by Antonio. In the left frame, the viewer sees

documentary footage from a cockroach dissection in a laboratory; in the right frame there is a meticulous dissection of a Hexbug, which mirrors the procedures of the live roach dissection, albeit with a screwdriver rather than a scalpel. The juxtaposition here between animal organs and mechanical parts brings into relief the border between animality and technicity. The entire assemblage is rendered more complex by the presence of anonymous human hands in each video, wielding their prosthetic tools. The project was designed to provide Antonio with an object-to-think-with that embodies much of her dissertation project. But what she produced, ultimately, is a theater of horror.

The video of the Hexbug dissection terminates when all the parts of the mechanism are put back into place, and the power button restores the toy to a buzzing vitality. In contrast to this, we have the video of the cockroach dissection, which ends when the insect's internal organs are permanently removed, the body stops twitching altogether, and the viewer is left to contemplate an empty carapace. The horror here is not for the viewer, but for the roaches in the terrarium, who are the victims of a "violence that labors," which is how we might describe all scenes of horror (Cavarero 2009, 12). As its subjects, the roaches in the terrarium, are exposed to the ceaseless mechanical buzzing of their mechatronic doppelgangers, unable to escape the giant video screen's looped images of asphyxiation, dismemberment, and disembowelment, *Roach Lab* embodies the concept of "life as laboratory," with all its biopolitical implications. Moreover, beyond the horror of the roaches, there is the horror of the artist/experimenter herself, who introduced the *Roach Lab* with trepidation at its first gallery opening, fully aware that several roaches had already died in the creation of the project. Finding herself in communion with the roaches, Antonio had to face her "own oblivion as a subject" (Agamben 1999, 106). The remainder of the *Roach Lab* story remains unspeakable.

FROM DUST TO DATA

On Existential Terror and Horror Philosophy

Forward-momentum is enough to build meaning, and possibilities for forward-momentum exist in nature, in the animal's instinctive behavioral *umwelt*, in the world cut out for his perception and attention. . . . But for the symbolic animal a complication enters: language replaces instinctive readiness. Man grows up naming objects for his attention and use. Language makes action broader and richer for the symbolic animal. But something curious occurs in this process: Language comes to be learned as a means of acting without anxiety.

ERNEST BECKER, *THE REVOLUTION IN PSYCHIATRY: THE NEW UNDERSTANDING OF MAN*

The difference between Terror and Horror is the difference between awful apprehension and sickening realization: between the smell of death and stumbling against a corpse.

DEVANDRA P. VARMA, *THE GOTHIC FLAME*

IN THE SPRING OF 2012, the Perimeter Institute for Theoretical Physics in Waterloo, Ontario, offered a double feature in its Theatre of Ideas. Equipped with mandatory earplugs, viewers witnessed back-to-back screenings of Herman Kolgen's *Dust* and Ryoji Ikeda's *Datamatics v2.0.* The Perimeter Institute, which was funded primarily by BlackBerry cofounder Mike Lazaridis, is a residency-based organization that focuses on both formal and phenomenological issues arising from fundamental questions in physics. Besides hosting prestigious academic fellows such as Stephen Hawking, the institute also offers cultural programming. The double bill of Kolgen and Ikeda was an exemplary if not obvious offering in this context, since both videos present a vision of life as both quantum and particulate, featuring not human actors but, respectively,

dust particles and data sets. What these videos embody is a Copernican Revolution in which human agency is placed under erasure by dust and data actants that seem equally vital, self-organizing, and even autotelic. I attended the event with a friend who burst into tears at the end of the screenings, a reaction that surprised and perplexed me. We hastily exited the theater and walked out into the rainy evening. What had provoked this response in my companion? Her desire to flee, she explained, was motivated by a sense that the films were "terrifying." Later, I wondered whether it was not terror but horror that drove her to tears. What is the difference between terror and horror in this case, and why does it matter? Have Kolgen and Ikeda produced horror films? What did this double bill have in common with a Saturday afternoon "creature feature"? These questions open a discussion of the relationship between terror, horror, technoculture, and contemporary philosophies of being, including, but not limited to, object-oriented ontology.

Herman Kolgen's *Dust* was inspired by Man Ray's photograph *Élevage de poussière* (*Dust Breeding*, 1920), which captures a year's worth of dust that had accumulated on the surface of Marcel Duchamp's *The Large Glass*. Whereas Duchamp's dust, which he lacquered onto the surface of his work, mobilizes the strange vitality of dust as a means of challenging the presumptions of the art world, Kolgen's *Dust* documents dust in vivo as an exercise in defamiliarization. The video can be seen only as a "live" performance in small theaters that provide maximum control over sound and audio. The viewers, as immobile receptors of stimuli, encounter dust from a microscopic level with their entire bodies, as it brings a world into being. In Kolgen's words, "*Dust* explores changes in the state of matter. At the edge of the imperceptible, pigments are suspended around a magnetic field. Random fibrous networks take shape and then form composite objects, hypnotic in their complexity. Sound particles paired with luminous aggregates exist on a scale that cancels out all points of reference" (Kolgen 2012). While dust is the star of this video, the piece also features an enigmatic fly, rendered large and luminous by camera technics and editing effects. In the estranging proportions afforded by an HD camera with a macro lens, the fly straddles the border between alien organism and mechatronic flight apparatus. But this is only a fleeting appearance, an almost subliminal role for this supporting actor, who is second in importance only to the inscrutable particles of dust. The fly appears once again in a more dramatic role, midway through the video, only now it appears to be dead. That is, dead but not lifeless. Blasted by sound waves, the fly's corpse is jostled about, caught up in the hypnotic swarms of dust. Is this not the hyperactive cyborg fly featured at the beginning of the video? Now, as a corpse, it takes flight once

again, caught up with the dust in its precarious dance of pattern and randomness. In this transformation of the fly, we are invited to contemplate the shift from technical animality to bare life, from the infinitude of digital special effects to the mortality of organic flesh—both the fly's and our own.

As Jussi Parikka (2010) suggests in *Insect Media*, "from biomedia art to various insect art pieces that deal with the modulations of the sensorial, it is exactly through the animality of perception and 'being-with' that the metamorphosis of the human being takes place" (204). In a Skype interview, I questioned Herman Kolgen about the fly's starring role in the video. Kolgen was well aware of the fly's capacity, at the beginning of the video, to provoke discomfort in the viewer. Its scale and proximity, Kolgen noted, combine to create a defamaliarizing effect, an effect of shock and disorientation. But what of the fly as corpse? Kolgen suggested that the corpse of the fly, like Duchamp's dust, merely appeared on the scene haphazardly after several days of shooting. Rather than removing it, Kolgen made the decision to let it be. The inclusion of this objet trouvé was a fortunate choice. The fly offers a crucial point of reference, a point into which the viewers can project themselves. If, as Parikka suggests, bodies such as swarms are "radically nonhuman"(2010, 204), then perhaps it is too much to ask viewers of *Dust* to identify with the radical otherness of swirling particulate matter. It is for this reason that they must turn to the fly, turn *into* the fly. The helpless viewer of *Dust,* confined to the theater seat, exposed eyes bombarded by particles, vulnerable bowels trembling with the relentless blasting of infrasound, becomes the fly.

The fortuitous appearance of the fly's corpse in *Dust* is punctuated by the more deliberate appearance of a human corpse. Almost midway through the video, once the dust has firmly established its vitality, the cadaver of an elderly man wrapped in white bandages falls vertically into the frame, drops onto the scene in slow motion, crashing violently to the ground, further agitating the dust.[1] The high-speed camera's quantum eye captures the particles as they scatter and regroup in the presence of this alien invasion, swirling around the rugged phalanges of the old man, whose fingerprints make an eerie, anthropocentric intrusion onto an otherwise inhuman stage. When I asked Kolgen about this heavy-handed artistic detail, he visibly winced. Although he could not explain why he regretted adding the human body into the mix, Kolgen suggested that it is a decision with which he still struggles, and he expressed a desire to edit it out for future screenings of the video. What I would suggest is that the corpse is indeed troubling, but not for the same reason as the fly. The corpse is not only an anthropocentric intrusion into a video that otherwise presents a close-up view of the vitality of nonhuman matter; it is also the

point at which *Dust* both reveals itself as human artifice and is simultaneously transformed from a *terror movie* into a *horror movie*, which, like all horror movies, relies on a heavy-handed delivery.

The fly is dead, and moreover, it lost its life in the making of the video. The fly is both sacrifice and gift. The corpse, on the other hand, is only staged as dead; it is an actor, a human agent inserting its clenched fist into the swarm. Kolgen will not speak for this human, will not stand up for it or defend it. It is excessive and beyond absolution. But more pertinently here, who will speak for the fly? Jussi Parikka, in his description of the work of artists who combine entomology and media technics, identifies their use of "found objects of nature" or "free media" as vehicles to "escape from the frameworks of 'human media'" (2010, 197). The terms *found* and *free* raise questions, as if they are agentless modifiers, randomly found circulating within language and free of value. If the intrusion of the human corpse in Kolgen's video reminds us of the anthropocentric desire for control embedded in supposedly nonspeciesist conceits, then the *free* and *found* corpse of the fly points to the ethical and ecological issues involved in insect art. Yet we might push beyond a discussion of the ethics of insect art, avoiding a confrontation with, for example, Damien Hirst's *In and Out of Love,* in which tropical butterflies emerge from pupae glued to canvases, only to die in the confines of a gallery's white box. Rather than discussing the treatment of the fly as object of suffering in Kolgen's work, we might consider the treatment of the fly's corpse. What's more, we might do so en route to considering the treatment of the dust, both in Kolgen's video and in Duchamp's *The Large Glass,* where it was glued permanently, petrified onto the surface of an objet d'art. Who will speak for the dust?

Questions such as "Who will speak for the dust?" border on the absurd. They recall the poetics of both romanticism and surrealism, while bringing to mind the more recent plea of W. J. T. Mitchell, which I have already discussed, for an end to the "self-indulgent breast beating" (2003, x) that characterizes animal rights movements and their potential offshoots: "Let us suppose, finally, that all these issues have been worked out and the rights of all animals, high and low, have been established. Would that be the end? Or would it then be time to turn to the rights of fruits and vegetables? Erasmus Darwin noted long ago that 'the loves of plants' are essential to their lives. Does that give them a claim to some sort of rights?" (2003, xi). To dismiss this problem of infinite regress in the determination of rights, Cary Wolfe suggests that what is at stake in the rhetoric of rights is not a hierarchy of *worthiness of being,* but a question of what it means to assign "rights" to nonhuman animals and other "objects" in the first place. As Wolfe suggests, it is not a matter of determining the rights

of things by establishing their "natural" qualities and assigning priorities (2010, 39) on a sliding scale or pyramid of relative value; rather, it is a matter of recognizing that ethics, in the final analysis, is a language game. Against the desire to link together a great chain of being, we have the sideways steps and missteps of worlds that are constantly being brought into being by objects both human and nonhuman. But this bringing into being can be recognized only through the use of language. That is to say, ethics "is about *concepts* and not about *objects*" (Wolfe 2010, 39). Questions such as "Who will speak for the dust?" remind us that we are inextricably enmeshed in this game, and that we have the option to push it to its limits. The question is, to what end? Why would we want to speak for the dust? Is this not in itself somehow excessive?

One reason to push the game to its limits, citing Ian Bogost, is to shatter "the reigns of both transcendent insight and subjective incarceration" (2012, 5). Yet we must question the effectiveness of "speaking for the dust," knowing full well that "subjective incarceration" is not a short-term penalty but an inevitable death sentence. Put otherwise, an alternative reason for exploring the question of rights, the question of what in Derrida's terms can and cannot be noncriminally put to death, is to practice the art of being an animal faced with two simultaneous and inextricable death sentences, two finitudes, to anticipate the work of Cary Wolfe discussed later in this chapter.[2] To speak for the dust petrified onto Duchamp's glass is to speak in full acknowledgment of these death sentences; it is to speak of one's own petrifaction in the face of both (a) physical death and (b) the limits of language. Such is the terror of philosophy, which, when pushed to the limits, can morph into a philosophy of horror.

In "On the Supernatural in Poetry," a seminal essay on gothic form, Anne Radcliffe (1826) attempts to tease out the subtle and elusive differences between terror and horror. Radcliffe's work serves in part as a corrective to Edmund Burke's highly influential essay, "A Philosophical Enquiry into the Origin of Our Ideas of the Sublime and Beautiful" (1756), which is a touchstone for Romantic aesthetics. The sublime in nature, suggests Burke, is experienced through the passion known as *astonishment:* "that state of the soul in which all its motions are suspended, with some degree of horror" (2001). Burke, who otherwise makes careful use of psychical terminology, refers to terror and horror indiscriminately, suggesting on one hand that "the sublimity of the ocean is due to the fact that it is an object of no little terror" and on the other that "infinity fills the mind with that sort of delightful horror which is the truest test of the sublime" (2001). Does the sublime, then, provoke terror or horror?

Burke's use of the term *astonishment* (petrified, turned to stone) to define the passion provoked by the sublime contradicts his contemporary

Anne Radcliffe's understanding of the psychology of the sublime. Radcliffe insists that the distinction between terror and horror is crucial for elucidating the psychological underpinnings of the gothic, which she wishes to align with the concept of the sublime. Her essay on the supernatural, published posthumously, consists of a dialog between two travelers, Mr. S- and Mr. W-, who discuss the characteristics of the sublime, primarily by making reference to the plays of Shakespeare. At one point, W- describes the horrifying encounter of the Weird Sisters in *Macbeth*, quoting the protagonist's "thrilling question":

> —what are these,
> So withered and so wild in their attire,
> That look not like the inhabitants o' the earth,
> And yet are on't? (I.iii:39–42)

The notion of the sisters as alien yet existing on earth, as bordering and perhaps threatening the human form, is crucial to understanding the concept of horror. As the conversation progresses between S- and W-, the travelers come to agreement that dreadful anticipation is an essential component of the sublime and that such a state of mind may be provoked by means of obscurity. Terror, W- suggests, in reference to imagery from Milton's *Paradise Lost*, "is seen in glimpses through obscuring shades, the great outlines only appearing, which excite the imagination to complete the rest." The conversation comes to a head when W- makes a definitive distinction between terror and horror:

> Terror and Horror are so far opposite that the first expands the soul, and awakens the faculties to a high degree of life; the other contracts, freezes and nearly annihilates them. I apprehend, that neither Shakespeare nor Milton by their fictions, nor Mr. Burke by his reasoning, anywhere looked to positive horror as a source of the sublime, though they all agree that terror is a very high one; and where lies the difference between terror and horror, but in the uncertainty and obscurity that accompany the first, respecting the dreading evil? (Radcliffe 1826)

Terror best describes the dread experienced by Macbeth and his companions as they travel through the fog to meet the witches on the heath; horror occurs in the shocking visual encounter of the witches.[3] Put more generally, as Devendra P. Varma (1957) suggests in *The Gothic Flame*, "The difference between Terror and Horror is the difference between awful apprehension and sickening realization: between the smell of death and stumbling against a corpse" (130).[4]

Radcliffe's distinction between terror and horror can be verified in reference to the origins of these terms. Radcliffe does not resort to etymology

specifically, but her association of horror with freezing suggests that she may be aware of the word's Latin heritage. *Horror* is derived from the verb *horreo,* which means *to bristle,* as in hairs standing on end. As Adriana Cavarero (2009) suggests in *Horrorism,* "the area of meaning covered by *'horreo'* and *'phrisso'* denotes primarily a state of paralysis, reinforced by the feeling of growing stiff on the part of someone who is freezing" (7). The word *terror,* on the other hand, can be traced not only to *trembling* but also to flight, in what Cavarero calls "the instinctual mobility of the ambit of terror" (4). Whereas horror contracts, freezes, and annihilates (Radcliffe), terror "moves bodies, drives them into motion" (Cavarero 2009, 7). The distinction between the two terms permits Radcliffe to elevate gothic fiction to the level of literature, primarily by pleading for the aesthetic (and perhaps moral) superiority of works that elicit terror over those that elicit horror. Radcliffe's words seem to ring true today if we consider, for example, how the literary and filmic genres of *suspense* and *thriller* (terror genres) might achieve critical acclaim, whereas the *horror* genre is generally viewed as B-grade material. Consider, for example, the words of Stephen King: "I recognize terror as the finest emotion and so I will try to terrorize the reader. But if I find that I cannot terrify, I will try to horrify, and if I find that I cannot horrify, I'll go for the gross-out. I'm not proud" (1980, 26).

This distinction between terror and horror provides Adriana Cavarero with a vehicle to describe the excesses of human violence—excesses that, following Hannah Arendt, threaten the ontological dignity of the human. The very expression "ontological indignity" reeks of anthropocentrism, as if, through some naïve ignorance of twentieth-century philosophy, we might accord a unified ontology to the human form; as if the human were a privileged object with innate rights. Yet, following Hannah Arendt and Judith Butler, Cavarero refers to the ontological dignity of the human as that which allows us, in the final analysis, to distinguish between terror and horror, between crimes against a human and crimes against humanity. Focusing primarily on female suicide bombers in the Middle East, Cavarero's thesis is that the word *terror,* which has become synonymous with violent, politically motivated, strategic action, has been frozen into place, rendered immune to more complex psychological conceptions. Most importantly, the word *terror* does not speak for the victims of violent political action. It speaks instead to the perpetrators (terrorists) of that action, and to those who survive the terrorist acts and are left to face the psychological trauma of such events.

What is at stake here is how language games shape concepts and how those concepts in turn, by leaving things out, form the basis of biopower. As Cavarero

suggests, "Names and concepts, and the material reality they are supposed to designate, lack coherence. While violence against the helpless is becoming global in ever more ferocious forms, language proves unable to renew itself to name it; indeed, it tends to mask it" (2009, 2). In response to this situation, Cavarero recommends a distinction between terrorism and what she calls "horrorism," which pinpoints the violence done to vulnerable bodies through deliberate human action: "On closer inspection, violence done against the helpless does turn out to have a specific vocabulary of its own, one that has been known, and not just in the Western tradition, for millennia. Beginning with the biblical slaughter of the innocents and passing through various events that include the aberration of Auschwitz, the name used is 'horror' rather than 'war' or 'terror,' and it speaks primarily of crime rather than of strategy or politics" (3). Cavarero notes that "the crude reality of bodies rent, dismembered, and burnt [cannot] entrust its meaning to language in general or to any particular substantive" (2–3). However, paying careful attention to the role of language in describing violence is central to understanding the mechanics of biopower, just as it is crucial in the formation of an ethics.

Keeping in mind *Macbeth*'s Weird Sisters, Cavarero observes that women have played a central role in the mythology of horror, beginning perhaps with the horrible duo of Medusa and Medea. Whereas Medusa stands out as the "mythical face of horror," Medea is renowned for her "more repugnant crime against the helpless" (2009, 3). Edmund Burke's association of horror with *astonishment* rings true in the case of Medusa, whose victims are quite literally turned to stone at the site of her repulsive face. The source of this revulsion, suggests Cavarero, can be traced in the violence enacted on the human form as represented in the visage of Medusa, whose snaky hair renders her monstrous, and transfixes her victims. "Gripped by revulsion in the face of a form of violence that appears more inadmissible than death, the body reacts as if nailed to the spot, hairs standing on end" (Cavarero 2009, 8). The sight of Medusa is worse than viewing a corpse, for her hybridic embodiment calls into question the integrity of the human form, paralyzing the viewer's ability to make sense of the sight. Horror, then, exceeds death; it represents not only the cessation of life but also a challenge to the human form itself. Unlike terror, horror has nothing to do with "the instinctive reaction to the threat of death"; rather, it has to do with "instinctive disgust for a violence that, not content merely to kill because killing would be too little, aims to destroy the uniqueness of the body, tearing at its constitutive vulnerability" (8). The key term *vulnerability* indicates why Medea, more than Medusa, is emblematic of the relationship between horror and the physical precariousness of the human animal.

Oblivious to any notion of care, Medea (at least according to Euripides's misogynistic version of the tale) mortally wounds *(vulnerare)* her own children to exact vengeance on her husband Jason. Most importantly, Medea murders not only the small children, but her own brother Absyrtus, whose body she dismembers and casts into the sea, piece by piece, as a tactic to escape the pursuit of her father Aeëtes, king of Colchis. In these scenes, "what is at stake is not the end of a human life but the human condition itself, as incarnated in the singularity of vulnerable human bodies" (Cavarero 2009, 8).

Medea's legacy persists in the actions of female suicide bombers, who capitalize on the vulnerability of human bodies to enact their atrocities. Of course, these women scatter their own bodies as well, turning themselves into weapons, intermingling flesh and bone with the stuff of *dirty bombs* (rusty nails, kitchen utensils, shards of glass, etc.). Cavarero points to the actions of female suicide bombers as a means of distinguishing contemporary terrorism from what she calls *horrorism.* Whereas terrorism involves a tactics of fear, the progressive instilling of anxiety into a targeted enemy, horrorism is confined to brief moments of time in which violence is enacted on those who are most exposed to wounding. In Cavarero's words, contemporary horrorism is "a technique of annihilation that focuses on the instant rather than on the process. The defenseless being is not fabricated with methodical persistence but only killed or wounded or mutilated" (2009, 75). The horror, here, occurs at an ontological level, through a transformation of the human animal itself: the bomber is transformed into an explosive device, an assemblage of circuits, glass, bits of iron, and other materials; the victims are transformed "beforehand," as Cavarero notes, "from singular being to random being" (75). Suicide bombing not only assaults the physical bodies of the bomber and random individuals; it also attacks their ontological integrity. Following discussions of the holocaust by Hannah Arendt and Primo Levi, Cavarero suggests that "the crime [both of the holocaust and of suicide bombing] discloses its profundity, going to the very roots of the human condition, which suffers offense at the ontological level" (32). Unlike terror, which is experienced as the fear of a singular individual threatened by an impending danger, horror threatens the entire species. Horror, which finds its apotheosis in genocide, is not about individuated deaths; it is about the extinction of the human species.

A comparison of suicide bombing to genocide, and in particular to the holocaust, does not rely on an argument of scale. Cavarero is not suggesting (as do both Jacques Derrida and J. M. Coetzee's character, Elizabeth Costello, regarding the death of livestock) that the number of individuals killed by suicide bombing equals the number of individuals killed in Dachau and Auschwitz.

The point here is that even the horrific death of a singular human can serve as a crime against all of humanity, can serve as a gesture toward human extinction. Of course, this brings us to the elephant in the room of Cavarero's discussion, which is the very question of what it means to be human. As Cavarero suggests, citing Hannah Arendt, "horror has to do precisely with the killing of uniqueness, in other words; it consists in an attack on the ontological material that . . . transform[s] unique beings into a mass of superfluous beings whose 'murder is as impersonal as the squashing of a gnat'" (2009, 43). Cavarero builds much of her argument on Arendt's discussions of the holocaust, particularly in *The Human Condition* and in *The Origins of Totalitarianism*. For Arendt, the *Lager* (death camps), by annihilating what she sees as the uniqueness that qualified the human condition, transformed humans "into specimens of the human animal, who behave like dogs in Pavlov's experiments" (cited in Cavarero 2009, 43). The problem here, of course, as anticipated by the preceding reference to Derrida, is that this conception of horror as human disindividuation is conspicuously speciesist. If horror occurs when *man* is reduced to the status of a *nonhuman animal* (e.g., a dog or a gnat), then this suggests that horror can only be a uniquely human passion. It is one thing to see the mutilated body of a pig, Cavarero seems to suggest, and quite another to see the mutilated body of a human. Only the latter scene is capable of provoking horror.

To pursue this point, is it possible, for example, to feel horror at the sight of a mutilated dog? Or how about a pig? Cavarero addresses this question obliquely in a chapter aptly entitled "So Mutilated That It Might Be the Body of a Pig." Her point seems to be that, in the face of a mutilated human, our first response, triggered by self-preservation or perhaps by personal experience, might be the expectation that we are viewing a nonhuman animal. Hence, while the mutilated body of a pig or a dog might provoke terror, following the logic of Cavarero, it cannot provoke horror, which arises only when the human form itself suffers an "ontological indignity." Rather than view this speciesist concept of horror as an indictment of Cavarero's anthropocentricity, I would suggest that the distinction is both instructive and useful in the development of an ethics to guide our relationship with nonhuman animals. Consider, for example, how this distinction might apply to Cora Diamond's (2009) essay "The Difficulty of Reality and the Difficulty of Philosophy," which might be read, with a nod to J. M. Coetzee, as a chapter on the deaths of animals. Cary Wolfe has written extensively about this essay, which he views as an exemplary thesis on the concept of *unspeakability:* "not only the unspeakability of how we treat animals in practices like factory farming but also the unspeakability of the limits of our own thinking in confronting such a reality" (2010, 69). Diamond's

thesis revolves around Elizabeth Costello, a character from Coetzee's book *The Lives of Animals* (1999), who in Diamond's words, "is a woman haunted by the horror of what we do to animals. We see her as wounded by this knowledge, this horror, and by the knowledge of how unhaunted others are" (2009, 46). For Diamond, Costello embodies the pervasive "woundedness or hauntedness" of Coetzee's lectures in *Lives of Animals* (Diamond 2009, 47). "What wounds this woman, what haunts her mind," suggests Diamond, "is what we do to animals. This, in all its horror, is there, in our world. How is it possible to live in the face of it? And in the fact that, for nearly everyone, it is as if nothing, as the mere accepted background of life?" (47).

Clearly, the version of horror encountered in Diamond's essay is far removed from the horror defined by Cavarero as a threat to the ontological dignity of the human. Horror here arises from Costello's response to the mass-killing of animals; but also, and this is crucial to recognize, it arises from her indignation in the face of fellow humans who do not adequately value, or more precisely, recognize the lives of animals. It is this second horror, as a human animal pleading to fellow humans who do not properly recognize the lives of animals, that causes her sense of isolation (Diamond 2009, 74). As Cary Wolfe suggests, Costello's lecture demonstrates both "the exposure of our concepts to the confrontation with skepticism and the *physical* exposure to vulnerability and mortality that we suffer because we, like animals, are embodied beings" (2010, 72). But following Cavarero's claims, Costello can feel *horror* toward the human denial of animal cruelty only if she sees this denial as constitutive of an ontological indignity to the human species. The killing of nonhumans by humans is horrifying only if humans and nonhumans share the same ontological status. Put otherwise, Costello is calling for an ontology that ties humans more closely to nonhuman animals, in such a way that to respect the ontological dignity of the human would require not putting nonhumans to death.

As Bernard Stiegler suggests in *Technics and Time 1*, "all suffering at seeing the other suffer is but projection, the anticipation of the elementary fragility, of the essential peril in which he finds himself, out of which and in which he is encountered" (1998, 130). For Costello, this projection extends to nonhuman animals. Her ontological recipe can be achieved only through a radical identification with and projection into nonhuman animals, and we see this when her lecture, rising to gothic heights, shifts precariously from a discussion of the death of animals to a discussion of her own death. "I know what it's like to be a corpse," says Costello. "The knowledge repels me. It fills me with *terror*" (Coetzee 1999, 73; my emphasis). With these words, Costello is expressing a patent experience of death anxiety, or more precisely, existential

terror. But at the same time, her reference to being a corpse, frozen, trans-fixed, suggests horror, as if she has faced death in the instant, that is, her own death. The problem here is that if horror requires moving beyond the antici-pation of an event to its full-frontal experience, then it is impossible to experi-ence one's own death as a source horror. However, through an imaginative or compassionate conflation of oneself with an other—in this case a nonhuman other—Costello can experience the killing of nonhumans as a simultaneous death of the human species.

Costello continues her gothic soliloquy by adding, "What I know is what a corpse cannot know: that it is extinct, that it knows nothing and will never know anything anymore. For an instant, before my whole structure of knowl-edge collapses in a panic, I am alive inside that contradiction, dead and alive at the same time" (Coetzee 1999, 73–74). Recalling the words of Ernest Becker, Diamond is expressing the essential anxiety of the human animal: "What does it mean to be a self-conscious animal? It means to know that one is food for worms. This is the terror: to have emerged from nothing, to have a name, con-sciousness of self, deep inner feelings, an excruciating inner yearning for life and self-expression—and with all of this yet to die" (1973, 87). However, given Costello's identification with nonhuman animals and her expansive ontologi-cal conception of her own humanity, there is something else happening here, something beyond Becker's existential terror. Costello's description of her psy-chological state clearly describes a sense of horror, which, given the context of her discussion, has been instilled by imagining the undignified deaths of non-human animals. Most importantly, perhaps, Costello's use of the term *extinct* here signals a categorical distinction from simple *death*. What Costello is describing here is not simply her own death, but her sense of being petrified at the sight of an ontological indignity, an indignity that she experiences through an affiliation with both human and nonhuman animals. As I have already sug-gested, horror, which finds its apotheosis in genocide, is not about indi-viduated deaths; it is about the extinction of a species. Costello embodies a point of view from which the genocide of animals simultaneously renders the human species extinct.

At least one more question remains in all of this, and that is whether Costello can really know what it is like to be a corpse. In his semi-fictional response to Coetzee's *Lives of Animals,* Peter Singer expresses disdain for the idea that Costello can "think [her] way into the existence" of any being (1999, 91), let alone a corpse. Asking what it is like to be a corpse would seem to be an absurd concept to consider, much like "Who will speak for the dust?" However, the question deserves attention since Diamond's essay involves not one corpse

(Costello's), but two. This second corpse, which makes a brief but no less hor-rifying appearance in Diamond's essay, emerges from Mary Mann's short story "Little Brother." The story is only five pages in length, describing the ill-fated delivery of Mrs. Dodd's thirteenth child, who is stillborn. What makes the tale "spiky," as A. S. Byatt (1998) describes it in appropriately gothic terms, is that the corpse of the newborn is transformed into a doll for the children of the house. Mrs. Dodd, yet another progeny of Medea, reflects laconically on the scene by explaining to her visitor, "Other folkes' child'en have a toy, now and then, to kape 'em out o'mischief. My little uns han't. . . . He've kep' 'em quite [quiet] for hours, the po'r baby have; and I'll lay a crown they han't done no harm to their little brother" (Mann 2008, 141). Diamond reflects on this story to demonstrate how it "shoulders us from a sense of being able to take in and think a moral life, from a sense of being able to take in and sense a moral world. Moral thought gets no grip here" (2009, 64). There is a double terrible-ness in this tale, suggests Diamond, "the terribleness of what is going on and the terribleness of the felt resistance of the narrated reality to moral thought" (64). What is interesting here is Diamond's use of the term *terrible* (which pre-cedes her description of Costello's horror provoked by the plight of animals) to describe both the plight of the stillborn child and the ontological indigna-tion Costello senses when faced by the mother's laconic response. Surely, this is not a terrible tale at all, but a horror story. The potential double horror here would involve a response to (a) the ontological indignity done to the vulner-able body of the dead child and (b) the ontological indignity of the mother's apathetic reaction to this treatment of the stillborn child. Diamond's descrip-tion of this scene as "terrible" rather than "horrible" (which is how she describes the mass killing of animals), must be viewed as a confusion of terms, unless she places a higher value on nonhuman animals than she does on the human child. This precarious confusion of terms, which I confess infects the entirety of this chapter, is yet another symptom of the unspeakability of a situation in which "moral thought gets no grip" (Diamond 2009, 64).

The potential for both a nonhuman animal and a tiny human corpse to provoke horror is as much a failure of language (the second finitude) as it is a success of the imagination. As Diamond suggests, there is "nothing wrong" with "imaginatively read[ing] into animals" the expectation that we as human beings are demanded to be "as other than animal" (1995, 333), and hence to resist causing their suffering. The problem, suggests Diamond, is that when we project an ontological flattening onto humans and other species of ani-mal, "there is no footing left from which to tell us what we ought to do" (1995, 333). It is for this reason that Cary Wolfe lauds Diamond for suggesting that "it

is not by denying the special status of the human being, but by intensifying it that we can come to think of nonhuman animals not as bearers of interests or rights holders but rather as something much more compelling: fellow creatures" (2010, 115). What makes this alliance with nonhuman animals possible, according to Diamond and Wolfe, is their vulnerability, and in particular, their mortality. Nonhuman animals are, in the words of Diamond, "our fellows in mortality" (2009, 77). I would like to suggest that what Wolfe and Diamond propose in their work is a philosophy of terror, a philosophy in which our own consciousness of mortality, a consciousness that can only be obscure, impossible, sublime, provides appropriate footing for an ethical stance regarding the treatment of animals and other nonhuman things. This stance is made possible by retaining uniqueness for the human animal, a uniqueness based primarily on the human's awareness of mortality. Hence, we have a philosophy rooted in dread, or a terror philosophy.

But what would it mean for a philosophy to obliterate the uniqueness of the human, as the suicide bomber does, for example, by transforming herself into an assemblage of glass, iron, circuits, flesh, and bone? The result would be a philosophy of horror, or more appropriately, a horror philosophy. Let us conjure up once again, for the third time even, *Macbeth's* Weird Sisters. But first, we should note that they are not the only horrifying women in the play. Lady Macbeth herself makes use of imagery that moves us beyond the dread of terror and into the excess of horror. Perhaps the best example is in her attempt to shame her husband into sticking to the plan:

> I have given suck, and know
> How tender 'tis to love the babe that milks me:
> I would, while it was smiling in my face,
> Have pluck'd my nipple from his boneless gums,
> And dash'd the brains out, had I so sworn as you
> Have done to this. (1.7.54–59)

This is not the only gruesome handling of a human baby in the play, which hinges on the plot-solving detail that "Macduff was from his mother's womb / Untimely ripp'd" (5.8.15–16). These references to infants are far more memorable in *Macbeth* than the ones present in the words of the Weird Sisters, but it is in the witches' incantations over the cauldron that we see most clearly the workings of horror:

> Scale of Dragon, Tooth of Wolf,
> Witches' Mummy, Maw and Gulf

Of the ravin'd salt Sea shark,
Root of Hemlock digg'd i' the dark,
Liver of Blaspheming Jew,
Gall of Goat, and Slips of Yew
Silver'd in the Moon's Eclipse,
Nose of Turk, and Tartar's lips,
Finger of Birth-strangled Babe
Ditch-deliver'd by a Drab,
Make the Gruel thick and slab.
Add thereto a Tiger's Chaudron,
For the Ingredients of our Cauldron. (1.4.22–34)

It is essential to ask at what point this litany turns horrible. For some animal rights activists, the mishandling of a wolf's tooth might be cause for horror. But from an unabashedly anthropocentric point of view, the recipe becomes horrifying at the mention of the Jew; that is, if we accord the Jew, let alone the Turk and Tartar, with full human status, a question that would require an altogether separate discussion of race in the work of Shakespeare. Without a doubt, Shakespeare reserves the climax of the horror for the last half of this incantation, where the "Finger of Birth-strangled Babe" is given two full lines of emphasis. Once again, there is a double horror at work here: first, there is our repulsion to the mishandling of the vulnerable Babe (the horror would be less severe if, say, the finger were lost by a warrior who died in battle); and second, there is our repulsion to the witch's assault on the ontological dignity of the human. The human parts—nose, lips, and finger—are thrown into the cauldron alongside hemlock root, wolves' teeth, and yew slips. The result of this brew is a horrifying ontological flattening, which accounts for the unspeakable morality of this scene.

Witches, of course, are not the only progenitors of horrifying litanies whose flat ontology is capable of provoking horror.[5] Consider, for example, Ian Bogost's "bestiary of the undead," which is how he describes his "alien ontology" (2012, 133). Bogost's design, it seems, is to create a philosophy that provokes terror, as discussed in the following passage: "In the face of the undead, we exhibit terror. Troubled souls seek relief, silence, release. They operate by broken logics, ones recognizable as neither alive nor dead but striving for one or the other. We fear them because we have no idea what they might do next" (2012, 133). Of course, as should be amply clear by now, in the face of the undead, we do not exhibit terror—we exhibit horror. And we do so because the undead present us with an unspeakable affront to the ontological dignity of the human. For

example, Primo Levi (1988) describes the walking dead in the internment camp at Monowitz-Auschwitz as "non-men who march and labor in silence, the divine spark dead within them, already too empty to really suffer. One hesitates to call them living: one hesitates to call their death death, in the face of which they have no fear, as they are literally too tired to understand" (83–84). To borrow Julia Kristeva's words from the *Powers of Horror*, the undead present us with "a massive and sudden emergence of uncanniness . . . on the edge of non-existence and hallucination, of a reality that, if I acknowledge it, annihilates me" (1982, 2). The undead come to us as Kristeva's *abject*, the symptom of which is "a language that gives up, a structure within the body, a non-assimilable alien, a monster, a tumor, a cancer that the listening devices of the unconscious do not hear, for its strayed subject is huddled outside the paths of desire" (1982, 11). The undead, in their monstrosity and unassimilability, *annihilate* us; they unseat and unsettle us; they are weird and wayward; they send us astray.

These traits of the undead are useful for those who wish to mount a horror philosophy. In "Zombies Ate My Ontology," Nathan Gale (2009) suggests that

> as non-human objects take on human characteristics, they become creepy or horrific. Yet, looked at from the opposite end, as humanity is stripped away of language and of the ability to create and fantasize, it too becomes horrendous.

With this in mind, Gale proposes a "zombie ontology," thereby pushing the borders of object-oriented philosophy (OOP) / object-oriented ontology (OOO) to its abject extreme:

> Zombies are the uncanny kernel of the Real, they are not the object which leaves a remainder, they ARE the remainder. Zombies are Das Ding, the Thing, human qua object. And because of this, OOP/OOO must deal with the zombie much in the same way Postmodernism (especially in Haraway and Lyotard) had to deal with the cyborg. However, instead of talking about how humanity will have become, OOP/OOO will have to talk about in what ways humanity is not unique— how we are all zombies. They must take up the zombie as a human representative since only in the zombie do we find the human as it "really" exists, without any obfuscation. (2009)

Gale's "zombie ontology" demonstrates what happens when philosophy deliberately strips the human animal of its uniqueness, strips it even of its own death. There is no question of defining the human in terms of its finitude here, for this is not a terror philosophy, a philosophy rooted in the unspeakability, the *impossible possibility,* of death. What we have here is a horror philosophy,

one that seeks to outstrip death for an opportunity to stand petrified in the face of the corpse.

It is difficult to tell if Nathan Gale's philosophy is on the level. One would like to think that it is comedy writing, in the same way that one might instinctively assume, in the presence of a mutilated human body, that one is seeing a pig. But Gale's work is the logical and naïve extension of OOO, especially that flavor of OOO that revels in the leveling of litanies—"mountain summits and gypsum beds, chile roasters and buckshot, microprocessors and ROM chips" (Bogost 2012, 34)—for the sake of annihilating human uniqueness. It should come as no surprise that *Alien Phenomenology* begins with a contemplation of Alan Weisman's book *The World Without Us,* which inspires Bogost to imagine "the things that would take place if humans were to suddenly vanish from earth. Subways flood; pipes cool and crack; insects and weather slowly devour the wood frames of homes; the steel columns of bridges and skyscrapers corrode and buckle" (6). What the author reveals is that OOO is indeed a philosophy of human extinction. When speculation about the *eventual* demise of the human individual gives way to a desire for the immediate demise of the human race, terror shifts gears into horror. And so we have a horror philosophy, one that "do[es] not have to wait for the rapturous disappearance of humanity to attend the plastic and lumber and steel" (6).

Of course, the most infamous horror philosophy of late comes to us from Eugene Thacker. In the concluding paragraph of *After Life,* Thacker (2010) discusses the very sort of "unintelligibility" noted by Derrida, Wolfe, and Diamond in their work on the lives of animals. He proposes that "to think a concept of life that is itself, in some basic way, nonhuman," is to introduce a "limit-concept" into philosophy itself (Thacker 2010, 268). Thus far, Thacker appears to be proposing a terror philosophy rooted in the unknowability of nonhuman others, a fear of the unknown, albeit without the sense of shared vulnerability expressed by Derrida, Wolfe, Diamond, and others. But what Thacker wants is not a seemingly outmoded conception of philosophical thought inflected with existential terror; what he wants instead is a horror philosophy, one for which "supernatural horror is one of the paradigms for the concept of 'life' today—not because of the fear of death, and not because of the crises that populate life, but because of a furtive, miasmatic unintelligibility that inhabits any ontology of life" (268). Thus far, Thacker's understanding of unintelligibility must be understood only as terror, a sense of dread provoked by the obscure, the "miasmatic" nature of trying to think an ontology of life beyond the human. Terror turns to horror, however, when Thacker "poses the basic dilemma" of thinking "a concept of life that is itself, in some basic way, [not

just] unhuman, [but] a life *without us*" (268). What is horrifying here is not Thacker's desire to think a concept of life that is unhuman, but a desire to think in excess of this, to a life *without us*. It is this excessive desire, this gesture toward extinction, that drives Thacker's horror philosophy.

In the introduction to *In the Dust of This Planet: Horror of Philosophy, Vol. 1,* Thacker (2011) suggests that he is not interested in the philosophy of horror, that is, reducing literary or cinematic horror to a "formal system" (3). Instead, his goal is to focus on a mode of philosophy based on "the isolation of those moments in which philosophy reveals its own limitations and constraints, moments in which thinking enigmatically confronts the horizon of its own possibility—the thought of the unthinkable that philosophy cannot pronounce but via a non-philosophical language" (Thacker 2011, 3). Once again, this description falls in line with the obscurity and unthinkability that are characteristic of terror. But Thacker's speculative exercise brings him to the horror film genre as a "non-philosophical" vehicle for examining the ontological extinction of the human in the face of unspeakable nonhuman creatures. Once again, the problem here is that many of the "creatures" Thacker discusses in the book are not necessarily horrible but terrible. Mists, ooze, and blobs (2011, 9), through their obscure formal properties, are certain to provoke terror, recalling once again that terror is above all a sense of dread in the face of unknowability. Horror, on the other hand, presents us with a hard-core certainty.

Horror is the certainty that Hannibal Lecter's mask was crafted from the flayed facial flesh of the prison guard. Horror is what Sally experiences as a captive of Leatherface, confronting the assemblage of severed limbs that have fallen victim to the Texas chainsaw. The reference to faces and masks here is not accidental, as it recalls the concept of the *face-to-face*, which serves as the basis of Levinas's ethics. Violence done to the human face is quite possibly the most powerful vehicle for provoking horror since it strikes directly at the physical trait that makes impossible a reduction to sameness. Following Levinas, Cavarero suggests that "horror always concerns the face. Or at any rate concerns it first and foremost, given that the uniqueness displayed in physiognomic features is immediately visible and that it discloses itself *[si affaccia]* by exposing itself to the other" (2009, 15). "The skin of the face," suggests Levinas, "is that which stays most naked, most destitute" (1985, 86), and it is for this reason that we might recognize in the face an essential poverty, a vulnerability that captures the common finitude shared by all living creatures. Horror occurs when this vulnerability is intentionally violated, when a recognition of one's own animal finitude tips over into a desire for the annihilation of the species.

To invent a horror philosophy, one must deal directly with violence, dole it out, even, en route to annihilating the species. I have already noted that the philosophy of Mario Perniola, inspired primarily by the work of Bataille, is designed to do violence to the very notion of ontological integrity, and it does so by annihilating the human form through a correlation of humans and things that enacts "the disappearance of the subject" (2004, 44). Thacker's *Horror of Philosophy,* which relies heavily on Bataille, is no less hard-core. In reference to Bataille's notions of continuity and discontinuity, Thacker suggests that "our intimate binding to everything gives us the impression of our interconnectedness and of the interconnectedness of all things, human beings being only one type of thing" (2011, 149). This concept of intimacy with the world is complicated by the fact that in order to achieve continuity with all things, we must exceed the limits of our own humanity. Or in Thacker's words, "To exist *as* the world, we must cease existing *in* the world" (149). It is this idea of extinction that drives Thacker's nihilistic philosophy, which tests the limits of speculation. It is also this notion of extinction that makes the sadomasochism of Sade so central to the work of Bataille, for it embodies quite literally, through the erotic binding of sexual intimacy and death, the annihilation of the subject in the face of the other.

Thacker may have penned *Horror of Philosophy,* but Bataille is without a doubt the premier horror philosopher, since his work is based primarily on exacting a horrific violence to the ontological integrity of the human. As Adriana Cavarero suggests, the work of Bataille (and I would add the work of Thacker, Bogost, and Perniola) presents us with "a certain mode of thinking about horror that tends to emphasize, if not relish, its erotic aspects" (2009, 48). Such a philosophy eschews contemplation of human finitude for the sake of reveling in the indefiniteness of being, which is also a gesture toward infinity. In Cavarero's words, "it is precisely this dissolution of the finite into the infinite, erotically enjoyed in cruelty, that solicits Bataille's interest in Sade, who remained one of his principal points of reference" (2009, 48). The legacy of Bataille, which is quite prevalent in the work of Thacker and other horror philosophers, becomes problematic if one tries to apply such modes of thinking in the context of contemporary debates on violence, whether it be the violence done to animals in factory farms or the violence inflicted on the vulnerable victims of a suicide bomber.

The point I wish to make is that the appeal to *intimacy* underscored by Thacker in his references to Bataille's erotics and to Nishitani's self-annihilation through "a most intimate encounter with everything that exists"

(2011, 158) is qualitatively (e.g., morally and ethically) different from a philosophy of intimacy that is attuned to the vulnerability and suffering of things. What is at stake here are two modes of philosophizing, both radically posthuman but different in that one stops at terror whereas the other rushes headlong into horror. It is the difference between a philosophy of terror that, recognizing the limits of thought, still seeks to intensify the status of the human and horror philosophy that denies any access to ontology and revels in the extinction of the human species. The latter calls for an ever-increasing responsibility on the part of humans toward both their human and nonhuman others, whereas the former takes delight in the thought that "every 'communication' participates in suicide and crime" (Cavarero 2009, 59). One expands the ontological scope of the human; the other, which can only be called necrophilic, annihilates the human altogether, not because it stops momentarily at the sight of the corpse, but because it chooses to lie down with it.

In an epigraph at the beginning of this chapter, Ernest Becker speaks of the "forward-momentum" shared by humans and other organisms. The videos discussed at the beginning of this chapter demonstrate how non-philosophical language, in this case a digital video, can turn us to stone by exposing us to an unsettling nonhuman world that annihilates our anthropocentric preconceptions. The video accompanying *Dust* at the Perimeter Institute was equally horrifying. *Datamatics v2.0* by Riyoji Ikeda presents the viewer with raw streams of data that are converted into sound and image, pushing the limits of human perception by means of an audiovisual excess that paralyzes the viewer in her seat. As with *Dust,* viewers of *Datamatics v2.0* must wear earplugs, bombarded as they are by pulsating infrasound that stirs the bowels. This excessive audio stimulation is matched by the visual spectacle of hyperspeed data flows, which helped drive my theater companion to tears. The viewer is launched into outer space for a rhythmic visualization of galaxies and star coordinates, then sucked back into an even more complex constellation of amino acids, leading eventually to strings of DNA buzzing hypnotically across the screen. The impression here is certainly that of a *world without us,* a world of digital vitality that, thanks to audiovisual pyrotechnics, pushes us deep into our seats, oppressively reminding us of our own insignificance in the face of a digital universe that our senses are unable to parse. What makes this video horrifying is its technical prowess, the excess of audio volume and visual detail, which were deliberately designed by Ikeda to overwhelm the audience's senses. But is it really safe to call this video a horror movie? It certainly appeared as such to my sensitive companion in the theater, the one who cares not for digital data but feels a deep affiliation with and responsibility for rabbits, spiders, and sometimes

even kitchen utensils. In the end, we must acknowledge that we ultimately choose what vulnerabilities to recognize and not recognize, and that this choice is at the center of our ethical and moral debates.

Perhaps the inhuman digital world of *Datamatics v2.0* provokes horror by reminding us that the human, "a creature whose nature is to try to deny his creatureliness" (Becker 1974, 220), is always already technical, implicated as it is in a coevolution driven forward by technics.[6] In the words of Bernard Stiegler, "what is specific to the human is the movement of putting itself outside the range of its own hand" (1998, 146). More cleverly, the human is "an accident of automobility caused by a default of essence *(panne d'essence)*" (121). But this accidental technicity, while it confounds our attempts to determine a human essence, does not require that we give ourselves over completely to the inorganic and the ahuman. If we are to uphold any right for the human species, it might well be, to borrow from David Wills, "the right to *hold back*, not to presume that every technology is an advance" (2008, 6). I would add to this that we need not presume every posthumanist theory is an advance. Finally, and above all, the technicity of the human should remind us of our capacity to expand our ontological dimensions, and with this comes a responsibility to move in directions that acknowledge our own vulnerability while recognizing the precarious finitude of others, both human and nonhuman, technical and nontechnical.

ACKNOWLEDGMENTS

While I was running with friends at a landfill known as "the Dump," Jason Petro and Tim Brunet were the first to entertain and encourage my outlandish *Dreadmill* concept, which is where this project of making and thinking begins. *Dreadmill* came to fruition with the help of many collaborators and believers, including the ever-versatile Steve Karamatos, the incredibly generous Marc Paulik, and several faculty members and students of E-Crit at the University of Detroit Mercy (UDM). Nathan Blume, Nick Rombes, and the Reverend Dr. Lincoln Swain are all in this book, in one way or another. Also at UDM, John Staudenmaier introduced me to *The Denial of Death,* which transformed *Dreadmill* into a book project. Loyal members of the Ernest Becker Foundation, especially Neil Elgee and Sheldon Solomon, helped me understand the full force behind *The Denial of Death* and inspired my existential commitment to the question concerning technology.

At the University of Waterloo, I was given the academic freedom and space (physical and ideological) to develop most of the projects and ideas outlined in these chapters, including the Critical Media Lab (CML) itself. This book is an affirmation of the CML concept, and it celebrates the work of students, faculty members, artists, and community members who have worked in the lab and supported its very idea. At the top of the list is Pouya Emami, whose technical tactics and loyal friendship kept the lab alive and fueled the mad science behind *Cycle of Dread* and *Myth of the Steersman.* To all the students who endured my unrealistic expectations and created objects-to-think-with in the CML, I owe a huge debt of gratitude. It is a shame that only some of you made it into this book, including Dani Stock, who proofread and formatted this manuscript when I lost my vision in the summer of 2013, and Jessica Antonio-Lomanowska, the "Roach Lady." This project was also supported financially by the Social Science and Humanities Research Council, the Canada

Foundation for Innovation, the Ontario Arts Council, the University of Waterloo Faculty of Arts and Department of English, and the Ernest Becker Foundation.

Given infinite space and time, I would now produce a long list of scholars who listened to the ideas in this book and provided feedback and support, including Bernard Stiegler, N. Katherine Hayles, Cary Wolfe, and a great many members of the Society for Literature, Science, and the Arts (SLSA), who sat through my panel discussions and weren't afraid to have death talks during coffee breaks. What drew me to the SLSA in the first place is Ron Broglio, my adoptive brother, profound commiserator, and philosophical soulmate. Ron has been a great champion of this book, and I daresay it would not exist without him.

There are other soulmates out there who may never read this book but who certainly helped make it possible, including my parents and siblings, some of whom had the courage to support this project by wearing a T-shirt emblazoned with the catchy phrase "Embrace Your Finitude." I thank Blake for introducing me to *Jak and Daxter,* learning to use all the gadgets before I did, and putting up with discussions of animal ethics while we were fishing. To Sophia, thank you for providing the heartbreaking beach scene in *Dreadmill* and for wisely coining the phrase "(Hypo)Critical Media Lab." And then there are Katelyn and Chelsey, who came to this project *in media res* and provided support without knowing it. Finally, I arrive at Laurel, to whom this book is dedicated. You gave me the courage to rescue this manuscript from the depths of despair and assemble it into a living thing that is part of our legacy. You have shown me that the most powerful forms of communication (even those between humans and rocks) are rooted in empathy, in the recognition of a shared vulnerability. Most of all, you have taught me the difference between having intellectual convictions and having the conviction to live thoughtfully. Thank you.

NOTES

Introduction

1. The bat reference is an obvious nod to Thomas Nagel, whose essay "What Is It Like to Be a Bat?" serves as a touchstone here.

2. In *Evocative Objects,* Turkle explores how objects might serve as "companions to our emotional lives or as provocations of thought" (5). To do Turkle justice, I must note that she focuses intently on the affective dimension of this relationship, suggesting, "We think with the objects we love; we love the objects we think with" (5). I explore this seemingly questionable focus on object-love in chapter 7.

1. Necromedia Theory and Posthumanism

1. In my interview with Stiegler published in *Configurations,* he follows Socrates's understanding of *kleos* as "'reputation,' 'glory,' 'posterity,' etcetera" (O'Gorman 2010, 474). It is important to distinguish *kleos,* which is assigned posthumously, from the recognition of heroic action more generally. As Stiegler notes, "recognition, according to Hegel, takes place in frontal relations with others, face-to-face, while *kleos* does not" (O'Gorman 2010, 474–75). As I suggest throughout the book, technology can serve as a vehicle for both heroic recognition and posthumous *kleos.*

2. Heidegger's summary definition of *gestell* as the essence of technology marks the crucial point at which he distinguishes technology from technical instruments: "Enframing means the gathering together of that setting-upon which sets upon man, i.e., challenges him forth, to reveal the real, in the mode of ordering, as standing-reserve. Enframing means that way of revealing which holds sway in the essence of modern technology and which is itself nothing technological" (1982, 20).

3. In Landow's terms, hypertext represents "an almost embarrassingly literal embodiment of a principle that had seemed particularly abstract and difficult when read from the vantage point of print" (1992, 53).

4. According to Wolfe (2010), "Hayles's use of the term, in other words, tends to *oppose* embodiment and the posthuman, whereas the sense in which I am using the term here insists on exactly the opposite: posthumanism in my sense isn't posthuman at all—in the sense of being 'after' our embodiment has been transcended—but is only posthuman*ist,*

in the sense that it opposes the fantasies of disembodiment and autonomy, inherited from humanism itself, that Hayles rightly criticizes" (xv).

5. My repetitive use of the term *man* to describe "human" is not intended to be a gendering of the characterizations offered here. I have chosen to retain the word *man* for the sake of linking these terms to their origins in the work of Kierkegaard. I should make it clear, however, that I am well aware of Kierkegaard's purported misogyny, and I am not attempting to propagate it in any way by using the word *man* in a generic sense for the term *human*.

6. According to Stiegler, "in terms of consumption, the capitalist way of life has become an addictive process characterized by diminishing long-term satisfaction, which has engendered a significant malaise pervading consumption, a malaise that has 'replaced culture'" (2010, 48). Stiegler's adherence to Frankfurt School concepts has spurred critics of his work, but I would argue that this Marxist bent is a necessary component for a therapeutics of care that targets the technocultural industry.

7. My clinical terminology is drawn primarily from the U.S. Surgeon General's most recent report on mental health, aptly titled *Mental Health: A Report of the Surgeon General*. This report is available online at http://www.surgeongeneral.gov/library/mentalhealth/home.html.

8. As Stiegler suggests, "attention control via cultural and cognitive technologies ('technologies of the *spirit [esprit]*,' those malignant spirits haunting the adult minor as apparatuses for capturing, forming, and deforming attention), has become the very heart of hyperindustrial society; however, it no longer relies on psychotechnics but on psychotechnological apparatuses whose devastation we see on TF1, Channel Y, and so on" (2010, 22). I explore this idea at length in chapter 9.

3. Telephone, Pager, Two-Way Speaker, and Other Technologies of Betrayal

1. All film summaries are taken from the Internet Movie Database, http://www.imdb.com, accessed December 16, 2006.

2. As Alan Ball points out in the DVD voiceover, the original script called for shots of Lester's ghost flying just above the street toward his house. This detail was edited out for aesthetic purposes.

3. For an excellent study of narrative strategies that employ the perspective of the dead, see Alice Bennett, *After Life: Narrative Experiments and Life after Death*.

4. Early in the film, Carolyn makes reference to "the Lomans," the family who moved out of the house next door.

5. Brooks makes reference to Jonathan Reis, a German inventor who invented a telephone prototype in 1860. As scientists proved years later, the phone would have been functional with only a minor adjustment. According to Brooks, Reis's failure "was one of faith rather than technology—he failed because he did not really believe that the telephone was possible." In Brooks, "First and Only Century," 209.

6. See Brooks 1977, 210.

7. Note that this obliteration of the body was also registered early on after the invention of the telegraph. As Katherine Stubbs (2003) demonstrates in "Telegraphy's Corporeal Fictions," "on the telegraph circuit, it was theoretically possible to misrepresent oneself, to engage in a covert form of masquerade, trying on a new body and a new social identity" (92).

8. While this is clearly a film about transgressing a rigid, domestic disciplinary system, the "Behind the Scenes" portion of the DVD continuously reinforces the idealistic vision of this film as a "family project." Portions of this special feature involve interviews with the proud and well-adjusted parents of the director, Sofia Coppola.

9. This turn of events threatens to turn the film into what some might consider a disappointing morality play that, more than anything, reinforces the North American social hero system. In "Restoration, American Style," Nicholas Rombes (2000) laments the fact that *American Beauty,* rather than providing a daring critique of suburban futility, is merely a sample of "new critique as reminiscence." "Sure," notes Rombes, "Lester's rebellion against his obsolescence as a Husband, Father, Worker, is a form of critique, but it's one driven by a return to Old Forms and Orders." This argument is strengthened by the fact that characters in the film are punished for transgressing the norms of the "Old Order" nuclear family.

10. In *Gramophone, Film, Typewriter,* Kittler brings this point home by quoting Virilio's account of the invention of the chronophotographic gun: "In 1874 the Frenchman Jules Janssen took inspiration from the multi-chambered Colt (patented in 1832) to invent an astronomical revolving unit that could take a series of photographs [when attached to a telescope]. On the basis of this idea, Etienne-Jules Marey then perfected his chronophotographic rifle, which allowed its user to aim at and photograph an object moving through space" (Virilio, II).

11. This is actually a music video for the song "Cancer for the Cure" by *Eels* (Dreamworks, 1999).

12. At the time the very first draft of this chapter was written, cnn.com provided daily aerial shots of damage assessment in Afghanistan. The site also provided, under the word *retaliation* in a pull-down menu, an extensive overview of electronically powered U.S. weapons used in the war, including the famous Tomahawk cruise missile, which uses a global positioning system to reach its targets.

13. The short film *Plastic Bag* (2009), by Ramin Bahrani, seems to have been inspired by this scene from *American Beauty.* In Bahrani's version, a first-person voiceover delivered by Warner Herzog narrates the bag's existential journey from the supermarket to the sea, in trenchant terms that test the empathetic capacity of the viewer.

14. The role of forgetfulness in technoculture is an immense subject that ranges from Stiegler's notion of disindividuation brought about by the externalization of memory to Victor Mayer-Schonberger's discussion of the perils of storing our personal information on the Internet, which explains the title of his book, *Delete: The Virtue of Forgetting in the Digital Age.*

5. Angels in Digital Armor

1. This glitch can currently be observed in a YouTube video at http://www.youtube.com/watch?v=DTYwveKOAfI (June 21, 2011). If this link is "dead," a search for "cod4 tree glitch" should yield results.

2. On March 27, 2002, Richard Durn opened fire during a city council meeting in Nanterre, France, killing eight people and injuring another nineteen. The following day he leaped to his death from a window during a police investigation. These events are generally referred to as *la tuerie de Nanterre.*

3. "If we do not enact an *ecological critique* of the technologies and the industries of the spirit, if we do not show that the unlimited exploitation of spirits as markets leads to a ruin comparable to that which the Soviet Union and the great capitalist countries have been able to create by exploiting territories or natural resources without any care to preserve their habitability to come—the future—then we move ineluctably toward a global social explosion, that is, toward absolute war" (Stiegler 2009a, 88).

4. Bruno Latour provides a critical examination of millenarianism in *We Have Never Been Modern* (1993). From a Latourian perspective, we might argue that the invention of modernity and even postmodernity reflects a collective desire for cosmic specialness, driven forward by a community left empty-handed after the death of God. This thesis cannot be treated at length here, especially since Stiegler himself adheres strongly to a concept of modernity. I have questioned Stiegler about this issue in the context of Latour's work in an interview entitled "Bernard Stiegler's Pharmakon," published in the Fall 2010 issue of *Configurations*.

5. In reference to the concept of enframing that is central to his questioning of technology, Heidegger notes that technology "radically endangers the relation to the essence of truth" (1982, 32). Of course, he also suggests that "we look into the danger and see the growth of the saving power" (1982, 32). This optimism seems to indicate a pharmacological understanding of technology that, unfortunately, Heidegger did not explore at length in his career.

6. Clearly, there are glaring anthropocentric assumptions about human specialness in the work of Pyszczynski et al. (2003), as well as in the work of Ernest Becker. These speciesist assumptions are rooted in an existential psychodynamic that emerges from evolutionary theory. One might easily challenge these assumptions by suggesting that nonhuman animals and other things may be capable of experiencing death anxiety and forming cultures as a means of buffering said anxiety. But my purpose here is to focus specifically on human behaviors, and while this chapter therefore remains unabashedly speciesist, it does not deny the possibility of existential terror within the lifeworld of nonhuman beings. This topic is discussed at length in chapter 6.

7. As Edmund Burke suggests in "A Philosophical Enquiry into the Origin of Our Ideas of the Sublime and Beautiful," "upon escaping some imminent danger" we experience "a sense of awe . . . a sort of tranquility shadowed with horror" (2001).

8. Phillippe Ariès's *Western Attitudes toward Death* provides a brief though compelling account of the ritual history of death denial in Western culture, in spite of Derrida's critique of his work as philosophically unrigorous (see *Aporias*). As Ariès suggests, in the nineteenth century, conspicuous mourning rituals mark an important shift in the psychological fear of death: "Henceforth, and this is a very important change, the death of the self is a death of another, *la mort de toi,* thy death" (2010, 68). Contemporary rituals of mourning, such as Facebook sites that celebrate the unique identity of the dead, continue to serve this purpose, distancing us from death by turning it into a spectacle of the other's death.

9. This discourse on the "possible impossibility" is taken up by Derrida (1993) in *Aporias,* where he challenges Heidegger's romantic appeal to a notion of *presence.*

Of particular interest in this essay is Derrida's inaugural question, "Am I allowed to talk about my death?" This question not only initiates Derrida's argument about the "ownership" of death ("my death" vs. the death of the other) but also signals Derrida's recognition that the discussion of death itself is taboo in contemporary culture.

10. As Cho's dorm-mates revealed during an interview on CNN, Cho sometimes took pictures of fellow students without warning. He was also caught taking inappropriate cell phone photos of classmates under their desks. It could be said that Cho practiced for his gun-toting assault on the VTech students by snapping unwelcome photos of them. See Kleinfeld, N.R.

11. Stiegler deals with the issue of self-esteem by drawing on Gilbert Simondon's concept of "individuation," which is discussed at length in *Technics and Time.* The concept of "heroism," as proposed by Becker, is perhaps best reflected in Stiegler's discussion of memory and "exception" in *La Technique et le Temps 3,* as seen, for example, in the following passage, inspired by Simondon: "the positivity of the exception can be defined as that which permits one to be *excepted from decease* and to remain in memory, such as that which can remain beyond oneself as heritage *over and above one's mortality"* [la positivité rétentionelle de l'exception peut être définie comme ce qui permet de s'*excepter du décès* et peut donc rester en mémoire, comme ce qui peut rester au-delà de soi comme heritage *par-dela sa mortalité*] (2001, 153). This and all remaining translations of *Technics and Time 3* are my own.

12. The relationship between "high culture" and a more general conception of culture can be understood through an exploration of memory, which as Stiegler notes has undergone a vast transformation in modern times with the advent of analog and digital mnemotechnologies. The relationship between memory, culture, and technology accounts for a huge portion of Stiegler's work. It is explored at length in my interview with Stiegler, "Bernard Stiegler's Pharmacy," which deals directly with mnemotechnology, heroism, and immortality (O'Gorman 2010).

13. Unfortunately, Becker wrote very little about the Frankfurt School, mentioning it only in passing in *Escape from Evil,* his final work. Here, he praises the school's "union of Marx and Freud," a merger that is central to Becker's later writings. In a deathbed interview conducted by Sam Keen in 1974 for *Psychology Today,* Becker suggested the following: "I also see my work as an extension of the Frankfurt School of sociology and especially of the work of Max Horkheimer. Horkheimer says man is a willful creature who is abandoned on the planet; he calls for mankind to form itself into communities of the abandoned. That is a beautiful idea and one that I wanted to develop in order to show the implications of the scientific view of creatureliness" (1974, 71). A detailed study of Becker and the Frankfurt School has yet to emerge. Such an endeavor could help align Becker more clearly with other cultural theorists of his generation.

14. Microsoft's offer of $25,000 to fuel the search for Brandon Crisp was fruitless. The money was donated instead to the Brandon Crisp Foundation, established by the teen's parents. Interestingly, the foundation does not support research or services related to video game addiction. Instead, it provides funding for economically disadvantaged children to play

amateur sports. In Fukuyama's terms, what the Crisps have done is create a vehicle for teens to replace one outlet for megalothymia with another.

15. Stiegler describes the World Cup, televised globally, as nothing more than a "typical event within the apparatus of consumption" (Stiegler 2009a, 63), but he is ignoring the role that the event plays in facilitating a vicarious (dare I say "inauthentic") form of megalothymia. I would argue that the event does support a Kojèvian "fight to the death for recognition" in the form of hooligans, who wear tribal colors, mark their faces with war paint, and are willing to endanger their lives physically for the sake of supporting their cause.

16. The data are provided by the Yanghu Adolescents Quality Development Center, which indicates that twenty-four million Chinese youth between the ages of six and twenty-nine were addicted to the Internet in 2009 (Tian 2010).

17. It might be argued, *pace* Dreyfus (2001), that the Internet does indeed entail various types of risk beyond the physical, including a risk of reputation, cyberbullying, potential for addiction, and so on, some of which might even lead to suicidal behavior. But my goal here is to broaden the arguments of Becker, Kierkegaard, and Kojève and Hegel, and this requires a focus on physical risk alone in the pursuit of recognition. I thank Danielle Stock for reminding me of this important detail.

18. Regarding the classroom, Dreyfus devotes a chapter (2001, 27–49) of his critique of telepresence to distance education.

7. Speculative Realism Unchained

1. *The Third Policeman* could easily serve as a primer on OOO. Flann O'Brien's surreal novel sends the protagonist through a hell inspired by atomic physics. The bicycle mentioned in the epigraph serves as one of the supporting characters in the book, a role that is beyond simple anthropomorphism to present a theory of human/nonhuman assemblage. A statement made by Sergeant Pluck regarding human/bicycle companionship is worthy of full citation here, as a counterpoint to Haraway's discussion of her own transgenic human/dog companionship: "The gross and net result of it is that people who spend most of their natural lives riding iron bicycles over the rocky roadsteads of this parish get their personalities mixed up with the personalities of their bicycle as a result of the interchanging of atoms of each of them and you would be surprised at the number of people in these parts who nearly are half people and half bicycles" (O'Brien 1996, 88).

8. Myth of the Steersman

1. The exact type of canoe used by Tom Thomson has been a subject of great discussion among canoe experts. The definitive article on the subject was written by Mike Ormsby (2010), who conducted extensive research of archival evidence to conclude that the vessel was most likely a sixteen-foot Chestnut Cruiser.

2. In "Mapping Tom," Andrew Hunter (2002) suggests that the perception of Thomson as a rugged outdoorsman was wildly exaggerated, especially by his urban contemporaries.

9. Digital Care, Curation, and Curriculum

1. The origin of this term is itself the subject of much speculation. I first came across it in the following passage from Michael Ondaatje's 1993 novel *The English Patient*: "He hears the man's lovemaking continue, hears the silence of the woman—no whisper— hears her thinking, her eyes aimed towards him in the darkness. The word should be *thinkering*. Caravaggio's mind slips into this consideration, another syllable to suggest collecting a thought as one tinkers with a half-completed bicycle" (37).

2. I am referring here to the baroque tradition of the *kunstkabinett*. In *Materializing New Media*, Anna Munster (2006) compares the curiosity-driven organizational schema of the cabinet of curiosity with the aesthetic arrangement of cyberspace.

3. The term *broken tools* is borrowed from Graham Harman (2002), as discussed later in this chapter.

10. Roach Lab

1. I am referring here to a term employed by Jean-Jacques Lecercle (1990) to describe how language always exceeds our intention, leaving behind a *remainder*. This concept is also central to chapter 11.

11. From Dust to Data

1. As Julia Kristeva (1982) notes in *Powers of Horror*, the term *cadaver* (*cadere* in Latin) is etymologically linked to falling: "The corpse (or cadaver: *cadere*, to fall), that which has irremediably come a cropper, is cesspool, and death; it upsets even more violently the one who confronts it as fragile and fallacious chance" (3).

2. In "Eating Well," Derrida (1995) describes the "noncriminal" ritual of eating animals as the "executions of ingestion, incorporation, or introjection of the corpse" (278).

3. It is crucial to note that this distinction might be challenged by variations in the wardrobe, performance, and setting of the play; for example, if the witches were not dressed extravagantly, but merely evoke horror by their demeanor and description. The effect of terror may be prolonged by leaving horrible details to the imagination of the audience. Radcliffe seems to be aware of this point when she has S- suggest that Shakespeare, despite his predilection for supernatural beings, would never "compel us to recollect that he has a license for extravagance."

4. A useful history of the terror-versus-horror discussion is provided on a course website created by Lilia Melani at CUNY Brooklyn. Melani (2008) cites a number of authors on the question, demonstrating that there is little consensus regarding the distinction between terror and horror. She cites British novelist Dennis Wheatley, for example, who once suggested that "terror is a response to physical danger only, horror is fear of the supernatural."

5. Manuel DeLanda (2002) offers the following definition of "flat ontology," which has been taken up by Levi Bryant, Timothy Morton, and other object-oriented philosophers: "While an ontology based on relations between general types and particular instances is hierarchical, each level representing a different ontological category (organism, species, genera), an approach in terms of interacting parts and emergent wholes leads to a flat

ontology, one made exclusively of unique, singular individuals, differing in spatio-temporal scale but not in ontological status" (58).

6. Stiegler and Leroi-Gourhan's maxim that "the hand frees speech" (Stiegler 1998, 145) reminds us of the integral relationship between language and the human hand reaching beyond itself, which is constitutive of human technicity. As Cary Wolfe suggests, language presents us with a second finitude, "the finitude we experience in our subjection to a radically ahuman technicity or mechanicity of language, a technicity that has profound consequences, of course, for what we too hastily think of as 'our' concepts, which are therefore in an important sense not 'ours' at all" (2010, 90).

BIBLIOGRAPHY

Agamben, Giorgio. 1999. *Remnants of Auschwitz: The Witness and the Archive.* Trans. Daniel Heller-Roazen. New York: Zone.

Antonio-Lomanowska, Jessica. 2012. "The Roach Lab." Abstract for book chapter proposal. January.

Appadurai, Arjun, ed. 1988. *The Social Life of Things: Commodities in Cultural Perspective.* New York: Cambridge University Press.

Ariès, Phillippe. 1974. *Western Attitudes Toward Death: From the Middle Ages to the Present.* Trans. Patricia M. Ranum. Baltimore, Md.: Johns Hopkins University Press.

Associated Press. 2002. "Man Dies after Playing Computer Games Non-Stop." October 10. http://www.smh.com.au/articles/2002/10/10/1034061260831.html.

Barnes and Barnes. 1980. "Fish Head." *Voobaha.* Rhino Records.

Baranowski, T., J. Baranowski, K. W. Cullen, T. Marsh, N. Islam, I. Zakeri, L. Honess-Morreale, and C. deMoor. 2003. "Squire's Quest! Dietary Outcome Evaluation of a Multimedia Game." *American Journal of Preventive Medicine* 3, no. 24: 52–61.

Barthes, Roland. 1974. *S/Z: An Essay.* Trans. Richard Miller. New York: Hill and Wang.

———. 1977. Rhetoric of the Image. *Image-Music-Text.* Trans. Stephen Heath. New York: Hill and Wang.

Baudelaire, Charles. 1964. "A Philosophy of Toys." *The Painter of Modern Life, and Other Essays.* Trans. and ed. Jonathan Mayne. First published in the *Monde Littéraire,* 1853. London: Phaidon.

BBC News. 2005. "South Korean Dies after Game Session." August 10. http://news.bbc.co.uk/2/hi/technology/4137782.stm.

Beardsworth, Richard. 1996. *Derrida and the Political.* New York: Routledge.

Becker, Ernest. 1964. *The Revolution in Psychiatry: The New Understanding of Man.* London: Free Press of Glencoe.

———. 1968. *The Structure of Evil: An Essay on the Unification of the Science of Man.* New York: Braziller.

———. 1971. *The Birth and Death of Meaning.* New York: The Free Press.

———. 1973. *The Denial of Death.* New York: The Free Press.

———. 1974. Interview by Sam Keen. "Beyond Psychology: A Conversation with Ernest Becker." *Psychology Today* (April): 71–80.

————. 1975a. *Angel in Armor: A Post-Freudian Perspective on the Nature of Man*. New York: Macmillan.

————. 1975b. *Escape from Evil*. New York: The Free Press.

Benedikt, Michael, ed. 2006. *Cyberspace: First Steps*. Cambridge, Mass.: MIT Press.

Benjamin, Walter. 1999. "Fashion." In *The Arcades Project*, ed. Rolf Tiedemann, 62–81. Cambridge, Mass.: Harvard University Press.

Bennett, Alice. 2012. *After Life: Narrative Experiments and Life after Death*. New York: Palgrave Macmillan.

Bennett, Jane. 2010. *Vibrant Matter: A Political Ecology of Things*. Durham, N.C.: Duke University Press.

Bentley, G. E., Jr. 1969. *Blake Records*. Oxford: Clarendon Press.

Blake, William. 1995. *The Complete Poetry and Prose of William Blake*. Ed. David V. Erdman. New York: Anchor.

Boettinger, Henry. 1977. "Our Sixth-and-a-Half Sense." In *The Social Impact of the Telephone*, ed. Ithiel de Sola Pool, 200–207. Cambridge, Mass.: MIT Press.

Bogost, Ian. 2009. "Latour Litanizer." Weblog entry. *Ian Bogost—Videogame Theory, Criticism, Design*. December 16. http://www.bogost.com/blog/latour_litanizer.shtml.

————. 2012. *Alien Phenomenology or What It's Like to Be a Thing*. Minneapolis: University of Minnesota Press.

Bolter, Jay David. 1991. *Writing Space: The Computer, Hypertext, and the History of Writing*. Hillsdale, N.J.: Lawrence Erlbaum.

————. 2003. "Theory and Practice in New Media Studies." In *Digital Media Revisited*, ed. Gunnar Liestol, Andrew Morrison, and Terje Rasmussen, 15–33. Cambridge, Mass.: MIT Press.

Bolter, Jay David, and Richard Grusin. 2000. *Remediation: Understanding New Media*. Cambridge, Mass.: MIT Press.

Breton, André. 1987. *Mad Love*. Trans. Mary Ann Caws. Lincoln: University of Nebraska Press.

Brooks, John. 1976. *Telephone: The First Hundred Years*. New York: Harper and Row.

————. 1977. "The First and Only Century of Telephone Literature." In *The Social Impact of the Telephone*, ed. Ithiel de Sola Pool, 208–24. Cambridge, Mass.: MIT Press.

Brooks, Rodney. 2003. *Flesh and Machines: How Robots Will Change Us*. New York: Vintage.

Brown, Bill. 2003. *A Sense of Things: The Object Matter of American Literature*. Chicago: University of Chicago Press.

Burke, Edmund. 2001. "A Philosophical Inquiry into the Origin of Our Ideas of the Sublime and Beautiful with Several Other Additions." *Harvard Classics*, vol. 24, part 2. New York: Bartleby.com. http://www.bartleby.com/24/2/.

Butler, Judith. 2004. *Precarious Life: The Powers of Mourning and Violence*. New York: Verso.

Byatt, A. S. 1998. "Introduction." In *The Oxford Book of English Short Stories*, ed. A. S. Byatt, xv–xxx. Oxford: Oxford University Press.

Carr, Nicholas. *The Shallows: What the Internet Is Doing to Our Brains*. New York: W. W. Norton and Company, 2010.

Cavarero, Adriana. 2009. *Horrorism: Naming Contemporary Violence*. Trans. William McCuaig. New York: Columbia University Press.

Cavell, Stanley. 1989. *This New yet Unapproachable America: Lectures after Emerson after Wittgenstein*. Albuquerque, N.M.: Living Batch Press.

China Daily. 2005. "1 in 8 of Young Is Net Addict." November 24. http://www.chinadaily.com
.cn/english/doc/2005-11/23/content_497040.htm.

Cho, Seung-Hui. 2007. Suicide note excerpts published in CNN article online: "Shooter: 'You
Have Blood on Your Hands.'" April 18. http://www.cnn.com/2007/US/04/18/vtech.nbc/.

Chong, Josh. 2008. "Evosolution Industries: Freddy the Feed-back Feed-bag Doll." Term paper
in the Department of English, University of Waterloo.

"Climbing Trees?" 2008. *Call of Duty World at War Forum.* October 21.

Coetzee, J. M. 1999. *The Lives of Animals.* Princeton, N.J.: Princeton University Press.

Coppola, Sophia. 1999. *The Virgin Suicides.* Paramount Classics.

Cowley, Ben, Darryl Charles, Michaela Blake, and Ray Hickey. 2008. *ACM Computers in Enter-
tainment* 6, no. 2 (July): 2–20.

Coyne, Richard. 1998. "Cyberspace and Heidegger's Pragmatics." *Information Technology &
People* 11, no. 4: 338–50.

————. 1999. *Technoromanticism.* Cambridge, Mass.: MIT Press.

Csikszentmihalyi, Mihaly. 1990. *Flow: The Psychology of Optimal Experience.* New York: Harper
and Row.

DeLanda, Manuel. 2002. *Intensive Science and Virtual Philosophy.* London: Continuum.

Derrida, Jacques. 1986. *Glas.* Trans. John P. Leavey Jr. and Richard Rand. Lincoln: University
of Nebraska Press.

————. 1993. *Aporias.* Trans. Thomas Dutoit. Stanford, Calif.: Stanford University Press.

————. 1995. "Eating Well, or the Calculation of the Subject." In *Points . . . Interviews, 1974–
1994,* ed. Elizabeth Weber, trans. Peggy Kamuf and others, 96–119. Stanford, Calif.: Stan-
ford University Press.

————. 1997. *Chora L Works.* New York: Monacelli Press.

————. 2002. *Echographies of Television: Filmed Interviews.* Trans. Jennifer Bajorek. Cam-
bridge: Polity.

de Sola Pool, Ithiel, ed. 1977. *The Social Impact of the Telephone.* Cambridge, Mass.: MIT
Press.

Diamond, Cora. 1995. "Eating Meat and Eating People." In *The Realistic Spirit: Wittgenstein,
Philosophy, and the Mind,* ed. Stanley Cavell, Cora Diamond, John McDowell, Ian Hack-
ing, and Cary Wolfe, 43–89. Cambridge, Mass.: MIT Press.

————. 2009. "The Difficulty of Reality and the Difficulty of Philosophy." In *Philosophy and
Animal Life.* New York: Columbia University Press.

Dombois, Florian. 2007. "Call for Papers: 2008 European Society for Literature, Science and
the Arts Conference."

Douglas, J. Yellowlees. 1996. "Abandoning the either/or for the and/and/and: Hypertext and
the Art of Argumentative Writing." *Australian Journal of Language and Literacy* 19, no. 4
(November): 305–16.

Dreyfus, Hubert L. 2001. *On the Internet.* New York: Routledge.

Eagleton, Terry. 2000. *The Idea of Culture.* Oxford: Blackwell.

————. 2003. *After Theory.* New York: Basic Books.

————. 2004. "Where Have All the Intellectuals Gone?" *New Statesman.* http://www.newstates
man.com/site.php3?newTemplate=NSReview_Bshop&newDisplay
URN=300000088090.

Ellard, Colin. 2009. *Where Am I? How We Can Find Our Way to the Moon but Get Lost in the Mall*. New York: HarperCollins.

Eno, Brian, and David Byrne. 1981. *My Life in the Bush of Ghosts* (album). Sire.

Erdman, David V., ed. 1970. *The Poetry and Prose of William Blake*. Garden City, N.Y.: Doubleday.

Essick, Robert N., and Morton D. Paley. 1982. *Robert Blair's The Grave Illustrated by William Blake*. London: Scholar Press.

Flanagan, Mary. 2006. "Reskinning the Everyday." In *Re-Skin*, ed. Mary Flanagan and Austin Booth. Cambridge, Mass.: MIT Press.

———. 2010. *[borders]*. http://www.maryflanagan.com/borders.

Foer, Jonathan Safran. 2009. *Eating Animals*. New York: Little, Brown, and Company.

Foucault, Michel. 1973. *This Is Not a Pipe*. Trans. James Harkness. Berkeley: University of California Press.

———. 1996. "Rituals of Exclusion." In *Foucault Live* (interviews, 1961–1984), ed. S. Lotringer, 68–73. New York: Semiotext(e).

Freedgood, Elaine. 2006. *The Ideas in Things: Fugitive Meaning in the Victorian Novel*. Chicago: University of Chicago Press.

Fromm, Eric. 1968. *The Revolution of Hope: Toward a Humanized Technology*. New York: HarperCollins.

Fukuyama, Francis. 1992. *The End of History and the Last Man*. New York: Avon.

Gale, Nathan. 2009. "Zombies Ate My Ontology." Weblog entry. *An Un-Canny Ontology*. August 17. http://uncannyontology.blogspot.ca/2009/08/zombies-ate-my-ontology.html.

Gibson, William. 1984. *Neuromancer*. New York: Ace Books.

Gilchrist, Alexander. 1907. *Life of William Blake*. New York: John Lane.

Goldenberg, J. L., T. Pyszczynski, J. Greenberg, S. Solomon, B. Kluck, and R. Cornwell. 2001. "I Am Not an Animal: Mortality Salience, Disgust, and the Denial of Human Creatureliness." *Journal of Experimental Psychology* 130, no. 3: 427–35.

Griffin, Drew, Jeanne Meserve, Christine Romans, and Michael Sevanhof. 2007. "Campus Killer's Purchases Apparently within Gun Laws." *CNN*, April 19. http://www.cnn.com/2007/US/04/19/gun.laws/.

Griffin, Matthew, Susanne Herrmann, and Friedrich A. Kittler. 1996. "Technologies of Writing: Interview with Friedrich A. Kittler." *New Literary History* 27, no. 4 (Autumn): 731–42.

Guillory, John. 1993. *Cultural Capital: The Problem of Literary Canon Formation*. Chicago: University of Chicago Press.

Hansen, Mark B. N. 2006. *Bodies in Code: Interfaces with Digital Media*. New York: Routledge.

Haraway, Donna. 1991. "A Cyborg Manifesto: Science, Technology, and Socialist-Feminism in the Late Twentieth Century." In *Simians, Cyborgs and Women: The Reinvention of Nature*, 149–81. New York: Routledge.

———. 2007. *When Species Meet*. Minneapolis: University of Minnesota Press.

Harman, Graham. 2002. *Tool Being: Heidegger and the Metaphysics of Objects*. Chicago: Open Court.

Hayles, N. Katherine. 1999. *How We Became Posthuman: Virtual Bodies in Cybernetics, Literature, and Informatics*. Chicago: University of Chicago Press.

———. 2005. "Attacking the Borg of Corporate Knowledge Work: The Achievement of Alan Liu's *The Laws of Cool*." *Criticism* 47, no. 2: 235–38.

———. 2007. "Hyper and Deep Attention: The Generational Divide in Cognitive Modes." *Profession* (2007): 187–99.

Hegel, G. F. 1977. *The Phenomenology of the Spirit*. Trans. A. V. Miller. New York: Oxford University Press.

Heidegger, Martin. 1967. "Who Is Nietzsche's Zarathustra?" Trans. Bernd Magnus. *Review of Metaphysics* 20: 411–31.

———. 1982. *The Question Concerning Technology and Other Essays*. Trans. William Lovitt. New York: Harper Perennial.

———. 1995. "Being and Time" (sel.). In *Existentialism: Basic Writings*, ed. Charles Guignon and Derk Pereboom, 211–54. Indianapolis: Hackett.

Hemingway, Ernest. 2002. *Death in the Afternoon*. New York: Simon and Schuster.

Hunt, Robert. 1808. *The Examiner*. August 7, pp. 509, 510.

Hunter, Andrew. 2002. "Mapping Tom." In *Tom Thomson*, 19–45. Vancouver, B.C.: Douglas and McIntyre.

Ihde, Don. 2002. *Bodies in Technology*. Minneapolis: University of Minnesota Press.

Jarzembecki, Laura. 2008. "Cybersound: Re-embodying the Body." Term paper in the Department of English, University of Waterloo.

Jüttner, Julia. 2006. "German School Shooting: Armed to the Teeth and Crying for Help." *Spiegel Online*, November 21. http://www.spiegel.de/international/german-school-shooting -armed-to-the-teeth-and-crying-for-help-a-449814.html.

Keirsey, David, and Marilyn Bates. 1984. *Please Understand Me: Character and Temperament Types*. Del Mar, Calif.: Prometheus Nemesis.

Kierkegaard, Søren. 1954. *The Sickness unto Death*. Trans. Walter Lowrie. New York: Anchor.

———. 1944. *The Concept of Dread*. Trans. Walter Lowrie. Princeton, N.J.: Princeton University Press.

Kim, Victoria. 2005. "Video Game Addicts Concern S. Korean Government." Associated Press. http://www.cnn.com/2005/TECH/fun.games/10/07/korea.onlinegameaddic .ap/index.html.

King, Stephen. 1981. *Danse Macabre*. New York: Everest.

Kittler, Friedrich. 1999. *Gramophone, Film, Typewriter*. Trans. Geoffrey Winthrop Young and Michael Wutz. Stanford, Calif.: Stanford University Press.

Kleinfeld, N. R. 2007. "Before Deadly Rage, a Life Consumed by a Troubling Silence." *New York Times*, April 22. http://www.nytimes.com/2007/04/22/us/22vatech.html?page wanted=all&_r=0.

Kohler, Chris. 2008. "The Graveyard's Ten-Minute Tale of Death." *WIRED Game|Life*. March 21. http://www.wired.com/gamelife/2008/03/the-graveyards.

Kojève, Alexandre. 1980. *Introduction to the Reading of Hegel*. Assembled by Raymond Queneau, ed. Allan Bloom, trans. James H. Nichols Jr. Ithaca, N.Y.: Agora Press.

Kolgen, Herman. 2012. "Dust." http://www.kolgen.net/projects/dust.

Kristeva, Julia. 1982. *Powers of Horror*. Trans. Leon S. Roudiez. New York: Columbia University Press.

Kurzweil, Ray. 2000. *The Age of Spiritual Machines: When Computers Exceed Human Intelligence*. New York: Penguin.

Landow, George. 1992. *Hypertext: The Convergence of Contemporary Critical Theory and Technology*. Baltimore: Johns Hopkins University Press.

Lanningham-Foster, Lorraine, T. B. Jensen, R. C. Foster, A. B. Redmond, B. A. Walker, D. Heinz, and J. A. Levine. 2006. "Energy Expenditure of Sedentary Screen Time Compared with Active Screen Time for Children." *Pediatrics* 118, no. 6: 1831–35.

Latour, Bruno. 1993. *We Have Never Been Modern*. Cambridge, Mass.: Harvard University Press.

Lecercle, Jean-Jacques. 1990. *The Violence of Language*. New York: Routledge.

Lefebvre, Michel. 1991. *The Production of Space*. Cambridge: Blackwell.

Levi, Primo. 1988. *The Drowned and the Saved*. Trans. Raymond Rosenthal. New York: Summit.

Levinas, Emmanuel. 1985. *Ethics and Infinity: Conversations with Philippe Nemo*. Trans. Richard A. Cohen. Pittsburgh: Duquesne University Press.

Little, R. P. 1955. "Some Recollections of Tom Thomson and Canoe Lake." *Culture* 16, no. 2 (June): 200–208.

Liu, Alan. 2004. *The Laws of Cool: Knowledge Work and the Culture of Information*. Chicago: University of Chicago Press.

Lyotard, Jean-François. 1991. "The Sublime and the Avant-Garde." Trans. Lisa Liebmann, Geoffrey Bennington, and Maria Hobson. In *The Inhuman*, 89–107. Cambridge: Polity Press.

MacGregor, Roy. 2010. *Northern Light: The Enduring Mystery of Tom Thomson and the Woman Who Loved Him*. Toronto: Random House.

Madigan, Jamie. 2010. "Analysis: The Psychology of Immersion in Video Games." *Gamasutra*, August 25. http://www.gamasutra.com/view/news/29910/Analysis_The_Psychology_of_Immersion_in_Video_Games.php.

Mann, Mary E. 2008. *The Complete Tales of Dulditch*. Dereham: Larks Press.

Mann, Steve. 2002. "Sousveillance as an Alternative Balance." http://wearcam.org/sousveillance.htm.

Mann, Steve, with Hal Niedzviecki. 2001. *Cyborg: Digital Destiny and Human Possibility in the Age of the Wearable Computer*. Toronto: Doubleday Canada.

Martin, Julia. 2003. "The Speaking Garden in William Blake's *The Book of Thel*: Metaphors of Wisdom and Compassion." *Journal of Literary Studies* 19, no. 1: 53–81.

Maslin, Janet. 1999. "'American Beauty': Dad's Dead and He's Still a Funny Guy." *New York Times*, September 15. http://www.nytimes.com/library/film/091599beauty-film-review.html.

Mayer-Schonberger, Viktor. 2009. *Delete: The Virtue of Forgetting in the Digital Age*. Princeton, N.J.: Princeton University Press.

McGann, Jerome. 2013. "The Conceptual Foundations of Ivanhoe." Home page of Jerome McGann. http://www2.iath.virginia.edu/jjm2f/old/rockwell2b.htm.

McGonigal, Jane. 2011. *Reality Is Broken: Why Games Make Us Better and How They Can Change the World*. New York: Penguin.

McLuhan, Marshall. 1996. "The Agenbite of Outwit." *McLuhan Studies*, issue 2. http://projects.chass.utoronto.ca/mcluhan-studies/v1_iss2/1_2art6.htm.

———. 2001. *Understanding Media: The Extensions of Man*. New York: Taylor and Francis.

Meillassoux, Quentin. 2009. *After Finitude: An Essay on the Necessity of Contingency*. Trans. Ray Brassler. New York: Continuum.

Melani, Lilia. 2008. "Terror vs. Horror." August. http://academic.brooklyn.cuny.edu/english/melani/gothic/terror_horror.html.

Mendes, Sam. 1999. *American Beauty*. Dreamworks Pictures.

Miller, S. A. 2002. "Death of a Game Addict." *Milwaukee Journal Sentinel,* March 30. http://www.freerepublic.com/focus/chat/658054/posts.

Mitchell, Rob. 2010. *Bioart and the Vitality of Media*. Seattle: University of Washington Press.

Mitchell, W. J. T. 1994. *Picture Theory: Essays on Verbal and Visual Representation*. Chicago: University of Chicago Press.

———. 2003. "The Rights of Things." Foreword to Cary Wolfe, *Animal Rites: American Culture, the Discourse of Species, and Posthumanist Theory*. Chicago: University of Chicago Press.

Moravec, Hans. 1990. *Mind Children: The Future of Robot and Human Intelligence*. Cambridge, Mass.: Harvard University Press.

Mosco, Vincent. 2005. *The Digital Sublime: Myth, Power, and Cyberspace*. Cambridge, Mass.: MIT Press.

Munster, Anna. 2006. *Materializing New Media: Embodiment in Information*. Dartmouth, N.H.: University Press of New England.

Nagel, Thomas. 1974. "What Is It Like to Be a Bat?" *Philosophical Review* 83, no. 4 (October): 435–50.

Niedzviecki, Hal. 2004. *Hello, I'm Special: How Individuality Became the New Conformity*. Toronto: Penguin Canada.

Noble, David F. 1999. *The Religion of Technology: The Divinity of Man and the Spirit of Invention*. New York: Penguin.

Oates, Joyce Carol. 1999. "To Invigorate Literary Mind, Move Literary Feet." *New York Times,* July 18. http://partners.nytimes.com/library/books/071999oates-writing.html.

O'Brien, Flann. 1996. *The Third Policeman*. Champaign, Ill.: Dalkey Archive Press.

O'Gorman, Marcel. 1995. "Hypericonomy." Personal, unpublished document.

———. 2000. "Transparency and Deception on the Hardware Fashion Scene." *Ctheory,* December. http://www.ctheory.net/articles.aspx?id=227.

———. 2006. *E-Crit: Digital Media, Critical Theory and the Humanities*. Toronto: University of Toronto Press.

———. 2012. "Broken Tools and Misfit Toys: Adventures in Applied Media Theory." *Canadian Journal of Communication* 37, no. 1: 27–42.

O'Gorman, Marcel, and Bernard Stiegler. 2010. "Bernard Stiegler's Pharmacy: A Conversation." *Configurations* 18, no. 3 (Fall): 459–76.

Ondaatje, Michael. 1993. *The English Patient*. New York: Vintage.

Ormsby, Mike. 2010. "Canvas Covered Mystery: The Unknown Fate of Thomson's Canoe." *Canoe Roots Magazine,* Summer/Fall: 17.

Ortega, José. 1957. *The Revolt of the Masses*. New York: Norton.

Parikka, Jussi. 2010. *Insect Media: An Archaeology of Animals and Technology*. Minneapolis: University of Minnesota Press.

Parikka, Jussi, and Erkki Huhtamo. 2011. *Media Archaeology: Approaches, Applications, and Implications*. Berkeley: University of California Press.

Perniola, Mario. 2004. *The Sex Appeal of the Inorganic: Philosophies of Desire in the Modern World*. Trans. Massimo Verdicchio. London: Continuum.

Peters, John Durham. 1999. *Speaking into the Air: A History of the Idea of Communication.* Chicago: University of Chicago Press.

Plato. 2007. *Six Great Dialogues.* Trans. Benjamin Jowett. Mineola, N.Y.: Dover.

Pyszczynski, Tom, Sheldon Solomon, and Jeff Greenberg. 2003. *In the Wake of 9/11: The Psychology of Terror.* Washington, D.C.: APA Books.

Radcliffe, Anne. 1826. "On the Supernatural in Poetry." *New Monthly Magazine,* vol. 16, no. 1: 145–52. *Literary Gothic.* http://www.litgothic.com/Texts/radcliffe_sup.pdf.

Rajan, Tilottama. 2001. "In the Wake of Cultural Studies: Gloabalization, Theory and the University." *Diacritics* 31, no. 3 (Autumn): 67–88.

Raley, Rita. 2009. *Tactical Media.* Minneapolis: University of Minnesota Press.

Rank, Otto. 1993. *The Trauma of Birth.* Toronto: Dover.

R.E.M. 1994. "Star 69." *Monster* (album). Warner Bros.

Rombes, Nicholas. 2000. "Restoration, American Style." *Ctheory,* Fall. http://www.ctheory.net/text_file.asp?pick=223.

Rotman, Brian. 1993. *Ad Infinitum: The Ghost in Turing's Machine; Taking God Out of Mathematics and Putting the Body Back In.* Stanford, Calif.: Stanford University Press.

Rozin, Paul, Linda Millman, and Carol Nemeroff. 1986. "Operation of the Laws of Sympathetic Magic in Disgust and Other Domains." *Journal of Personality and Social Psychology* 50, no. 4 (April): 703–12.

Samyn, Michaël. 2008. "The Graveyard Post Mortem." November 2. http://taleof-tales.com/blog/the-graveyard-post-mortem/.

Sander, David. 2000. "'Habituated to the Vast': Ecocriticism, the Sense of Wonder, and the Wilderness of the Stars." *Extrapolation* 41, no. 3: 283–97.

Santora, Mark. 2007. "Roommates Describe Gunman as Loner." *New York Times Online,* April 17. http://www.nytimes.com/2007/04/17/us/17cnd-ROOMMATE.html?_r=1&oref=slogin.

Sconce, Geoffrey. 2000. *Haunted Media: Electronic Presence from Telegraphy to Television.* Durham, N.C.: Duke University Press.

Siegel, Scott Jon. 2008. "Check out Indie Art Game 'The Graveyard.'" *Joystiq,* April 4. http://www.joystiq.com/2008/04/04/check-out-indie-art-game-the-graveyard.

Silverstone, Roger, and Eric Hirsch, eds. 1994. *Consuming Technologies: Media and Information in Domestic Spaces.* New York: Routledge.

Silverstone, Roger, Eric Hirsch, and David Morley. 1994. "Information and Communication Technologies and the Moral Economy of the Household." In *Consuming Technologies: Media Information in Domestic Spaces,* ed. Roger Silverstone and Eric Hirsch, 15–31. New York: Routledge.

Simondon, Gilbert. 1989. *L'individuation psychique et collective.* Paris: Aubier.

Singer, Peter. 1999. "Reflections." In *The Lives of Animals,* J. M. Coetzee, ed. Amy Gutmann, 85–92. Princeton, N.J.: Princeton University Press.

Sneil_IV. 2000. "Yes, I Have a Pager. No, I'm Not a Drug Dealer. Yeesh." epinions.com, June 18. http://www.epinions.com/kifm-review-4A79-D7FD75B-394D7FCF-prod5.

Stafford, Barbara Maria. 2001. *Visual Analogy: Consciousness as the Art of Connecting.* Cambridge, Mass.: MIT Press.

Stelarc. 2007. "Animating Bodies, Mobilizing Technologies: Stelarc in Conversation; With Marquard Smith." In *Stelarc: The Monograph*, ed. Marquard Smith, 215–42. Cambridge, Mass.: MIT Press.

Stephen, Andrew. 2007. "The Unmentionable Causes of Violence." *New Statesman*, April 20. http://www.newstatesman.com/north-america/2007/04/american-images-history-cho.

Steyn, Mark. 2007. "A Culture of Passivity: 'Protecting' our 'Children' at Virginia Tech." *National Review Online*, April 18. http://www.freerepublic.com/focus/f-news/1819428/posts.

Stiegler, Bernard. 1998. *Technics and Time, 1: The Fault of Epimetheus*. Trans. Richard Beardsworth and George Collins. Stanford, Calif.: Stanford University Press.

———. 2001. *La Technique et le Temps 3: Le Temps du Cinéma et la Question du Mal-être*. Paris: Galilée.

———. 2008. *Technics and Time 2: Disorientation*. Trans. Richard Beardsworth. Stanford, Calif.: Stanford University Press.

———. 2009a. *Acting Out*. Trans. David Barison. Stanford, Calif.: Stanford University Press.

———. 2009b. "Teleologics of the Snail: The Errant Self Wired to a WiMax Network." *Theory, Culture, and Society* 26, no. 2–3: 33–45.

———. 2010. *Taking Care of Youth and the Generations*. Trans. Stephen Barker. Stanford, Calif.: Stanford University Press.

Stock, Danielle. 2012. "Multiplication and Division: Embodied Action in Digital Space-Time." *Canadian Journal of Communication* 37, no. 1: 129–34.

Stubbs, Katherine. 2003. "Telegraphy's Corporeal Fictions." In *New Media 1740–1915*, ed. Lisa Gitelman and Geoffrey B. Pingrey, 91–112. Cambridge, Mass.: MIT Press.

Taylor, Benjamin Franklin. 1886. "The Telephone." *Complete Poetical Works*. Chicago: S. G. Griggs.

Thacker, Eugene. 2010. *After Life*. Chicago: University of Chicago Press.

———. 2011. *In the Dust of This Planet: Horror of Philosophy, Vol. 1*. Hants, U.K.: Zero Books.

Thoreau, Henry David. 2007. *Walking*. Rockville, Md.: Arc Manor.

Tian, Lan. 2010. "Young Internet Addicts on the Rise." *China Daily*. Updated February 3. http://www.chinadaily.com.cn/china/2010-02/03/content_9417660.htm.

Turkle, Sherry. 1984. *The Second Self: Computers and the Human Spirit*. New York: Simon and Schuster.

———. 1995. *Life on the Screen: Identity in the Age of the Internet*. New York: Touchstone.

———. 2007. *Evocative Objects: Things We Think With*. Cambridge, Mass.: MIT Press.

———, ed. 2009. *The Inner Life of Devices*. Cambridge, Mass.: MIT Press.

———. 2011. *Alone Together: Why We Expect More from Technology and Less from Each Other*. New York: Basic Books.

Ulmer, Gregory L. 1985. *Applied Grammatology*. Baltimore: Johns Hopkins University Press.

Varma, Devendra P. 1957. *The Gothic Flame: Being a History of the Gothic Novel in England; Its Origins, Efflorescence, Disintegration, and Residuary Influences*. New York: Russell and Russell.

Virilio, Paul. 1989. *War and Cinema: The Logistics of Perception*. Trans. Patrick Camiller. London: Verso.

———. 1997. *Open Sky*. London: Verso.

Wainwright, Rufus. 2002. "The One You Love." *Want Two*. Geffen Records.

Wikipedia. 2012. "Curator." http://en.wikipedia.org/wiki/Curator.

Williams, Raymond. 1958. *Culture and Society, 1780–1950*. London: Chatto and Windus.

Wills, David. 2008. *Dorsality: Thinking Back through Technology and Politics*. Minneapolis: University of Minnesota Press.

Winthrop-Young, Jeffrey, and Michael Wutz. 1999. "Translators' Preface: Friedrich Kittler and Media Discourse Analysis." In Friedrich Kittler, *Gramophone, Film, Typewriter*, xi–xxxviii. Stanford, Calif.: Stanford University Press.

Wolf, Maryanne. 2008. *Proust and the Squid: The Story and Science of the Reading Brain*. New York: Harper Perennial.

Wolfe, Cary. 2003. *Animal Rites: American Culture, the Discourse of Species, and Posthumanist Theory*. Chicago: University of Chicago Press.

———. 2010. *What Is Posthumanism?* Minneapolis: University of Minnesota Press.

Xinhua News Agency. 2006. "Chinese Heroes vs. World of Warcraft." August 30. http://english.people.com.cn/200608/30/eng20060830_298142.html.

York, Sarah. 2011. "The Forgiveness Machine." Blog post. April 13. http://blindmansmark.wordpress.com/2011/04/13/the-forgiveness-machine/.

Zielinski, Siegfried. 2006. *Deep Time of the Media: Toward an Archaeology of Hearing and Seeing by Technical Means*. Cambridge, Mass.: MIT Press.

INDEX

component, make-oriented, 159; critical object production informed by applied philosophical method, 124; curiosity-driven curriculum, 163; *Cyberbodies: Rhetoric and Fiction,* 160–61; *The CyberSound Glove,* 161–63; *Cybridity,* 160; digital prostheticization of a canoe, 132; *Division Pixel Suppliers,* 159–60; Experimental Digital Media (XDM), 159; experiments adapted by, 78; flow hypothesis, 103; funded by a federal grant program, 155; *Myth of the Steersman,* 5, 128f7, 130–36, 133f9, 135f10, 193; penny-farthing bicycle, 105, 108, 124, 150, 213; projects undertaken by, 17; *Roach Lab* and Jessica Antonio-Lomanowska, 166f11, 168–69; supports work of humanists, social scientists, and artists, 158; terror management theory (TMT), 165–68; THEMUSEUM, 130, 135f10, 159–60; TMT experiments, 168; *What Does a Body Know,* 162

Csikszentmihalyi, Mihaly, 95, 101–4, 101f4, 104f5, 205

cultural: hero system, 40, 52, 56, 73, 77, 83–84, 87, 110; identity, 156; man, sickness of automatic, 20; neuroses, 21, 40; pathologies, 43; theory, 18, 20, 73, 141–42

culture: of blogging, tweeting, and Facebooking, 92; computer culture and "rule-governed" worlds, 88; "lacks any social or ethical checks," 156; of limited authentic heroism, 83; meat-based, 88; of passivity, 82; print-oriented, 141; psychic numbness in our, 46; of resistance, 14; of rules and simulation, 88; technological, 14, 63; of technology for technology's sake, 14; of technoprostheticization, 72; of unlimited consumption, 87. *See also* contemporary culture; technoculture

cyberspace: about, 41, 74–75, 120; erotics of, 120; myths, 74, 135; narratives, 74; technologies of, 120

Cyberspace: First Steps (Benedikt), 71, 75

Cyberspace and Heidegger's Pragmatics (Coyne), 120, 205

cyborg (cybernetic organism), 34, 109–25, 136, 158

Cyborg: Digital Destiny and Human Possibility in the Age of the Wearable Computer (Mann and Niedzviecki), 33–34, 208

Cyborg–Luddite, 33

"Cyborg Manifesto" (Haraway), 160, 207

Cycle of Dread, 4, 103–5, 107f6, 108, 193

Datamatics v2.0 (Ikeda), 171, 190–91

Dawson College (Montreal), 91

Dead Like Me (Showtime), 38

death: of animals, 180–81; anxiety, 181, 198n6; aware, 17; awareness of, 78; being-toward-death, 78; being-towards, 78, 80; birth of, 13, 79; of Blake, 105; of Brandon Crisp, 90, 93; camps, 180; cat's wrongful, 37; certainty of, 77, 138; communications technologies and, 42; contemplative, 99; cultural hero system and, 40; decay and, 165; defying worlds of nonhuman things, 110; demystifying and glamorizing, 38; denaturalization and, 13; denial and existential authenticity, 40; denial of, 19, 40, 42, 73, 77–78, 80, 82, 86, 94; denial strategies, 82; devices capturing ghosts and, 42; devotion to the holy trinity of media, war, and, 41; digital assets and, 10; disastrous feeling of, 13; by duplication, 66; existential pursuit of recognition, 94; existential terror of, 78; extinction of a species, 182; face of the corpse and, 187; faked, 115; fashion and, 114; fear of, 187; fight to the death for recognition, 84, 86; finitude and, 110; foreknowledge of, 79; Foucaultian death of the concept of man and literal, 41; genocide and, 179; of God and the last man, 80, 198n4; gun-shot, 67; heroic and sublime denial

death (cont.)

of, 86; home-movie, 67; hope to transcend, 83; horror and, 178–80, 182; human attitudes toward, 81; humanity and, 11; of the human species, 182; illusion that we can skirt, 78; imminence of, 165; impossible possibility of, 186; individuated, 182; inevitability of, 79, 83; instruments of, 66; knowledge of our inevitable, 78; Lester's, 54; of livestock, 179; logic of seek and destroy and human, 42; looking forward and beyond, 13; make light of, 38; media, 66; media technologies and, 42; Monowitz-Auschwitz internment camp, 186; mortality and, 24; near-death experience, 78; no humanity without, 13; of nonhumans, 181–82; ontological indignity and, 182; by overwork, 39; parents blamed for, 88; philosophical perspective, 38; by phone, 44; potential nihilism and, 18; program on cable television, 38; reaction to the threat of, 178; reality is, 71; reckoning, 13, 47; by redundancy, 66; relation to, 13, 79; reticent about suffering and, 141; sadness about, 76–77; scene in *Graveyard*, 99–100; self-deluding denial of, 42; sentence, 175; sexual intimacy and, 189; shock factor of, 38; sincere interest in, 38; smell of, 171, 176; of South Korean game addicts, 81, 93; of space, 75; specific moment of, 166; in sport-car driving, mountain climbing, stock speculation, gambling, 86; suffering and, 18; by suicide bombing, 179; taste like, 15; taste of, 12; technicity and, 4; technological devices and, 38; technology, human embodiment and, 61; technology-related, 81; terrifying knowledge of, 80; "the great beyond" of, 42; threats of Eric Harris, 90; of Tom Thomson, 129, 131–32, 136; TV programs about, 38; ultimate fate, 77; of video

game players as national heroes, 88; video of, 42; violence and, 178; zombie ontology and, 186. *See also* antihero(es); anxiety; human finitude; mortality; mortality salience; suicidal behavior

death and technology: applied media theory and, 138; central to posthumanism, object-oriented ontology, and horror philosophy, 94; collusion of, 13; incontrovertible link between, 8; interrelatedness of, 8; media technologies and, 4; object-oriented ontology and, 94; posthumanism and, 94; relationship between, 39, 153; terror management theory and, 153

Death in the Afternoon (Hemingway), 5, 207

Death of a Salesman (Miller), 40

Death of the Strong, Wicked Man, The (Blake), 105–6

Debord, Guy, 39

deep attention, 146–47, 160

deep sea fishing, 86

denaturalization, 13

Denial of Death, The (Becker), 1, 17–18, 23, 78, 193, 203

dépérissement, 13

depressive introvert, 43

depressive psychosis, 21, 43

Derrida, Jacques, 3; cultural theory, 18; death, "ownership" of, 199n9; deconstructive theorist, 140; *Glas*, 140; grammatology, 151; horror as human disindividuation, 180; late modernist artist, 18, 142; logic of the specter, 12; morbid notion of the "messianic," 12; objects-to-think-with, 149; pedagogy challenges humanities scholarship, 149; possible impossibility, 198n9; postcard, 151; quotidian objects in his texts, 148; ritual of eating animals, "noncriminal," 201n2; shared vulnerability, 187; suicide bombing vs. genocide, 179; taste like death, 15; taste of death, 12; unintelligibility, 187

desire: for annihilation of the species, 188; for belief in technological progress, 78; for contact and unity, 122; for contact with the inorganic, 114; for control embedded in nonspeciesist conceits, 174; for cosmic specialness, 198n4; for fame, 23; for gadgetry, 78; for heroic action, 86; for holism, unity, and communication, 119; for "holistic unitary patterning of chaos theory," 122; for immediate demise of the human race, 187; for immortality, 14, 73; for recognition, 23, 58–59, 73, 76, 82, 84–85, 93, 110; for self, 89; for unity and holism, 116

Detroit Police Department, 8, 49, 52

Dial M for Murder (Hitchcock), 44

Diamond, Cora: anxiety of the human animal, 182; "The Difficulty of Reality and the Difficulty of Philosophy," 180, 182–83, 205; "Eating Meat and Eating People," 205; mass killing of animals, 183; moral life and moral thought, 183; mortality and nonhuman animals, 184; ontological flattening projected onto humans, 183; shared vulnerability, 187; special status of the human being, 184; unintelligibility, 187; women haunted by horror, 181

"Difficulty of Reality and the Difficulty of Philosophy, The" (Diamond), 180, 182–83, 205

digital artists, 140, 155, 157

digital assets on servers, 10

digital humanities, 14, 125, 138, 140–41, 150–51, 154, 156

digital identity, 10

Digital Sublime, The: Myth, Power, and Cyberspace (Mosco), 74–76, 78, 88, 92, 209

digital things, 137

Digital Ventriloquized Actor (DIVA), 162–63

disembodiment, 4; apocalyptic or emancipatory discussions of, 138; digital, 74; fantasies of, 17, 196n4; simulation of, 82; tele-action and, 88. *See also* embodiment

DIVA. *See* Digital Ventriloquized Actor

domestic surveillance system, 51

domestic transgression, 51–54

dorsal conception of the human, 12

Dorsality (Wills), 24, 212

Dreadmill, 4, 61–69, 193–94

Duchamp, Marcel, 172–75

Durn, Richard, 73, 90, 197n2

Dust (Kolgen), 171–74

dyscommunication networks, 41

Eagleton, Terry: *After Theory*, 18, 141–42, 205; cultural theory, defamation of, 141–42

Eating Animals (Foer), 3, 206

"Eating Meat and Eating People" (Diamond), 205

E-Crit: Digital Media, Critical Theory and the Humanities (O'Gorman), 4, 14, 140–42, 151, 155

Einstein, Albert, 95

electronic information movement, 47

embodiment, 158–59, 161, 178, 195nn3–4. *See also* disembodiment

Eno, Brian, 12–14, 203

epiphylogenesis, 17, 145

European Conference of the Society for Literature, Science and the Arts, 157

EverQuest (video game), 88

Evocative Objects: Things We Think With (Turkle), 38, 195n2, 212

evolution (evolutionary): biological, 3; coevolution, 17, 145, 164, 191; stage of technics, 81; symbolic and biological, 3; technicity, symbolic and biological, 3; theory, existential psychodynamic and, 198n6; video camera, 42

existential (existentially): account of what it means to be human, 22; act driven by psychological motivations, 46; action, embodied, 93; analysis explains

existential (existentially) (cont.)
hyperindustrial programming of
consciousness, 73; analysis of
technoculture, 73; authenticity and
death denial, 40; back end of *The
Graveyard*, 100; balanced being, 21;
call to action, 76; cognitive zone,
104; commitment to the question
concerning technology, 193;
contemplation and death reckoning,
47; context for technological being, 11;
curative, 18; depression, 43; dimension
of contemporary philosophies of
technology, 4; dread, 103–4; dread vs.
immersion, 104f5; game, 99, 105; ghost,
43; implications of a finite body and
an infinite symbolic system for
representing reality, 77; motivation of
the computer-savvy generation, 91;
needs, 76; needs of a technical animal,
34; needs of the human animal, 73;
objective of all human beings, 9;
perspective, 45; philosophy, 38;
psychodynamic that emerges from
evolutionary theory, 198n6; pursuit of
recognition and death denial, 94; sense
of cosmic importance, 75; "sickness,"
19–20; terror, 22, 28, 77–78, 181–82, 187;
terror of death, 78; terror within the life
world of human beings, 198n6; theory of
technocultural behaviors, 72–73; threat
to a functioning society, 82; vantage
point to make heroic choices, 72;
well-adjusted characters, 56
existentialism, 22

Facebook, 33, 90–92, 198n8
Face in the Crowd, A (film), 39
Family Plots (TV series), 38
fantasies: adolescent, 56; of disembodiment,
17, 196n4; of unlimited power, 17
Fear dot com (film), 39
fellatio, 49, 54, 116. *See also* oral sex
fish heads, 2–3

"Fish Heads" (video), 2
Flanagan, Mary, 98–99, 127, 206
Flow: The Psychology of Optimal Experience
(Csikszentmihalyi), 95, 101–4, 101f4,
104f5, 205
Foer, Jonathan Safran, 3, 206
Foucault, Michel: concept of man, death of,
41; cultural theory, 18; late modernist
artist, 18, 142; life as surveillance
apparatus, 39; man trapped within
panoptic disciplinary structures, 54;
pipe, 151; power/knowledge, history
and theory of, 151; *La trahison des
images*, 151, 206
Frankfurt School, 85, 151, 196n6
Free Press International Marathon, 32
Fukuyama, Francis, 85, 200n14, 86;
apocalyptic perspective, 76; end of
history and the last man, 76, 85;
heroes and emptiness, 86; heroism,
93; heroism, achievement of, 93;
illusion that we can skirt death, 78;
megalothymia, 85, 200n14; pursuit of
financial well-being, 85; recognition as
driving force in history, 84; religious
"roots," 86; story of Leontius, 84, 84–85;
thymos, 84–85

Gale, Nathan, 122, 186, 206
games, role-playing, 93
GameSpot, 71
genetic engineering, 80
German high school shooting, 90
Ghost Whisperer (CBS), 38
Gibb, Steven, 96
Gilchrist, Alexander, 105, 206
Gill, Kimveer, 91, 93
God, death of, 80
Goldenberg, J. L., 165, 167, 206
Goodall, Jane, 3
gothic fiction, 177
Gothic Flame, The (Varma), 171, 176, 212
Gramophone, Film, Typewriter (Kittler), 37,
42, 197n10, 208

promise of, 94; technology's false promise of, 10; vulnerability and finitude vs., 25. *See also* mortality

In and Out of Love (Hirst), 174

incarceration, subjective, 175

Insect Media: An Archaeology of Animals and Technology (Parikka), 173–74, 210

Internet addiction boot camps, 87

In the Dust of This Planet: Horror of Philosophy, Vol. 1 (Thacker), 188–89

"In the Wake of Cultural Studies: Globalization, Theory and the University" (Rajan), 142–43, 147, 149, 210

In the Wake of 9/11: The Psychology of Terror (Pyszczynski), 77, 210

introvert, 23–24, 43, 46, 48

isotope detector, 7

Ivanhoe Project, 140

Jak and Daxter (Playstation 2 game), 96, 98–99, 194

Jerusalem (Blake), 120

Kierkegaard, Søren: characterology, 43–44; *The Concept of Dread*, 46, 207; cultural pathologies, 43; demoniac rage, 23; existentialism, 22; human capacity for anticipation, 80; human finitude and animal condition, 21–22; the immediate man, 46; inauthenticity, 19–20; the introvert, 22, 46, 48; modernist understanding of being, 21; pupil of dread, 57; pupil of possibility, 58; technology and cultural pathologies, 43

Kiersey Temperament Sorter, 22

Kittler, Friedrich, 3; accidents from telecommunications networks, 41; *Gramophone, Film, Typewriter*, 37, 42, 197n10, 207; holy trinity of media, war, and death, 41; media as "flight apparatuses to the great beyond," 42; media determine our situation, 41; necromedia theorist, 42; pick up the soldering iron and build circuits, 142;

pictures repeat the transport of bullets, 54; primary strategy in war is surveillance, 55; prophetic theorizations, 42; realm of the dead has been withdrawn from books, 42; republic of scholars, 141; second cultural studies, 142; telephones ringing and ghosts in the receiver, 45; video camera evolution from the chronophotographic gun, 42; "what the machine gun annihilated, the camera made immortal," 82

Klebold, Dylan, 81, 90

Kohler, Chris, 100, 207

Kojève, Alexandre, 84, 93

Kolgen, Herman, 171–72

Kristeva, Julia, 3, 18, 142, 186, 201n1, 207

Kurzweil, Ray, 16, 74, 208

La Dolce Vita (film), 11

landscapes, apocalyptic, 9

Large Glass, The (Duchamp), 172, 174

"Latour Litanizer" (Bogost), 123, 204

La trahison des images (Foucault), 151, 206

Laws of Cool, The (Liu), 140, 143, 149, 207

Lefebvre, Henri, 153, 208

Leroi-Gourhan, André, 11–12, 202n6

Levinas, Emmanuel, 188, 208

Life of William Blake (Gilchrist), 105, 206

Life on the Screen (Turkle), 151, 212

lifestyle: extremist, 9; of Hollywood stars, 12; sedentary, 9; unheroic, 9

Liu, Alan: aesthetics of "destructive creativity," 149–50; creative destruction inspired by innovate-or-die mentality, 150; culture "lacks any social or ethical checks," 156; destructivity of knowledge work, 150; destructivity tempered by historical perspective, 150; ethos of postindustrial knowledge work, 156; "the humanity of technique," 146; innovative knowledge work, 157; *The Laws of Cool*, 140, 143, 149, 207; myth of progress, 156; rejection of "curatorial history," 150; romancer of the digital

MARCEL O'GORMAN is associate professor of English at the University of Waterloo and director of the Critical Media Lab. His published research, including *E-Crit: Digital Media and Critical Theory and the Humanities,* is concerned with the fate of the humanities in a digital culture. He is a practicing artist whose work combines digital media with conspicuous objects, including a treadmill, a penny-farthing bicycle, a cedar-and-canvas canoe, an antique greenhouse, a coffin, and a Catholic tabernacle.